First published on the occasion of the exhibition
'GSK Contemporary – Aware: Art Fashion Identity'
Royal Academy of Arts, London
2 December 2010 – 30 January 2011

Supported by

Catalogue supported by
London College of Fashion

Exhibition organised by the
Royal Academy of Arts, London

Exhibition Curators
Exhibition concept by Gabi Scardi and
Lucy Orta, and co-curated with
Kathleen Soriano (Director of Exhibitions,
Royal Academy of Arts) and Edith Devaney
(Curator, Royal Academy of Arts)

Exhibition Manager
Sunnifa Hope

Photographic and Copyright Co-ordination
Kitty Corbet Milward

Curatorial Research Assistants
Valentina Laneve
Camilla Palestra

Exhibition Designer
Calum Storrie

Publisher
Damiani editore
via Zanardi, 376
40131 Bologna, Italy
t. +39 051 63 50 805
f. +39 051 63 47 188
www.damianieditore.com
info@damianieditore.it

Editor
Abbie Coppard

Co-editors
Gabi Scardi and Lucy Orta

Editorial Co-ordination
Eleonora Pasqui
Enrico Costanza

Design
Lorenzo Tugnoli

Printed in November 2010 by Grafiche Damiani, Bologna

Copyright © Royal Academy of Arts, London, 2010

British Library Cataloguing-in-Publication Data
A catalogue record of this book is available from the British Library

ISBN 978-88-6208-162-7

Front cover: Acconci Studio, *Umbruffla*, 2005–10. Silk, chiffon, radiant film, cotton thread, boning, 114.3 x 152.4 x 114.3 cm. Courtesy Acconci Studio (Vito Acconci, Francis Bitonti, Loke Chan, Pablo Kohan, Eduardo Marquez, Dario Nunez, Garrett Ricciardi) Consultants: Billings Jackson Design; Katie Gallagher

Back cover: Azra Akšamija, *Nomadic Mosque*, 2005 Textile and photographs, 160 x 50 x 30 cm. © Azra Akšamija and Jörg Mohr 2005

GSK Contemporary

Aware

Art Fashion Identity

DAMIANI

Contents

Foreword

The exhibition 'GSK Contemporary –
Aware: Art Fashion Identity' has been
developed by the Royal Academy
of Arts with a view to exploring the
opportunities that exist at the edges of
contemporary art and how they relate
to and interact with associated practices
such as, in this case, fashion and clothing.
As an Academy, with a fine art school and
a membership of 80 Royal Academician
artists and architects, provocation and
debate is at our heart. This exhibition
challenges the viewer to consider the
everyday elements that are involved in
defining our individual and collective
identities – what we wear denotes who
we are, where we come from, and what
'tribe' we belong to. Clothing has the
ability to illustrate our way of life and
even our unconscious, communicating
our beliefs, status and aspirations.

Providing such a potentially
powerful mechanism of expression, an
exploration of the role of clothing has
been at the heart of the artistic practice
of a number of contemporary artists. It
has particular resonance for those artists
who are attuned to the social situations
of their times and the transformations
underway. These artists adopt and
absorb into their artistic practice many of
the preoccupations of fashion designers.
The distinctions between both disciplines
have shared meeting points: both are
routed in history and therefore look back

as much as forward, and they have the ability to provide vehicles to present and question key issues and needs of our time. The interpretation of the artists and designers allows clothing to become an expression of identity and to speak of our experience of the world around us – its history, its political and social complexities and its changing nature. 'Aware' reflects upon the relationship between our physical coverings and our 'constructed' personal environments; our individual and social identities; and the contexts in which we all live, through clothing that has been designed or constructed to fulfil a function that goes beyond the limitations of ornamentation or fashion.

Glaxo-Smith-Kline's support for this strand of contemporary art programming at the Royal Academy has been fundamental to the development of our thinking and practice in this area. Their sponsorship of this series of GSK Contemporary exhibitions, of which 'Aware' is the third, has been that of an involved partner at every level, and we are extremely grateful to the team at GSK who have championed the project so admirably.

The possibilities around 'Aware' have been taken to even higher levels through the Royal Academy's partnership with London College of Fashion, and particular thanks must go to Frances Corner for her interest and active involvement in the development of the exhibition, its commissions and its associated programmes. Other partners and supporters in the project should also not be forgotten, least of all the many artists, their dealers and the private and institutional lenders who have generously supported the exhibition.

Finally, our heartfelt thanks go to Sunnifa Hope and Kitty Corbet-Milward in the Exhibitions Department at the Royal Academy. Their attention to detail and supreme organisational skills, whilst working at great speed, keep us all on track. The exhibition would not, of course, have been possible without the curators. This initial exhibition proposal was the result of a convergence of ideas and much discussion between Gabi Scardi and the artist Lucy Orta, who then generously allowed me and Edith Devaney to shape the exhibition alongside them. I would also like to thank Caroline Beamish for translating Gabi Scardi's texts for this catalogue so swiftly, and extend heartfelt thanks to Abbie Coppard for all her help in bringing the catalogue together.

The Royal Academy is delighted to be mounting an exhibition that challenges and makes us question the way in which we lead our lives. Contemporary art is uniquely placed to negotiate such relevant subject-matter on our behalf, and an Academy is the natural home for such considerations.

Kathleen Soriano
Director of Exhibitions
Royal Academy of Arts

Exhibition supporter's statement

GlaxoSmithKline (GSK) is pleased to be working with the Royal Academy of Arts as part of our community investment programme. We are proud to be the title sponsor of this exhibition, 'GSK Contemporary – Aware: Art Fashion Identity'.

The continued success of the partnership between GSK and the RA is testament to the creativity and innovation behind the exhibitions. As a company, GSK is committed to transforming lives whilst balancing the demands of our employees, shareholders and the wider society in which we operate and serve. Contributing to the arts remains an integral part of this effort, and we hope you find the third season of GSK Contemporary to be stimulating and engaging.

Themes of discovery are fundamental to a research-based company like GSK; in supporting the GSK Contemporary season of the past three years we hope that visitors will discover links between science and art.

Katie Pinnock
Director UK Corporate Contributions
GlaxoSmithKline

Catalogue supporter's statement

London College of Fashion is delighted to be a partner in this exciting and challenging exhibition, and to be able to provide contributions from some of the college's leading researchers, artists and designers.

The relationship between art and fashion, through conceptual and practical expression, is at London College of Fashion's core. We were immensely proud to endorse the development of 'GSK Contemporary – Aware: Art Fashion Identity', from its original concept by Lucy Orta, London College of Fashion Professor of Art, Fashion and the Environment, together with curator Gabi Scardi. Additionally, we are privileged to support two new commissions by Yinka Shonibare and Hussein Chalayan, the creation of which will directly connect to our teaching and research activity.

London College of Fashion is committed to extending the influence of fashion, be it economically, socially or politically, and we explore fashion in many contexts. This exhibition encapsulates vital characteristics of today's fashion education, and it supports my belief that fashion has the potential to bring about social change when considered in contexts of identity, individuality, technology and the environment. We see this in the work of Professor Helen Storey, whose *Wonderland Project* brings together art and science to find real solutions for a more sustainable world, and in the exploration of craftsmanship, patronage and historical practice in the work of Professor Dai Rees.

With the recent appointment of London College of Fashion Curator, Magdalene Keaney, and significant developments to the Fashion Space Gallery at London College of Fashion we now intend to increase public awareness of how fashion has, is, and will continue to permeate new territories. The opportunity to work with the Royal Academy in presenting 'Aware' has been instrumental to our vision for this, and I look forward to future collaborations.

Professor Frances Corner OBE
Head of College
London College of Fashion

The Sense of Our Time

BY GABI SCARDI

Clothes have always been the foremost pointer to individual and social identity. Clothing is fundamental to physical survival, but also a vehicle of identity; as mask and costume, it is an interface between self and others, an element of recognition or discrimination. Situated between what we are and what we wish to present of ourselves, clothes can also reveal our way of life and our unconscious. They may communicate position, aspirations and desires, needs and our vision of the world. Although clothing is emblematic of the aesthetic dimension that may be adopted in life, it can very easily cross over into something predominantly ornamental. Clothing constitutes a cultural entity in time and space, and its nature relates directly to place and period, to cultural shifts and to a specific economic and social context and its transformations. Rather than being merely a formal exercise, clothing is alive – to the extent that it is connected to (and compromised by) reality.

Correlated to both function and the personality of the wearer, clothes lie at the core of the experiments carried out by the many artists who are particularly attentive to new contexts and values, to the social situations of their times and the transformations under way. These artists take on the forms and methods, as well as physical elements, from an adjacent sector: fashion design. The proximity between these two worlds arouses comparisons at a theoretical as well as a design level, at a methodological as well as an operational level.

Vital, receptive, responsive, tensed between imagining and making, constantly in progress and eager to interpret the meaning of existence and the world, fired by a regenerating tendency to experiment, the two disciplines – art and fashion design – live together in harmony and disagreement, connivance and drastic divergence.

Art, like fashion design, is simultaneously a reflection and a representation, a camouflage but also a mode of existence. In both disciplines, the formal quality and significance of the contents are consubstantial and impossible to ignore. Both represent precision within heterogeneity, discipline within freedom. Neither is passive – on the contrary, both interpret reality as they have created it. As Virginia Woolf wrote: 'Vain trifles as they seem, clothes have [...] more important offices than merely to keep us warm. They change our view of the world and the world's view of us. [...] Thus, there is much to support the view that it is clothes that wear us and not we them; we may make them take the mould of arm or breast, but they mould our hearts, our brains, our tongues, to their liking' (*Orlando*, 1928).

In his quest for self-knowledge, and knowledge of his environment, the artist approaches clothing as a prism through which to take a fresh look at the world, to distil its particular character and to convey its main tendencies and needs.

Like the most experimental fashion designers, artists are motivated by the desire to give a voice to their era, to distil its particular character and to convey its main tendencies and needs. They synthesise the visual identity of a period of time. This does not mean, however, simply being well-informed about the 'latest trend'. Both art and fashion design look backwards as much as forwards, acting as the channel between past and present, heading towards movements that are still in an embryonic stage, waiting to happen in the near future.

When interpreted via the individual gaze of the artist or designer, fired with

Gabriele Di Matteo, *Nuda Umanità / History Stripped Bare*, 2000 / 2010. Oil on canvas, 30 x 40 cm each, 66 of 200 works. Courtesy Federico Luger, Milan

From left to right:
The Neanderthal Man
The Egyptians during spring time
The Etruscans at war vs the Romans
The Roman senate
The Gauls at war vs the Romans
Pyrrhus, the African king of Epirus, at war vs the Romans

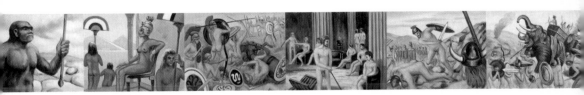

experimental zeal, then clothes are freed from the seasonality of collections and trends, from their commercial and consumerist, or merely functional status.

Art and fashion design represent a kind of reverse side to the reductive vision of glamorous fashion generally provided by the glossy magazines; fashion as a deductive exercise, functioning in a market basically ruled by conformist labels, dangerously connected to the celebrity system; based on a self-referential interpretation of seduction and an anachronistic idea of beauty – which actually pays no attention to bodily reality. By withdrawing clothing from the fashion circus, as represented here, artists root their own creative activity in everyday life, infusing it with commitment and critical sympathy. In their working methods they shun the continuous haste and blind egoism of a present which looks only inwards at itself, gathering substance in order to interpret a particular moment, fragile in its transitory nature but powerful in its urgency.

Clothing which responds to needs beyond the search for protection and safety is nothing new. Originally man wore an undifferentiated garment that fulfilled a protective function: the pelt of a wild animal around his naked body. Change began when symbolic purpose was added to practicality. This is when clothing was transformed into a language that conveyed signs with communicative power, linked to behaviours and dispositions – corresponding to hierarchies and the social order. The need to cover oneself thus combined with religious and apotropaic intent, the outward expression of convention, codified or spontaneous ritual. Clothing is a manifestation, an instrument and a protagonist. Fashion in its current sense was to emerge much later, when society began to shake off its rigid attitudes and opened up to change. From then on, clothing marked each new stage much more decisively than it had before.

'The clothed body is the physical/cultural territory in which we play out the visible and tangible performance of our external identity. The history of dress is also the history of the body, the way we have constructed it, envisaged it, divided it between men and women according to its productive and reproductive functions, its discipline, the hierarchies written all over it, and the discourse which has created its passions and feelings' (Patrizia Calefato, Fashion Theory, 2000, p. 118).

The passage of time has been accompanied by radical transformations in styles of dress during periods of change and rupture: from the Enlightenment to the French Revolution, from the culture of the early twentieth-century avant-garde to Modernism (which viewed individual creativity as one of the great themes, able to influence art as well as fashion and all the other disciplines); to the Bauhaus, with its belief in innovation in the name of world democracy; to the Maoist revolution, which did away with the kimono and women's bound feet, and put everyone into a boiler suit; and finally to the socio-cultural, anti-establishment revolution which, in the 1960s and '70s, swept through the Western world, overturning the established order. To discuss clothing therefore entails the discussion of history.

Artists have often adopted fashion as a subject. Following the climactic developments of Constructivism and Futurism, including the experiments in Neo-Concretism by Hélio Oiticica and Lygia Clark and their 'habitable clothing', if we confine ourselves to the past few decades there are innumerable examples. Joseph Beuys who, with the 'performance' that accompanied all his public appearances, invariably wore a felt hat, an aviator's jacket and boots, a waistcoat over his shirt and ancient trousers; he carried the ritual staff of a shaman, a sign that his sensory faculties were perhaps superior to those of others.

From left to right:
The murder of Julius Caesar
The birth of Christ
The Christians find shelter in the catacombs in Rome
The construction of the Coliseum
The vision of Constantine and his conversion to Christianity
St Patrick introducing Christianity in Ireland

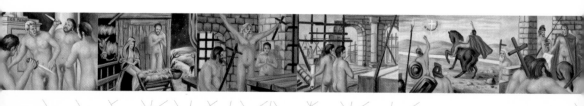

His original *Felt Suit* (1970) was tailored from one of his own suits and can be seen as an oblique self-portrait. For him the suit was an extension of his felt sculptures, in which the matted fabric appeared as an 'element of warmth'. He explained: 'Not even physical warmth is meant ... Actually I mean a completely different kind of warmth, namely spiritual or evolutionary warmth or the beginning of an evolution.' The meaning here is mystical, but it is also the sign of an early regard for ecology that Beuys had made the cornerstone of his work. In reality, we are talking about mental and spiritual ecology, inclining towards unity between ethics, politics and aesthetics; about global thinking, linking nature, culture, science and myth. Thinking that bore the imprint of ideological commitment, which considered 'clothing' to be an effective, concise means of communication.

Reconciling the female identity

It was not by chance that women artists in particular used dress and its forms in their work. We see them beginning to emerge from their confining role, overturning rules and taboos, rebelling against the dictates of beauty imposed by the male gaze, and against models of behaviour which inspired the critic and writer John Berger to write: 'Men look at women. Women watch themselves being looked at' (*Ways of Seeing*, 1972).

During the 1930s Méret Oppenheim, whose innovative, imaginative and varied work anticipated (with sophisticated humour) subjects connected with individuality and the feminine, managed to distil the attitudes and atmosphere of the entire period in her *Déjeuner en fourrure*. Later she produced works such as *Ma gouvernante* and *Beyond the Teacup*. Oppenheim's extremely wide-ranging work included not only painting, sculpture and installations, but also masterpieces of clothing, jewellery and design pieces.

In 1957 Atsuko Tanaka, who was part of the Gutai Group, presented her work at the second Gutai exhibition in the Ohara Kaikan Hall in Tokyo. *Electric Dress* was a kimono-like garment made of electric wire and multicoloured neon light bulbs, to suggest the organic interconnection between the body, with energy flowing through it, and the dynamic, glowing identity of the contemporary city illuminated by flashing neon advertisements.

Louise Bourgeois began her career in the 1950s. She viewed clothing as the product that, more than any other, bears witness to life and to the materialisation of creation. It narrates the body and its fears, its need to cover and protect itself. Dress is also the item that comes face-to-face with sexuality, interrogating the past and challenging the artist's unconscious. Over her very long career, she produced innumerable installations that included clothing, ready-made or made expressly for the purpose. These highly emotive pieces brim with hidden narratives, conveying a sense of intimacy and heartlessness. They promote the idea that introspection is not a defection from life, that only by searching inside oneself, throwing light in dark corners, joining up the threads of the past and following them to the present, is it possible to survive the inalienable and traumatic memories that are preserved within our bodies.

We are on the threshold of the 1960s. One of the most significant revolutions of the period was to overthrow the traditional image of womanhood, leading to a tremendous surge in gender studies, the shortening of skirts and, by introducing a question mark into a system hitherto based on the separation of the sexes, the return of the body to the spotlight.

At this stage, many women asserted themselves by adopting passionately held radical views. They included many artists, free for the first time to construct their own

From left to right:
The Saxons of Germany invading Great Britain
The Romans converting to Christianity
The end of the world around AD 1000
The legend of King Arthur
The Crusaders
Dante Alighieri writing the *Divine Comedy*

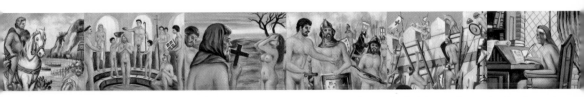

personal artistic profile, to experiment, to express themselves and to enjoy public success. These artists began working in different ways, relating either to the traditional daily activities undertaken by women (sewing, embroidery), or to the female stereotype – the confines of the home, domestic duties, child rearing. To give adequate form to these strongly-experienced subjects, they tried out new languages, modalities, new and less metaphorical modes of expression: performance above all, and photography, film and video. This desire to dislodge the male prerogative in art was translated into a rejection of the hegemony of the medium, the linchpin of the artistic tradition until now. Their activities contributed enormously to female emancipation and to the transformation of the language of Western art.

Clothes were central to the work of many women artists. In *Cut Piece*, Yoko Ono could be found sitting on a dais in the Yamaichi Hall in Kyoto in 1963, and in New York's Carnegie Hall in 1965, inviting the public to come up and cut strips from her clothing. While the scraps of fabric fell to the floor one by one, the unveiling of her body took on the significance of a leap over the boundaries of convention; it overflowed as it progressed into an aggressive act when the artist, still motionless but now nearly naked, was exposed in all her vulnerability. During these years Kusama also dressed and undressed herself, shedding her psychedelic, surreal, sexualised obsessions. A dress, an umbrella, a bag, a naked body or an entire environment can be contaminated by thousands of polka dots or phallic forms, buffeted by the wind of impudent rebellion, an overpowering energy, bullying, destabilising and subverting norms and conventions.

Cross-dressing was also used by Orlan who, veiled and draped, posed as the Virgin Mary; the blatant, extravagant sensuality with

which she infused the image went beyond the admissible, turning the significance of the traditional bare breast into blasphemous provocation.

The early work of Annette Messager was also based on gender: what identifies us, what moulds us? How can we reconcile the female identity that we construct with the identity attributed to us? In her installations the inclusion of old clothes gives them the intensity of a lived experience; they convey painful affective memory, a sense of expressive urgency.

From the outset, in 1975–6, Cindy Sherman dressed up, made up and posed in the search for a way of defining herself by assuming other identities, both male and female.

In 1975 Birgit Jürgenssen published *Housewives' Kitchen Apron*. This is a self-portrait in which she puts on an apron/cooker, which looks bulky and is presumably very heavy. The garment clings to her body in a kind of symbiosis. A stick of bread emerges from the lap/window: the outcome of a strange pregnancy and also a phallic symbol, alluding to the role of mother, or to the role of available and generous wet nurse that women always seem to occupy. *Let me Out of Here* is the title of a 1976 shutter-release photograph in which the artist wears the clothes of a serious, bourgeois wife trapped behind a glass, an invisible but insuperable barrier which convention does not allow her to escape. With this ironic image Jürgenssen describes the condition of supervised liberty endured by many women, their unambiguous stereotype as mother, wife and keeper of the hearth. The artist was later to create a series of shoe-monsters, the *Schuwerk*, from the pregnant shoe to the shoe with wings.

Self-representation and role reversals are also present in the work of Eleanor Antin, who ironically proclaims herself 'king of Sloane Beach'. Dressed as a monarch, wearing a dark cloak and lace-edged shirt, she parades

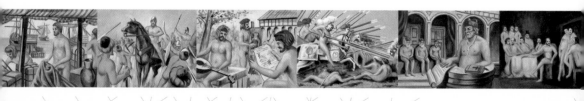

around the beach bowing and kissing people's hand. Through this playful transformation, Antin appropriates a traditional male prerogative: freedom of movement.

In *Mythic Being*, Adrian Piper dresses up as a man, using fashion to claim the right to choose the role of both creator and creation. In art history, as in real life, woman has almost always been the main subject of representation. Valie Export, meanwhile, a member of the Viennese Actionists, is the author of a provocative critique of social and political affairs which is at once visceral and conceptual. Her *Tapp und Tastkino* (1968) was a performance during which the public were invited to touch the artist's breasts by putting their hands inside a kind of prosthetic dress, a box with curtains strapped to her torso. She describes it as 'a cinema of touch and feel'. The more directly aggressive *Genital Panic* (1969) is also aimed at objectifying the body, with the action taking place in a porno cinema in Munich: 'I was dressed in a pullover and a pair of trousers from which I had cut out the pubic area.' The following year, in 1970, in *Body Sign Action*, Export had a garter tattooed on her leg and then exhibited it: a lover's gesture, the gesture of a man-eater or a temptress – yet too direct to be seductive, and too disrespectful of social norms not to appear aggressive.

In 1987 Jana Sterbak exhibited *Vanitas: Flesh Dress for an Albino Anorectic*, a dress made of raw meat, symbolic of erotic love and death, and of the transitory nature of life and love. In 1989 she created *Remote Control*: a woman is suspended from the waist downwards in a framework shaped like a crinoline on wheels. The woman cannot touch the ground with her feet. She is trapped. The structure is activated by a remote control, symbolising the problem of independent action.

Many artists at this time dressed and undressed themselves in order to deliver a powerfully direct and disconcerting message,

and made a major contribution to the redefinition of the female identity. The image of Marina Abramović with a star cut into her stomach, or of Gina Pane dressed as a bride, self-harming with thorns, have become genuine visual icons.

At one with our time

The moment of direct confrontation and defiant challenge is past; the most recent generation of Western artists seems more comfortable in their clothing, even though there is still ground to be won in the areas of equal opportunities and integration.

The strident tones of earlier protests remain, as do the demands for unfettered expression and the rejection of the stereotyped image from which women have only recently managed to escape. Commitment and personal involvement, and the attention to their plight gained by artists in the past are at the root of what is happening now.

The subject of identity is today dealt with on a different level. The challenge to both male and female artists is to decode the splintered, complex reality in which we live and to find a way of making a personal statement about today's needs – which have their own weight of knowledge, history, perceptive tools and codes of expression. Motivated by the desire to plough their own individual furrow, now more than ever they lean towards the specific in order to discover the universal within the specific.

It would be impossible for their work not to touch on the central themes of today: multiculturalism, geopolitics, habitat, community and exclusion, authority and control, social and environmental sustainability. But within these global phenomena they are still able to perceive the human dimension and their effect on individuals. Their awareness of the historical tensions and profound changes taking place in society today combines in their work with

From left to right:
The Jacobin rebellion
The Franco-English war in the prairies of North America
The European colonies arriving in the Caribbean
Frederick the Great of Prussia and the Seven Years' War
The Waterloo battle
The Italian revolutionaries

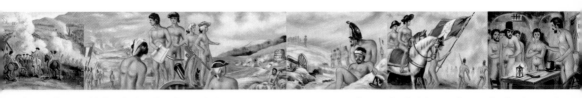

the ability to think in terms of people and the mundane; in other words, the problems, and above all the solutions, are human and have to be tackled individually. They may produce a paradigm, but they are never absolute and never identical for everybody. Nothing is more singular, more personal, more ordinary, more inexorably present every single day than clothing. It moulds to the body that inhabits it and, like some sort of 'storage tank', defines its space. By adhering to the body it absorbs its humours, adopts its silhouette and shares its experiences. It covers us like a second skin. We tend to choose our clothes personally and with care, so that they are comfortable and define our tastes and habits as we would wish to be defined. We choose things with which we can establish a profound relationship, in order to convey to others those features we have in common and those that are distinctive to us alone. Because clothing is intimate and individual it can give information about cultures and people. It is natural that for many artists dress should represent a semantic and expressive element to be used; in many cases the starting point of artistic practice is a personal experience. For those artists, the creation of works in the form of clothes is a means to articulate their own social and political concerns. Starting from the ability to immerse themselves in the folds of daily life, veering between observation and intuition, between reflection, action and interaction, their desire is to create metaphor, to produce a work with either a specific or a much more broad-based message.

The vehicle of identity *par excellence*, clothing makes it possible for artists to narrate the present, and also to explain a past that still speaks to them. As Stuart Hall writes: 'Cultural identity [...] is a matter of "becoming" as well as of "being". It belongs to the future as much as to the past. It is not something which already exists, transcending place, time, history and culture. Cultural identities come from somewhere,

have histories. [...] They undergo constant transformation' ('Cultural Identity and Diaspora', 1993).

Since individuals are not born with an identity pre-determined by their origins, but are constantly enriched by encounters and influences, cultures are themselves not closed and immutable: they are contingent and in a constant state of re-definition. Every individual, every living cultural environment is constantly integrating new, foreign elements into its own form of life and its own expressive tradition. Each cultural environment has a basic root, but at the same time is the product of relationships. It evolves through the confluence of different strands, by contamination and stratification. This is so much more evident in our increasingly mobile and volatile, and ever more interconnected world. Today's geopolitics is in fact characterised by complex dynamics, by interplanetary communication that gets progressively faster. A level of mobility that would in the past have been unthinkable now affects a growing number of people who have become globetrotters, either by choice or necessity. There are also growing waves of migrants, forced to change continents by the need for survival or the hope of a better life. This fluidity has injected vitality into the Old World, and also into countries pursuing new means of development. It also puts traditional lifestyles under pressure as it demands new types of social relationships, a new political and economic order and new symbolic and psychological attitudes. This situation is demonstrated by, among others, Andreas Gursky, whose dispassionate gaze documents macro-phenomena linked to global financial and economic power. One of his photographs shows the Kuwait Stock Exchange populated by men uniformly garbed in the traditional white *thab* and *ghutrah*: an expression of how rigidly codified social roles interact with the new global systems.

From left to right:
Karl Marx
The Pacific War
Abraham Lincoln
The capture of Rome
The death of King Umberto I
The shipwreck of *Titanic*

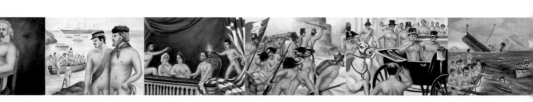

So while our identities are becoming more nomadic, the work of many of the artists who are taking part in this exhibition reflects, in the most diverse ways, this character of the world, investigating new forms of cultural stratification and of life in motion. The Turkish artist Handan Börütçene presents, in the form of a dress 'woven with history', a symbolic, diplomatic and also touristic journey around the Mediterranean. Claudia Losi also uses the narrative power of dress, to tell the story of a clothing fabric that changes into the skin of a huge and seductive touring art work: a life-sized whale made of fabric, designed to travel the world eliciting encounters, stories and experiences. One of today's major fashion designers, Antonio Marras, brings the fabric back to fashionable suits and jackets (*Whale Suits*, 2010). Those clothes will carry forever a memory of adventures and relations the whale collected during its journey.

Maria Papadimitriou follows the lives of the people who represent the essence of nomadic life, the Roma. She wishes to remove the stigma from their image, and provide a much less stereotypical, more vital image. She achieves this with an object representing both clothing and habitat, and emphasises the extent to which the way we dress and the objects we surround ourselves with are laden with symbolic meaning linked to custom, tradition and beliefs.

Azra Akšamija views clothing and architecture as one, and creates a tiny portable mosque that can be moulded to the human body. Our space is more and more compressed and formatted; we live in motion, we bring everything with us. And, in relation to architecture, the visionary project orientated towards the future is still to emerge. It has to bring together all the disciplines connected with building – art, design and architecture.

The same idea is promoted by Mella Jaarsma: identity is not a place to go back to, but the culture and traditions you bring with you. In Jaarsma's work this heritage literally becomes shelter and protection at the same time.

Although one of today's most profound changes – the origin of which lies in global phenomena – is precisely its evident intercultural orientation, the meeting of differences does not automatically lead to a merging; it can also produce violent disequilibrium and breakdown which are far from salutary. The planetary order is riven with tensions and marked by intense contradictions.

Many of the artists in this exhibition, aware of the current state of disturbance, feel the need to become active protagonists in our world by expressing their position explicitly, by promoting the values they believe in. It is nothing new for clothes to be able to express the conflicts that rend the world: in 1967 Martha Rosler used collage to create the powerful series *Bringing the War Home.* Produced during the peak of US military engagement in Vietnam and an extension of her anti-war activities, Rosler explains that the photomontages were a response to her frustration with the television and print media images. These always represent pain and destruction as distant phenomena, existing in an 'elsewhere' which does not belong to us and which we do not manage to feel. In her piece, grisly scenes of war are merged with images of fashion shows, made familiar to us by the mass media. These images thus enter our 'front rooms', rupturing the indifferent calm of the daily routine, a shelter for our fine feelings, with their irritating incongruity.

Today, artists like the Palestinian Sharif Waked directly confront the conflicts that ravage the world. Waked is well aware of the complexity of the situation in the Middle East, and is also closely involved with the terrible fate his own people have to face. He sees art as a way of exorcising the anguish of a situation from which it is not easy to escape. In creating a fashion collection he seizes the

From left to right:
Suffragette
The First World War
Lenin begins the October
 Revolution
Hitler inspecting his troops
Charlie Chaplin
Einstein

opportunity for temporary deliverance from daily humiliation.

Maja Bajevic, who, during the Balkan war, experienced a forced exile from her home in Sarajevo, wears the tragic story of her country literally stitched to her back. Her body becomes a scale of measurement, a diagram and maps. Her powerfully emotive work is a reflection on uprooting, trauma and loss, on the inalienable attachment people feel for their homeland.

Susie MacMurray describes a more personal trauma. With her spiky black dress *Widow*, she produces a reflection on the physicality of emotion. Other artists in the exhibition have, like Bajevic, had personal experience of displacement. Their work is an opportunity to reflect on their own nomadic existence between cultures; they recount their relationship with reality on the move, they give tangible form to the sensations of living astride borders and cultures, neither in nor out, or both inside and outside. They also display the richly furnished minds of cultural ambassadors, from diverse backgrounds and with different approaches.

The narrative potential of clothing also allows them to demonstrate the way the global order is not born of equal participation by all cultures, nor does it necessarily promote the development of a more equitable world. Through their work, Yinka Shonibare and Meschac Gaba speak of the still evident post-colonial situation of the African continent, and aim to dismantle every preconception of historical and cultural identity. Gaba uses braids, traditionally employed by African women for their hairstyles, to make wig-sculptures that recall the forms of architectural masterpieces of Western culture, such as the World Financial Center or the Chrysler Building. Shonibare questions the meaning of cultural and national definitions. To achieve this he employs brightly coloured, iconic 'African' fabrics – in fact, four-colour Dutch wax-printed cotton. He transposes this on to historical eighteenth/nineteenth-century dress styles and contemporary items of clothing.

Although European by birth, Alicia Framis has spent a lot of time in China and her work is based on the commercial phenomenon 'Made in China'. It also touches on the rhetorical content of an object, which concentrates meaning: the national flag, in this case the Chinese flag. *100 Ways to Wear a Flag* consists of a collection of women's clothing made by a series of designers from copies of the flag. The assertively 'masculine' character of the flag is overturned in order for it to adapt to the female form.

All these works bear a strong resemblance to stage sets in which clothing is the leading actor. Thanks to its immediacy and effectiveness in representing meaning and communicating roles, clothing in fact plays a major part in collective ritual, but it can also be a sign of belonging, even of extreme standardisation.

Although concealing difference can encourage equality, a uniform serves mainly to represent rules and authority in its most conservative sense, as well as repression. Clothing directly sanctions hierarchies and social codes, and is essential in legitimising particular cultures and religious rites. It can be solemn and formal, it can become standard or corporate clothing or uniform, the codified clothing *par excellence*. As a sign of belonging to a particular group, a uniform labels and defines. It expresses the subject as endowed with one dimension. Often linked to the need for, and the expression of power, a uniform means being part of a group and accepting its rules (and even feeling lost without it).

Imbued with significance as it is, a uniform can discard functionality in favour of recognisability. Artists such as Gillian Wearing RA describe this in their work. Wearing shows how the uniform's ability to create uniformity can be undermined by the lightest touch of

wit, or by sudden evidence of life. In Gabriele Di Matteo's *History Stripped Bare* (shown on these pages), he demonstrates the way we meticulously disguise ourselves, providing the 'behind-the-scenes' view as well. By stripping history of its adornments, he produces a tapestry of human life which acts as a salutary anti-rhetorical counterpart to official History. He satirises the trappings of power, and shows just how vainglorious history books can be. He illustrates the deliberate manipulation inherent in what we call 'history', and the extent to which we judge by what we see: a tendency that concerns not only history, but also our daily lives. That's exactly what the artist Nasan Tur says, through his work *Human Behaviours*. This is a multiple slideshow with hundreds of pictures of passers-by taken in different European cities, rigorously organised into categories. We live constantly under the watchful eye of the CCTV camera, individuals with bar codes whose every move is monitored. We are used to being labelled, pigeonholed forever on the strength of superficial stereotypes, with the result that we end up keeping tabs on each other, defining, equating and distinguishing, giving rise to phenomena of social inclusion and exclusion based on parameters fixed at random. All Tur does is to take this tendency to an ironic extreme, organising his collection on the basis of attitudes that are in no way exceptional, that are indeed hackneyed and commonplace. But, paradoxically, it is precisely the absolute ordinariness of the portraits he has catalogued that allows the variegated diversity of our everyday universe to emerge.

Fashion designers such as Yohji Yamamoto and Martin Margiela (La Maison Martin Margiela) also reject the grandiloquent. Their unassertive collections favour minimalist rigour, with a tendency towards deconstruction and a glance towards the transitory. Margiela's series *(9/4/1615)* is a genuine *memento mori*, a tribute to death and renewal.

The striking *Kimono Memories of Hiroshima* by Marie-Ange Guilleminot represents a cathartic journey backwards in time and history, to the tragedy of Hiroshima and beyond. Tradition, memory, healing and the very personal all occupy her work, which always has clothing at its epicentre. It consists particularly of attributing a new status to an item: a cheap, everyday object, such as tights, can be manipulated and can allow new, valuable functions to combine. This is connected with the idea that life should involve less reckless frenzy and waste, and the future should be more sustainable. Ecology, sustainable development and urban life: politically engaged artists have been exploring these themes for years. In the 1970s, Vito Acconci, one of the towering figures in the art of today, created an important piece on the subject of the body as disputed between the public and the private spheres. In our overcrowded world, the body sometimes yearns for its own space – an intimate, portable area, a refuge in time of need. Acconci Studio's *Umbruffla* evolved from this idea: a useful object, a wearable umbrella that becomes a space in which to hide.

The evidence of a crisis in the traditional relationship between humanity and the environment brings with it wide-ranging considerations on the need to husband the resources provided us by nature. The projects of many artists and fashion designers express a sense of responsibility, attentiveness to society and a quest for social development and 'ecological healing'.

These artists promote a new solicitude towards the world in which we live, a more responsible attitude to life. This attitude must manifest itself in changes to the pattern of our daily lives; activities should meet individual needs without abdicating responsibility for the planet. The style of life proposed would be quieter, more equitable, more sustainable. We need only to think of Helen Storey. Her dissolvable dress series

From left to right:
Kennedy in the Oval Studio
The assassination of President Kennedy
The Fab Four
Khomeini banished in France
Margaret Thatcher elected Prime Minister
The marriage of Lady Di and Prince Charles

sets off an organic process with the aim of finding new ways of integrating our needs into a natural cycle. Or Andrea Zittel, who imagines a society based on sufficiency rather than on the need for abundance, on a light, transparent economy, on ecological science in which micro and macro are one; the individual and the environment and all things are organically linked. Zittel makes her own clothes and maintains that care for oneself and the environment is a way of guaranteeing the survival of the planet. One should never be motivated by outside influences: the tasks of planning, choosing and deciding belong to us. This is a way of taking over the management of one's own life, of giving it meaning and pointing it in the right direction.

In *Carapace: Triptych, The Butcher's Window*, Dai Rees also discusses our relationship with the world, and speaks of intelligence and sensitivity, but also death and trauma in a distinctly uncomfortable way.

Questions are more crucial and replies more urgent when everything takes place in urban surroundings, where life can be more complex and the impatient rhythms of contemporary living pulsate so insistently. The comparison between haves and have nots is sharper in the city, the close encounters between individuals and culture can be more stressful. Not only that: the city is the prime

setting for the performance that is daily life, and the performative aspect of clothes and fashion gives shape to our way of relating to reality. It is a kind of theatre of life, in which representation is not the opposite of substance but exists alongside it. The scene of this spontaneous performance could be a modest barber's shop near the station in a large town, as in the work of Marcello Maloberti. Here, in a location regarded in Mediterranean countries as a classic meeting place, specific beauty codes gain meaning and importance, and a brilliant red apron can become a king's cloak.

It could be an area of Mumbai in India, where Kimsooja filmed her *Encounter – Looking into Sewing*, located in the part of town where fabrics for Western consumers are made. A slice of everyday life, but also an involving setting for one of the most crucial phenomenons of current global dynamics. Other artists, for example Katerina Šedá, show the way clothing helps establish man within his urban geography, in a specific social and relational environment. Lucy Orta may be considered an artist who, with thoroughness and continuity, and great wisdom, has managed to analyse clothing in all its forms, meanings and functions. Since the late 1980s Orta has adopted clothing as a reference point in an oeuvre which aims to steer the

From left to right:
Ronald and Nancy Reagan with Frank Sinatra
Queen Elizabeth and Prime Minister Troudeau sign a constitutional act
The fall of the Berlin Wall
Clinton, Rabin and Arafat
Lady Di and Dodi El Faied leaving the Ritz
The meeting of the Pope and Arafat in Rome

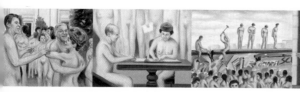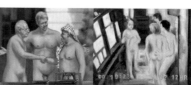

world in the direction of greater social and environmental sustainability. All her work is tinged by her generative approach. She marries art's anti-instrumental urges with a constructive thrust, ideas with organisational effort, seeing in art's imaginative energy an effective means of relating to concrete reality. Every piece is an opportunity to give shape to metaphor, but also a means of communicating ways of transforming the current cultural models. From mobility to food, to habitat, all aspects of life are close to Orta's heart and no project is too daunting to undertake.

Clothing can inform us about a different, more post-modern (and now possibly prevailing) kind of performance in which doing and saying, appearing and acting all combine to produce a kind of communication in which the abstract and the concrete converge. Grayson Perry with his *Artist's Robe*, and Hussein Chalayan in his sensitive version of bunraku, '*Son' of Sonzai Suru*, present this new kind of performance with its existential reading of 'the mask'. Costume, like-life with added life, emphasises, amplifies and empowers.

Clothing can also lend itself to dangerous games that lead to an incorrect perception of the 'other' and even of ourselves. Too often we perceive ourselves in the way we are considered, rather than who we really are. The judgment of others plants an idea in the mind which may or may not be accurate, but which finally we assimilate.

The artist's personal gaze can be an antidote to stereotyping and generalisation. It can dispel mystification and ideas that are not thought through, ideas that are inherited and assumed to be true. It can contribute to the re-emergence of the originality we all possess. We must understand it as a cluster of possible routes rather than a continuous line, as a fluid, chequered, open, uncertain, variable progress which provides pleasure, yes, but requires serious attention and a painstaking assessment of our own lifespan. Clothing is a countermeasure to the sterility of materials, to the arrogant perfection of aesthetic form that exists in every human endeavour. Into clothing is transposed the complex, stratified and changeable relationship between personal experience and collective memory, between an intensely-lived past, minus nostalgia, and the future. The relative nature of certainty and outcome encourages us to wander through the future, to look forward, to make plans that are not simply mindless affirmation, but are a vital sweepstake about what is going to happen. You have to dream of growth to be able to grow.

From left to right:
The Queen Mother's 100th
 birthday
Silvio Berlusconi's speech
Saddam Hussein
G W Bush, D Cheney, C Powell
 and C Rice
G W Bush and Tony Blair
The meeting of the Greats in
 Canada

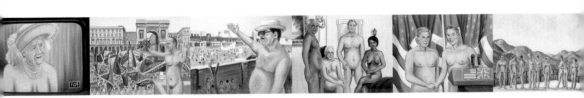

Fashion, Clothing and Identity:
A modern contradiction

BY JOANNE ENTWISTLE

That fashion and clothing play with identity has become taken for granted in everyday life. Make-over television shows perpetuate the idea that what you wear really matters to how people 'read' us, and ordinary conversations about dress may focus on the clothing worn by others and ponder over their meanings ('How could she wear that? What was she thinking?'). Clothing is imbued with meaning and thought to reveal something of the self, whether we like it or not. The everyday garments brought together in the privacy of our bedroom might be put on with conscious, deliberate or creative intention to signify some message about the self –'I am a professional woman/business man/rebellious teenager/Mod or Skater/devout Muslim' etc – or it might be the subject of intense private anxiety, especially if the wearer is to face an imagined critical audience, a new employer, for example. Some may, of course, bypass this altogether, scraping off the floor in an absentminded way the clothes worn the previous day, the wearer too busy or too unconcerned to give appearance any consideration. Yet, however unconscious, the wearer may still be read through these choices. While clothing 'messages' are opaque and open to misunderstanding, there is a common belief that clothing 'speaks' of identity.

There is a contradiction here, however. Modern dress is largely defined as fashionable dress, that is, dress that is changed regularly and systemically by a fashion system. This constant flux highlights the often superficial nature of our outward apparel. During one season, fashion might be all about girlish prints and youthful playfulness, the next it may proclaim a 'womanly' style and the 'return of grown-up clothes', until the pendulum swings back again. The fashion world – that world of illusion and glamour defined by designers, stylists and journalists – turns on this constant change. Consciously or unconsciously, everyone who plays this fashion game knows that the 'truth' of identity is never fixed or secure. However much the new styles are heralded, and however confident the proclamations are, everyone knows that fashions will keep on changing, sometimes evolving out of previous styles, sometimes in a radical backlash against them. We are invited – by designers, by journalists, by the stores themselves – to play this game of fashion and perform our identity through our choices of dress. Yet despite our knowledge of this game, and an awareness that clothes can conceal as much as they reveal – that they are superficial and temporally changing – this urge to try to secure identities through dress remains. We still want, and hope, to read others through their clothes.

There are many things we can learn about others through the way in which they dress. Gender is the most obvious identity marker that is articulated through clothes, from the very earliest clothes coded blue or pink, to particular garments – skirts being the obvious marker of 'femininity', at least within the West. Early feminist attempts to challenge the oppressive nature of this gender regime, or at least point to its artifice, tend to fall on deaf ears: the 'is it a boy or a girl?' enquiry demands a clear answer, and the easiest way to provide this is through clearly defined gendered dress. These markers of gender are arbitrary: while in the West it is pink for a girl and blue for a boy, not long ago the reverse was true; since pink is derived from red it was considered the 'stronger', more 'definitive' colour. 'If you like the colour note on the little one's garments, use pink for the boy

and blue for the girl, if you are a follower of convention,' proclaimed *The Sunday Sentinal* on 29 March 1914. Attempts to bypass this identity system and raise children 'gender neutral' – by some parents in Scandinavia for example, as recently reported in the UK press – are almost certainly bound to fail. The regime is too all-encompassing, too prevalent for any individual to fight, and one would expect that the children themselves will most likely demand to fit into one or other category once they acquire language and thus become aware of gender.

This point touches on something critical: that social structures and influences are key to understanding dress. Humans are social beings who share common language and values that articulate group membership. We are not atomised individuals but members of communities, and clothing signals our belonging. Indeed, this simple fact is a source of much academic interest, often focusing attention on clothing as part of the status system. Early writers on fashion and dress, such as sociologists Thorstein Veblen and Georg Simmel, attempted to explain the ways in which clothes might signify membership to identifiable classes or communities. In his work on the emerging petite bourgeoisies in America at the end of the nineteenth century, Veblen pointed to the way in which this class used specifically female fashion as a tool to articulate their wealth or pecuniary position in their competition with established élites. His argument that this status competition, which demanded women to become 'exquisite slaves' and wear the most elaborate fashions of the day, has long since been challenged, but it remains a potent theory all the same. Simmel's sociology in the early part of the twentieth century provides a more sophisticated analysis of the role played by clothes, especially fashion in modern societies. These societies, he argued, exhibit the dual and contradictory tendency towards both unity and differentiation, and

modern fashion exemplifies this. 'Fashion is the imitation of a given example and satisfies the demand for social adaptation [...] At the same time it satisfies in no less degree the need of differentiation, the tendency towards dissimilarity'. In other words, we signal that we belong by wearing the dominant fashions of the day and thus look similar to our contemporaries, but we want to be seen as individuals as well. His analysis also offers an explanation as to why fashions change when he argues that 'fashions differ for different classes – the fashions of the upper stratum of society are never identical with those of the lower; in fact, they are abandoned by the former as soon as the latter prepares to appropriate them.' So although fashion may start out being worn by an élite minority to assert their difference, this difference diminishes as fashions get widely adopted, and thus the fashionable set move on to another style. Depending on your viewpoint, Simmel's 'trickle down' model has been largely dismissed as too simplistic, or dispelled altogether with the arrival of mass fashion in the mid-twentieth century that allowed the faster dispersal of fashionable clothes, and a powerful media that disseminated fashion images to a wider population. Whatever the problems, Simmel's explanatory framework forcefully demonstrates how fashion has been viewed as a marker of difference.

Alongside gender and class, other elements of identity may be proclaimed or performed through dress, religion being the obvious one. Of all the signifiers of religious affiliation – cassocks, dog collars, nuns' habits – perhaps the most potent one in recent years has been the hijab, currently a focal point in France following the Government's law to ban it. This debate, and the law that provoked it, demonstrates clearly the way in which clothes can articulate (some) components of identity and, in doing so, mark out difference. Such differences – Muslim/non-Muslim – are, of

course, highly political. Clothes can and do articulate who belongs to a community, and who is outside or excluded from it. For some, especially minority groups, this difference is to be celebrated, while for others – in this case about 70 per cent of the French population – it is a political problem; and the markers that signify difference, such as the veil, are thought to segregate not integrate. Whether the ban allows for more integration or the stigmatisation of a Muslims in France remains to be seen, but this particular case study highlights how the boundaries of the body are, quite literally, symbolic of other potent boundaries of belonging and community.

Representations of the body in art have long lingered on the apparel we use to dress it, and no discussion of clothing and identity can fail to acknowledge their importance. Further, these representations in part construct identities; indeed, representations in art tell a tale of the power. While we have scant material on the everyday dress worn by ordinary people in history, the portraits we have of kings and queens in their finery testify to the grandeur of fashionable courtly dress while simultaneously illustrating position. For example, Holbein's paintings of King Henry XIII and the Armada portrait of Elizabeth I illustrate how dress was used to symbolically articulate power in Tudor times: the volumes of space created around the body transform it into something super-human, while the extravagant decoration and ornamentation articulate wealth unimaginable in its day. The paintings themselves are representations produced for the very purpose of proclaiming power, status and the supreme identity of the monarch. In other words, fashion is a way of representing the self that is itself constantly represented – through art and media images. We can further explore the connections between clothing and identity both anthropologically and historically, as well as through the ordinary ways in which clothing is utilised as part of the everyday performances of self. Starting with the anthropological perspective, there is overwhelming evidence to show that humans use symbols to communicate meaning, whether it be through language, clothing or other material objects. Early anthropological evidence and contemporary accounts all demonstrate that the human body is never left entirely 'naked', but is always 'dressed' in some way, using available materials to cover, adorn, decorate or modify the body's appearance.

Traditional societies tend to have more stable systems of clothing that demarcate community and membership and one's place within the hierarchy. This was once the case in Western societies as well, when dress was more clearly coded in terms of class position; the butcher, the baker (and the candlestick maker) all had some sort of 'uniform' that was clearly understood, and later, as we move through the nineteenth century, the arrival of suits and bowler hats demarcated a new middle class from the manual labourer

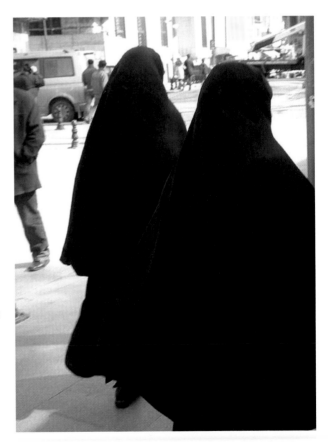

Women in a hijab, Sururi, Istanbul 2007. Photograph by David Lisbona

in overalls. What arguably begins to set traditional and modern societies apart is the emerging influence of a fashion system in the West that begins to make regular changes of clothing the norm. It has been often pointed out by some dress historians and anthropologists that the regular pendulum swings of fashion in the West are not found in those societies where traditions of dress are slower to alter, although not unchanging. However, this alone is not enough to set modern dress apart from traditional clothing systems. Indeed, no such clear separation exists today when so called 'traditional' societies now increasingly have access to Western ideology and fashion, and global migration has mixed it up still further, so that in the West traditional dress co-exists alongside the fashion system. Perhaps what sets modern dress apart from that found in traditional communities is arguably the particular emphasis placed on the idea of individuality and the need to 'express' the self or one's individuality over and above all else. Indeed, the call to 'be an individual' and to 'express yourself' are among the founding principles of modernity. Thus, in contrast to many traditional societies where social standing or community might be prioritised, in modern, Western societies the idea of the 'individual' has become the dominant way to understand identity and, through particular historical developments, it comes to be connected to appearance.

The emergence of this version of identity – as a distinct historical formation – has been well documented by historians; for example, Norbert Elias's analysis of 'individualisation' occurring alongside the 'civilising process' in Western Europe analyses the emergence of the idea of the unique individual located in a physically separate body; the pre-modern idea of identity didn't place emphasis on individual bodies in this way. This story is further developed in Richard Sennett's account of 'the fall of

public man' which examines the historical forces that produced our modern obsession with the authentic, self-contained and autonomous self. His analysis of eighteenth- and nineteenth-century accounts of identity shows the emergence of our modern connection between outward appearance and inward identity that led to a psychological version of identity.

Describing the elaborate and extravagant dress of the élite in the eighteenth century, Sennett argues that the body was read not as an indicator of some inner self or identity, but as a place for performance in public. In other words, the dress worn in public at this time was all about artifice and display, rather than an indicator of any interior reality of the person beneath. Indeed, this idea of self as an interior realm only began to take hold in the nineteenth century with the celebration of 'authenticity', which related exterior appearance to some imagined interior essence. The twin influences of nineteenth-century Romanticism and entrepreneurial capitalism, which were developing at the same time in protestant countries such as the United Kingdom and the US, are largely responsible for this psychological reading of the self, a point further underscored by the development of psychoanalysis towards the end of the century. Romanticism placed an increasing emphasis upon the self as a psychological reality that could – and should – be examined and expressed, while capitalism and the 'self-made man' became a nineteenth-century archetype. Under the terms of these historical developments, the idea that identity could be read from the surface grew, and with it the idea that we can know the other from reading their bodies and their dress. This is not to say that identity *is* 'authentic' and that it *should* be understood and read from appearance, just that it *comes to be understood* in these terms under very particular historic developments. By the late nineteenth century,

a plethora of physiognomic discourses had emerged that claimed to read the true essence of self from various aspects of the exterior body, with psychological crime novels, such as those featuring Sherlock Holmes, developing it further. That said, the idea that 'appearances can be deceiving' – the flipside of this modern incarnation of the self – was to become another common theme in the nineteenth century.

The archetypal figure at this time to demonstrate this careful construction of self through appearance is the dandy. Although this historical figure can be traced back much further – to Regency Britain and the colourful character of Beau Brummell – the dandy develops into the most modern of male figures in the mid- nineteenth century, dressed carefully in plain and simple dark apparel that gets taken up in the form of the three-piece business suit by the newly emerging industrial capitalists and office workers by the end of the century. Baudelaire's depiction of this paired-down simplicity of dress in *The Painter of Modern Life* captures the style eloquently:

'Contrary to what a lot of thoughtless people seem to believe, dandyism is not even an excessive delight in clothes and material elegance. For the perfect dandy, these things are no more than the symbol of the aristocratic superiority of his mind. Thus, in his eyes, enamored as he is above all of distinction, perfection in dress consists in absolute simplicity, which is, indeed, the best way of being distinguished.'

Here we see how the self is expressed and distinguished through dress, which becomes the mark of the unique, modern individual. We thus arrive at the contradiction at the heart of our modern connections between identity and clothing, dress and fashion: we are called upon to read identity from dress, but we also know that the exterior might not always be read as truthful.

This history of the self and the ideas we have inherited about identity and appearance develop in a different direction as we move through the twentieth century. The self begins to be gradually 'deconstructed', first by Freudian psychoanalysis and later by postmodernism. If psychoanalysis challenged the Western view of the unconscious, describing it as completely unified and in control of meaning, postmodernism further unravelled our certainties about identity by demonstrating the arbitrary nature of the signifiers we use to articulate identity. With postmodernism, the modern obsession with identity moves in the opposite direction: instead of authenticity, postmodernism emphasises identity as playful and depthless. For postmodernists, fashion, as the dominant dress system in the West, takes a central role in the play of signs. As a system of dress, its totally arbitrary swings make available a whole range of different styles

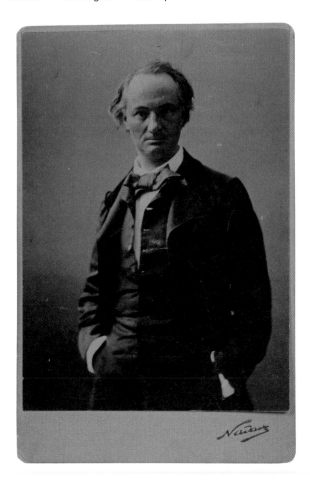

Gaspard-Félix Tournachon (1820–1910), *Charles Baudelaire*, 1855. Cabinet card, albumen print, mounted on card bearing studio stamp

that consumers can choose to wear, in what anthropologist Ted Polhemus called 'the supermarket of style'. Identity, under the terms of postmodernism, is up for grabs, something we can play with, and surface becomes the new depth.

Whatever the postmodernists say about dress and identity, and however unstable the meanings of our clothes, we do not have free reign over our dress, and our identity may not be so freely chosen either. The social nature of dress determines many of the clothes we can choose to wear. For one thing, the fashion system, made up of many different individual and groups, can only make available some choices and not others, thereby limiting the signs we can play with. Further, we dress for different occasions, each of them with particular 'rules' that may or may not be explicit. We are advised to wear black for most funerals and avoid white for weddings (unless we are the bride of course);

we would not wear a bikini to the office or a raincoat to go swimming. Our choices are never entirely free. Our dress is almost always contextual – time and place play their role in how clothing is interpreted and our clothing is always shaped by the prevailing social conventions. Returning to the business man dressed in a suit and tie, such garb now articulates 'business' because of a certain configuration of historical developments in the West, going back as far as the nineteenth-century dandies, who came to express the restraint and professional demeanour necessary to conduct business in the world of work. Yet, while this convention has become a global one, it is not without its local accents: in Bermuda, knee-length shorts are worn with jackets and ties in a combination that would be laughed at in Wall Street or the Square Mile!

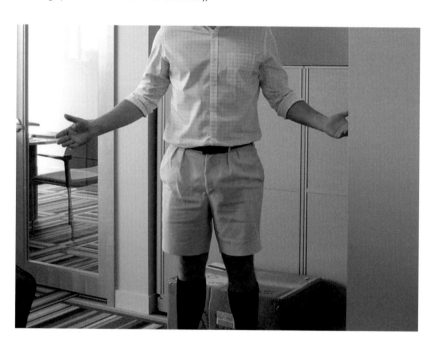

Bermuda shorts, 2010. Photograph by Lee McArthur

Conclusion

Identity is a modern obsession, and fashion and clothing have become a particularly modern way to articulate components of it. However, there is no straightforward relationship between them. Western individualism may attempt to assert some global dominance, as part of an ideology of the self as centered, unique, 'authentic' and capable of expressing itself, but it is not the only model of identity (and nor has it been historically) and the fashion system is not the only system to make claims to dress the self. Fashion and dress have been linked to identity in many different ways, and many groups attempt to control fashion and dress as a way of asserting identity, such as religious or ethnic membership. Increasingly, in a globalised world, these different identity and dress systems come into conflict, as is currently happening in France (and other Western countries) with the banning of the veil. Here, the clash is articulated as one of secularism over religious practices, but the fact that the focal point is an item of dress only underlines the highly potent and increasingly politicised nature of dress and identity in contemporary society.

No wonder clothing and fashion have been a focus for artistic practice. It seems hardly surprising that artists have been fascinated with the role of clothing in communication, especially in the light of our current obsession with appearance, stimulated by an ever-widening media arena which heightens our awareness of how we look. If nothing else, artistic practice can help to highlight these complex issues and articulate the very different ways in which identity might be linked to fashion and dress. The exhibition 'Aware: Art Fashion Identity' makes a significant intervention into these debates.

References

Baudelaire, C., *The Painter of Modern Life and Other Essays*, New York 1986 (1964), trans. Jonathan Mayne.

Breward, C., *The Culture of Fashion*, Manchester 1995.

Elias, N., *The Civilising Process Vol I: The History of Manners*, Oxford 1969 (1939).

Polhemus, T., *Streetstyle: From Sidewalk to Catwalk*, London 1994.

Sennett, R., *The Fall of Public Man*, Cambridge 1977.

Simmel, G., 'Fashion' in *International Quarterly*, 10 (1904), pp. 130–55.

Veblen, T., *The Theory of the Leisure Class*, London 2001 (1899).

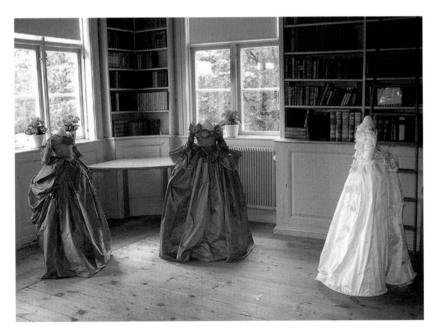

Eighteenth century dresses, Sweden, 2008. Photograph by Per Ola Wiberg

Questioning Identity

BY LUCY ORTA

'GSK Contemporary – Aware: Art Fashion Identity' has evolved out of a deep necessity to expand the definition and role that clothing plays within our society. It has taken almost twenty years of questioning and research (and a lot of frustration) finally to bring together a series of fellow artists and designers who share the same dedication to agitating the definition of fashion and demonstrate that clothing is a powerful instrument for communication that we have a tendency to choose, use and discard too arbitrarily.

The questions I began posing were generated by an uncomfortable doubt in my successful career as a young fashion designer and, not withstanding, linked directly to the economic decline throughout the early 1990s. The first Gulf War, followed swiftly by a stock market crash as well as mass unemployment leading to general social unrest, stood in stark contrast to the superfluous fashion we had been observing in the extravagant catwalk shows. Along with a group of similarly disheartened designers I began searching for alternative means of expressing the deep changes that were taking place in society. Our focus for redefining the role of clothing was directed towards basic needs, such as protection, survival shelter and cocooning: some examples that come to mind are the Final Home by Kosuke Tsumura for Issey Miyake, which are parkas stuffed with newspaper for heat conservation, Vexed Generation's muffled jackets and C.P. Company's transformable shelters.

I began spending less time in the Parisian couture houses fitting beautiful models with exquisite dresses, and more time in my partner's artist-studio, sketching Utopian responses to these fundamental needs. Among some of these early drawings we find the *Habitent*, a domed tent that converts in a matter of seconds into a waterproof cape; *Ambulatory Survival Sac*,

Lucy Orta, *Refuge Wear – Habitent*, 1992. Aluminium-coated polyamide, polar fleece, telescopic aluminium poles, whistle, lantern, 125 x 125 x 125 cm

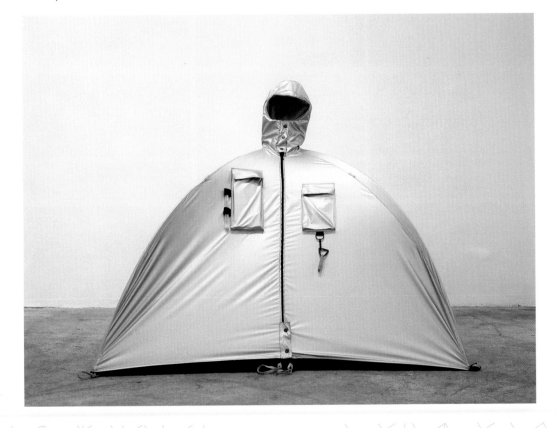

a sleeping bag that divides into two parts – a jacket and rucksack; and *Mobile Cocoon*, reflecting on basic survival strategies such as mobility, warmth, protection from harsh elements – refuge from an increasing alien and hostile society. Not having much success with these proposals within the fashion world, I gravitated closer to the Parisian contemporary art scene, and my 'prototype' *Refuge Wear* sculptures were immediately exhibited to much acclaim in a number of venues, including the Galerie Anne de Villepoix (1992), the 'Art: Foncion Sociale!' (Art: Social Function!), which was held inside Le Corbusier's Cité de Refuge Salvation Army homeless hostel (1993), and 'Ateliers 94' at the Modern Art Museum Paris (1994).

Around the same time a young avant-garde fashion scene was emerging from Holland and Belgium, diverting attention away from the élite Parisian couture. These designers presented their work in non-traditional catwalk venues in Paris and coincidently Martin Margiela at Le Cité de Refuge (1992) and Victor and Rolf in the Modern Art Museum (1994). Within this truly exciting design context my practice as a contemporary visual artist was to develop out of frustration at the established system – staging an impromptu *Refuge Wear Intervention* (demonstration) outside the entrance to the Carré du Louvre catwalk shows and some abandoned squats around Paris simultaneously – into a longer and deeper enquiry into the communicative aspects of clothing that reflected on notions of visibility/invisibility; the role fashion plays in the construction of individual and collective identities; and how we can harness the power that clothing exhorts on us through its extreme diversity and universality in ways that can alter our daily actions or even, perhaps,

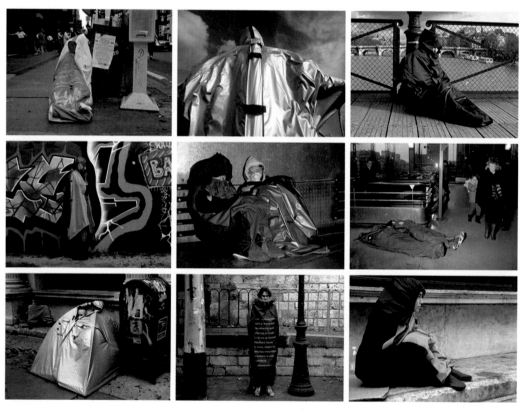

Lucy Orta, *Refuge Wear
City Interventions*, 1993–8.
Original Lambda colour
photographs, 200 x 290 cm

change society. In this short introduction to such a vast and fascinating subject I would like to touch upon some of the themes which merit special attention.

You may wonder how clothes can make us think differently about society and how fashion can possibly transform lives. Perhaps these two examples can inform us.

Andrea Zittel is an artist who has devised a large body of her work around the function her clothing plays within her life, right down to daily chores such as cleaning and cooking. She creates a garment for each occasion so the shape and the materials are carefully considered using handcrafted and traditional methods to construct each one. A garment is literally spun directly from the wool on the sheep's back, felted and moulded into the shape of a dress. The dress is not just a dress, nor is it just an apron! It's a holistic view on life and presents a special consideration for sustainable living. It could be described as a total manifestation of life = creativity, and thus emanates beautifully from the theories of Joseph Beuys.

The *Identity + Refuge* workshop I organised in 1995 with residents from the Salvation Army hostel in Paris demonstrates how fashion plays an important role in re-assuming an identity within society, after circumstances may have resulted in its loss or deprivation. What began life as a simple customisation project – whereby we altered and arranged the second-hand garments distributed to each of the residents arriving in the shelter – evolved into a truly visionary couture project. Using basic transformation techniques, the residents designed and

created an innovative collection of women's wear, which developed their creative skills, built confidence and reconstructed a psychology through the therapy of creating. On seeing the designs emerge from the makeshift cutting room we had sequestered in the laundry room of the Salvation Army, more members of the hostel became involved and together we were able to renovate all kinds of discarded items of furniture, lamps and household objects. These formed the backdrop to a catwalk show staged during Paris Fashion Week, to the acclaim of many journalists. These kinds of sustainable fashion initiatives are more and more frequent, some with great long-term benefits, such as the social enterprise Fine Cell Work which helps to rehabilitate prisoners by giving them the opportunity to earn and save money as well as the chance to rebuild their lives through craft and achievement.

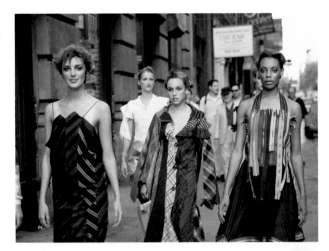

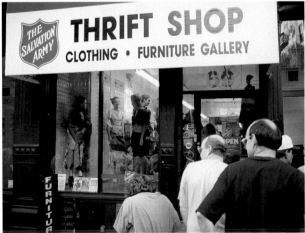

Lucy Orta, *Identity + Refuge*, 1995–6. Workshop and catwalk at Le Cité de Refuge, Salvation Army Paris and New York

In the work of artists such as Kimsooja, Andreas Gursky, Yinka Shonibare and Azra Akšamija, our understanding of clothes as markers of social/group differences or manifestations of individual pseudo-differences are challenged. In Claudia Losi's *Balena Project*, or my ongoing *Nexus Architecture*, clothing becomes the medium through which social links and bonds are made manifest, both literally and metaphorically. The links of zippers and channels, while enhancing the uniformity of the workers' overalls, create androgynous shapes that defy classification by the usual social markers and attempt to give form to the social, not the individual body. As fashion sociologist Dr Joanne Entwistle states: 'Instead of differences, we are offered a powerful vision of possible, momentary collectives or networks of being whose connections are rendered visible and visceral in time and space.'[1]

One of my deep preoccupations has been the relationship between clothing and communication. In the nineteenth century itinerant salesmen wore their numerous goods in sculptural forms: accumulations of brooms or baskets were piled into reeling towers, not dissimilar to the work of Mella Jaarsma. Even today, the sandwich men along Oxford Street wear their advertising boards enticing us to visit Sushi bars or yet another cell phone outlet. But text messages on clothing can be of a different nature; in some cases it can be disturbing, attracting us inexorably (just as packaging attracts customers) towards problems that are continually avoided by this consumer society. Philosopher and urban theorist Paul Virilio has remarked on the 'prophetic dimension' of *Refuge Wear* and *Nexus Architecture*, and he goes on to say: 'It is an acknowledged fact that our society has a packaging mentality which goes hand-in-hand with marketing and mobility. Packaging has a dual role: its prime role is to facilitate transport, and its secondary role is to facilitate the message. In Lucy Orta's work, clothes are no longer

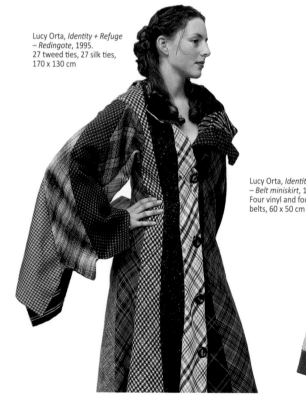

Lucy Orta, *Identity + Refuge – Redingote*, 1995. 27 tweed ties, 27 silk ties, 170 x 130 cm

1 Entwistle, J., 'Refuge Wear and Nexus Architecture' in 9th 'Havana Biennial' exhibition catalogue 2006

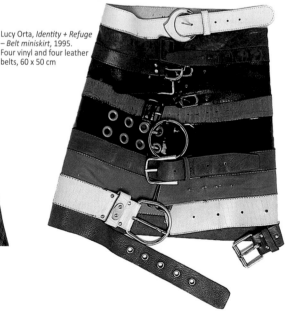

Lucy Orta, *Identity + Refuge – Belt miniskirt*, 1995. Four vinyl and four leather belts, 60 x 50 cm

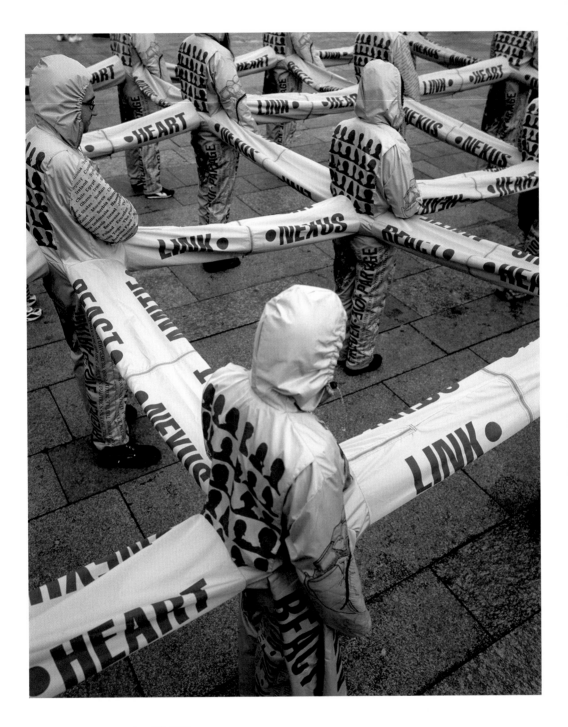

Lucy Orta, *Nexus
Architecture x 50
Intervention Köln*, 2001.
Lambda colour
photograph, 150 x 120 cm

perceived as a mere covering close to the body, as a second skin, but also as a form of packaging, in other words, half-way between architecture and dress. We know that there are several skins: underwear, the clothes themselves, and the overcoat. We could continue this onion-layer approach by saying that after the overcoat there is the sleeping bag, that after the sleeping bag comes the tent, that after the tent comes the container ... Clothes emancipate themselves, expand to try to become a house, a pneumatic raft ... The garment becomes more than mere clothing; it is a vehicle, a survival vehicle certainly but also a vehicle which protects against anonymity.'[2]

The theme of survival has been an important area of research as it touches upon both the personal and the global – the individual and the collective body. In the series *Life Guard* and *Survival Kit* there is an explicit reference to the tools and objects of emergency rescue missions, such as the harnesses in the drop-parachutes utilised by humanitarian expeditions to rapidly distribute vital supplies, or inflatable life jackets for sea rescue. These artworks also become objects of textual communication, silkscreen-printed with slogans and words onto their surfaces, often incorporating flags from different nations and functional and symbolic objects. The *Survival Kit* refers both to physical/material survival and symbolically to the spiritual needs of man, such as the recovery of a lost social dimension of solidarity.

In the seminar 'Vêtement et Sociétés' (Clothing and Society) in the former Museum of Mankind in Paris, ethnologist Yves Delaporte compared clothing to language, which we can analyse in two ways: either it is a pure metaphor, serving as an expression, or it is an affirmation that aspires to a deeper

2 Virilio, P., *Lucy Orta*, Contemporary Artist series, Phaidon Press London, 2003

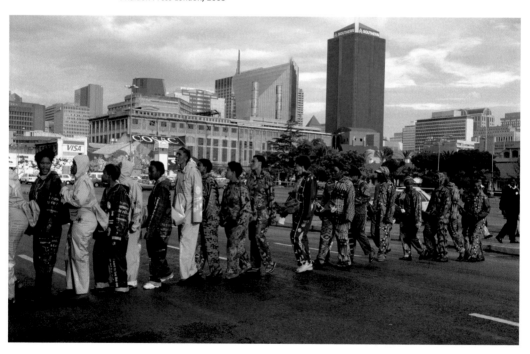

Lucy Orta, *Nexus*
Architecture Intervention
Johannesburg Biennale,
1997. Lambda colour
photograph, 120 x 150 cm

scientific analysis. In the latter case we are encouraged to question and reflect on the scientific proof of this hypothesis.[3] To cut a very long discussion short, the originality of language is that it is communicative, structured and full of signs and meaning, so comparatively clothing (or rather fashion) also contains a combination of all of these. Professor Delaporte also goes on to explain that perhaps this is due to the lack of ethnographic study using the tools and methods of semiotics. It is true to say that the academic study of fashion is relatively young and we have a lot of ground to cover if we are to convince the consumer society that fashion is more than a bulging wardrobe. In my other role as Professor of Art Fashion and the Environment at London College of Fashion, I hope the non-exhaustive selection of artists and their work that we are presenting in 'Aware: Art Fashion Identity' will provoke us, even just a little, to look and think about clothing differently.

3 Delaporte, Y., *L'Ethnographie* n° 92-93-94, 'Vêtement et sociétés', L'Entretemps, 1984

Lucy + Jorge Orta, *Life Line – Survival Kit*, 2008–09. Steel frame, laminated Lambda photograph, piping, two taps, various fabrics, silkscreen print, webbing, two floats, buoys, two flasks, whistle, rope, 100 x 100 x 3 cm

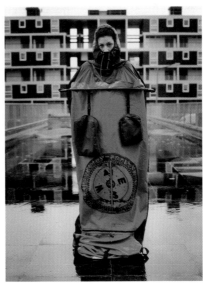

Lucy Orta, *Refuge Wear Intervention London East End*, 1998. Original Lambda colour photograph, 150 x 120 cm

Artists

Marina
Abramović

Marina Abramović is one of the most important figures in contemporary art. Her career began in the early 1970s with action and performance pieces aimed at stimulating consideration of the male and female roles, and on problems connected with the body; the potential and limitations of the body were explored, as well as our subjection to social control.

The main characteristic of her performances is that they are designed for a specific situation, and are never rehearsed or repeated. One of her most important performances, *Imponderabilia*, took place in 1977 at the Galleria Comunale d'Arte Moderna in Bologna, at the first International Festival of Performance. Abramović and her companion Ulay stood opposite each other, completely naked, on either side of the narrow entrance, and in order to

reach the gallery, visitors were obliged to push their way between the two naked figures. Today *Imponderabilia* is considered to have been a key moment in Body Art: cultural conditioning and taboo were elicited by the lack of clothing.

In other cases, clothing has played an important part in the artist's work. We need only to think of her *Energy Clothes* which serve 'to amplify external vibrations. Anyone using energy clothes becomes a human aerial.' For example, tall conical hats that can act as energy conductors.

In another of Abramović's celebrated performances she stood on a metal stage in a former neuro-psychiatric hospital in Volterra and danced. She wore a brilliant red dress and shoes which, armed with powerful magnets, held her feet to the floor, making her movements extremely arduous – an extraordinary image of vitality. In her more recent cycle *The Family III, Laos*, she depicts an army of beautiful children playing war games, toting guns and dressed in camouflage gear. The reality behind this fictional work is that war is not a game for over 300,000 children worldwide, who are direct participants in armed conflict.

MARINA ABRAMOVIĆ

Imponderabilia
Performance, 1977
Galleria Comunale
d'Arte, Bologna
© Marina Abramović.
Courtesy of Marina
Abramović and Sean
Kelly Gallery, New York.
DACS 2010

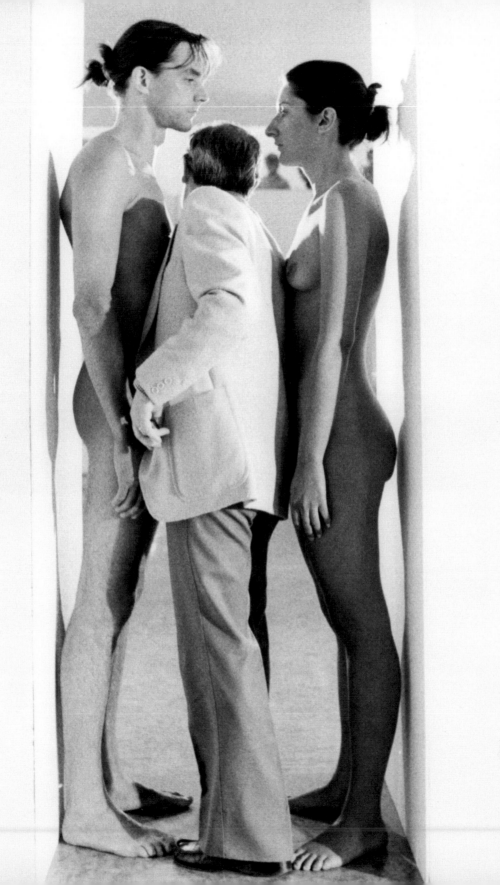

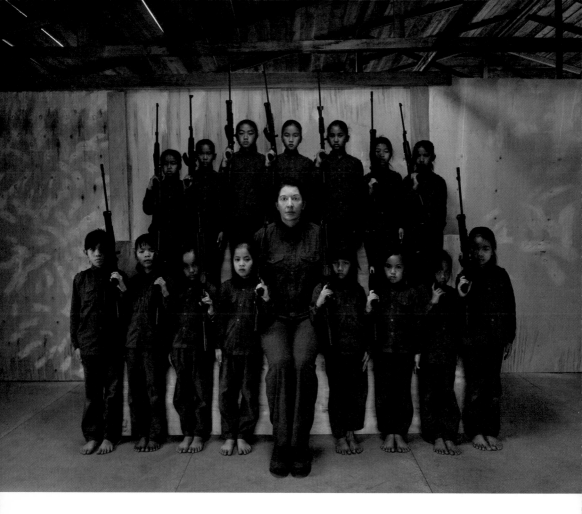

The Family I, Laos, 2008
Photograph
© Marina Abramović.
Courtesy of Marina
Abramović and Sean
Kelly Gallery, New York.
DACS 2010

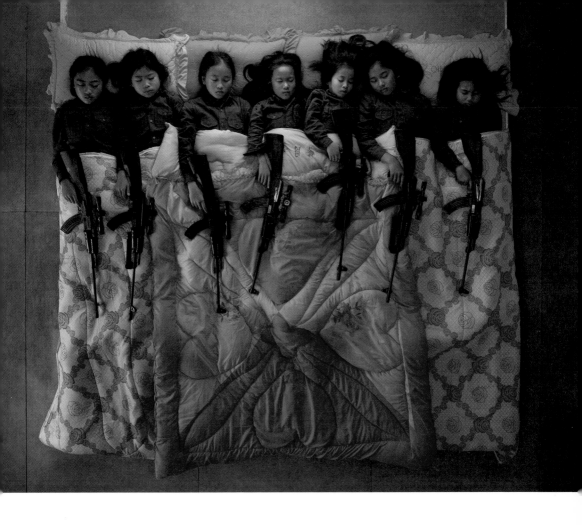

The Family III, Laos, 2008
Photograph
© Marina Abramović.
Courtesy of Marina
Abramović and Sean Kelly
Gallery, New York.
DACS 2010

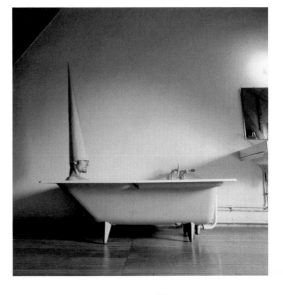

Energy Clothes, 2001
Video and photograph,
Spain, 2001
© Marina Abramović.
Courtesy of Marina
Abramović and Sean Kelly
Gallery, New York.
DACS 2010

Acconci
Studio

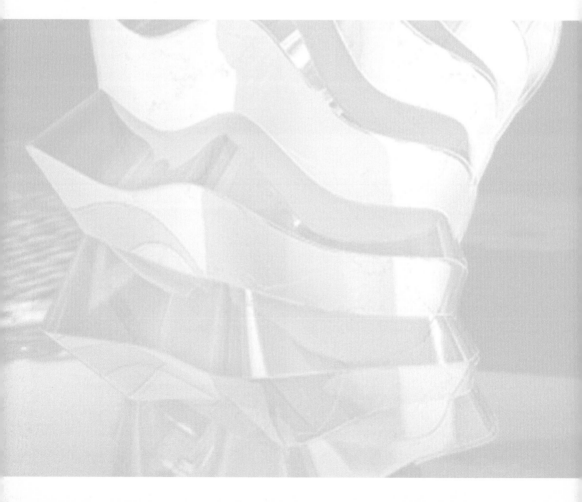

Vito Acconci is one of the major artists of the twentieth century. His work has always centred on his interest in attitudes to change and the constant evolution of reality. He has dealt with construction and architecture in a variety of ways in a spirit of criticism, using the imaginative resources of art; he has a marked interest in the public realm. From the 1970s on, Acconci produced an explosive series of pieces and actions which emphasised the way the human body is torn between private and public needs; he views all of human behaviour as sharing an unconscious deference to rules and boundaries, the most important of which are the boundaries separating private space from shared space.

At the end of the 1980s Acconci created the Acconci Studio, in which projects for urban spaces are created.

Taking his inspiration from the notion that, 'in our overcrowded world we need space and time to ourselves', Acconci produced the 'umbruffla'. This is a wearable umbrella, a small dwelling that we can carry about with us and in which we can hide when we need a moment of privacy. He describes it as follows: 'This is a new umbrella you could wrap yourself up in. Fix one end to your waist, the other to one wrist, so that both hands are free. Wearing it, you could dodge a passer-by, turn it towards the wind, and even welcome a companion under it with you. The umbruffla is made from two-way mirrored Mylar. From outside the surface is mirrored, so while you can see through from inside, you would be camouflaged by the reflections of the city which shimmers on you as you walk.'

The name of the object comes from the English word 'ruffle'. When the object is closed the ruffles are gathered, and when opened, they unfold and spring out into an umbruffla.

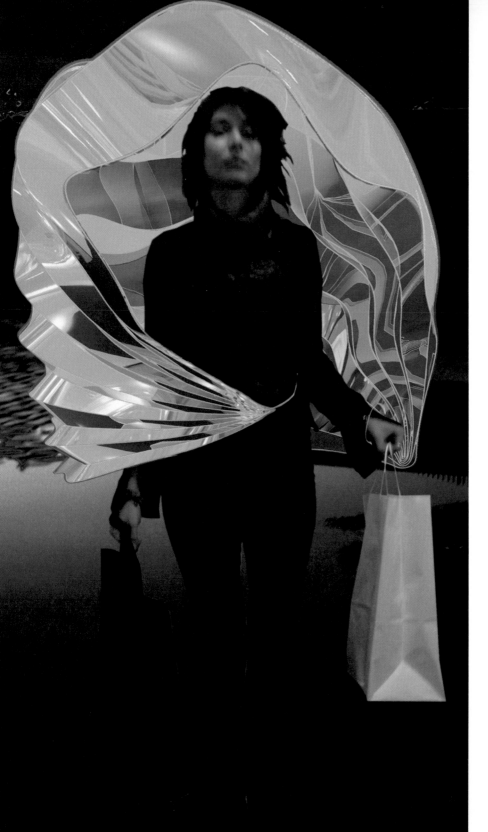

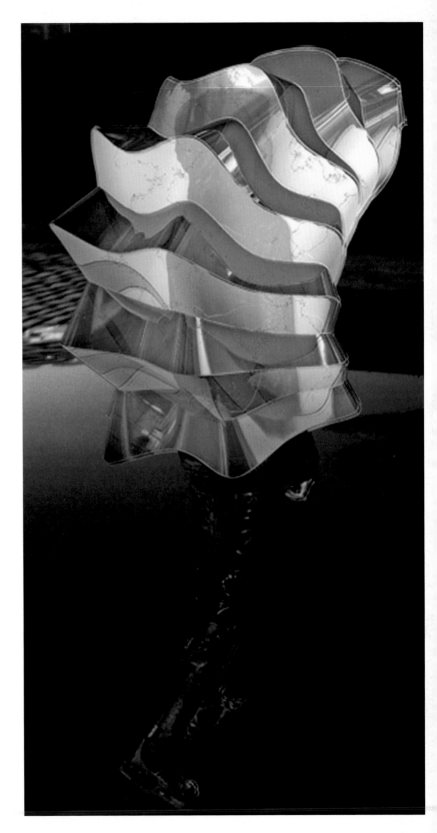

Umbruffla, 2005–10
Silk, chiffon, radiant film,
cotton thread, boning,
114.3 x 152.4 x 114.3 cm
Courtesy Acconci Studio
(Vito Acconci, Francis
Bitonti, Loke Chan,
Pablo Kohan, Eduardo
Marquez, Dario Nunez,
Garrett Ricciardi).
Consultants: Billings
Jackson Design;
Katie Gallagher

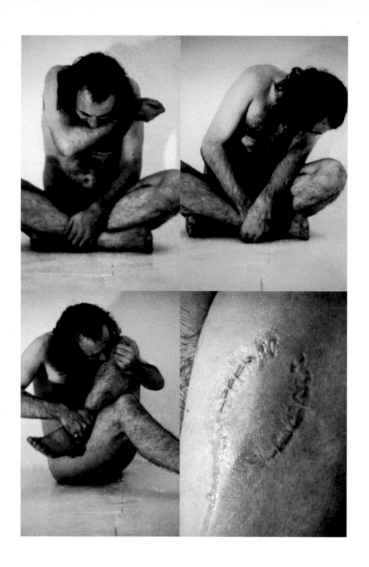

Trademarks, **1970**
Vito Acconci
Photograph, ink print

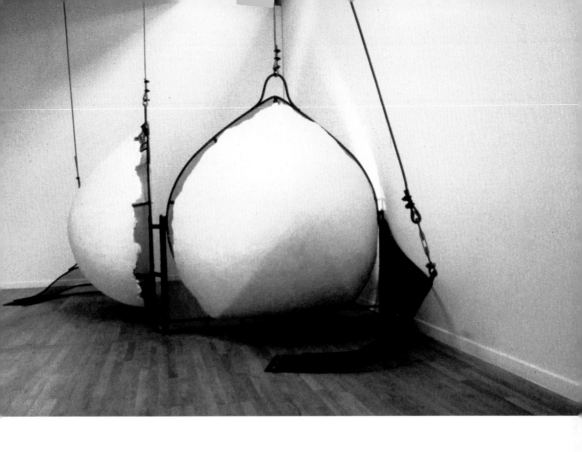

***Adjustable Wall Bra*, 1990**
Acconci Studio (Vito
Acconci, Luis Vera, Brownie
Johnson, Jenny Schrider)
Plaster, metal lathe,
steel, cable, canvas, light,
audio. Set of six, variable
dimensions

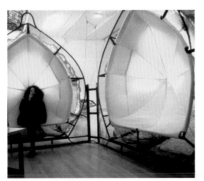

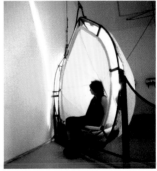

Azra
Akšamija

Society, identity and culture are not static and immutable, nor permanent: they are alive and constantly changing. Art, like architecture and fashion design, connected as they are by imagination and the desire to build, can represent the motivation for this change as well as the outcome. The artistic practices of Azra Akšamija are based on this premise, and her *Nomadic Mosque* in particular.

The *Nomadic Mosque* is wearable architecture, an item of clothing that can, if necessary, transform itself into a miniature, individual mosque whose design is based on the worshipper's personal needs. It aims to redefine the traditional form and functions of the mosque in a contemporary context: monumentality is rejected in favour of qualities such as flexibility, versatility, mobility and modular space. It allows for individual religious practice in a world which values personal rather than collective engagement, and which increasingly demands agility. Akšamija has also created *Frontier Vest*, a wearable prototype for the expression of different belief systems. This is a hybrid combination of a contemporary jacket and ritual objects. It can be transformed either into a *Talit*, a Jewish prayer shawl, or into an Islamic prayer rug. It lends itself to different uses, both sacred and secular. The need to recognise that others can be different from ourselves, and also identifying what we have in common, is summarised in this work.

Nomadic Mosque, 2005
Textile and photographs,
160 x 50 x 30 cm
© Azra Akšamija and
Jörg Mohr 2005

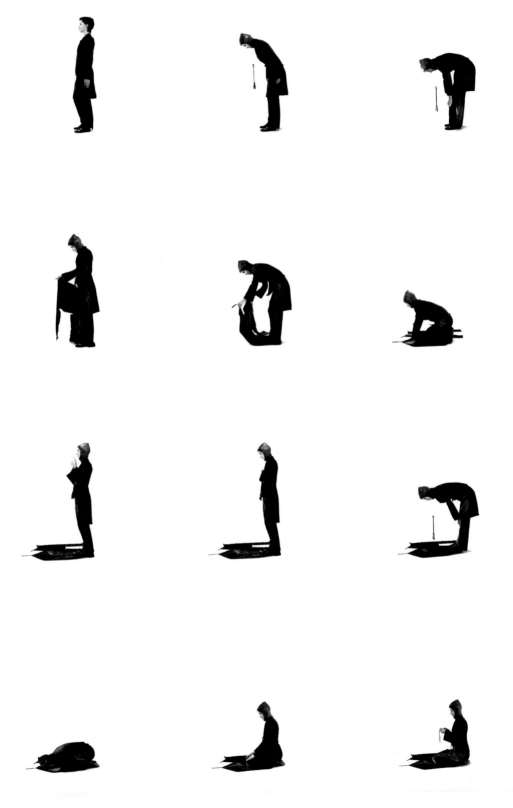

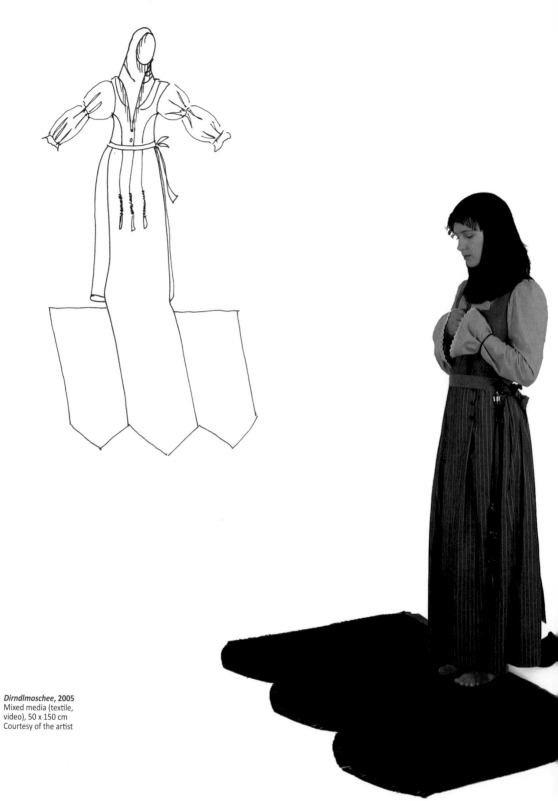

Dirndlmoschee, 2005
Mixed media (textile,
video), 50 x 150 cm
Courtesy of the artist

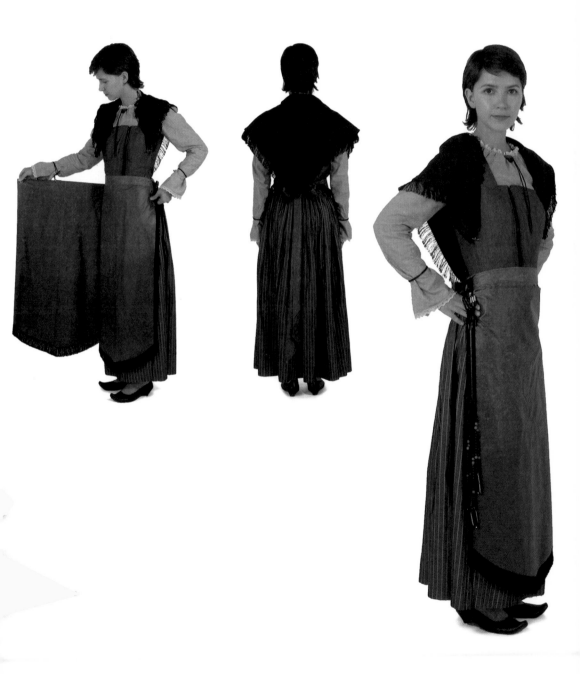

Maja
Bajevic

Maja Bajevic was born in Sarajevo in 1967. While she was studying in Paris, the city of her birth succumbed to the brutal trauma of war, forcing her into involuntary exile. From that moment her work began to focus on the subject of identity, and on the thin line that separates (and unites) public and private identity. Her aim is to reveal the mechanics of inclusion and exclusion, of control and coercion, of the authoritarian attitudes underlying routine conflict and tension – sometimes explicit, sometimes only hinted at and hidden.

Her work has an ethical and political content, a direct emotional and physical involvement; her point of view is declaredly subjective and is connected with her own life story.

Dressed Up is one of her early works. The artist cuts a piece of fabric on which the map of former Yugoslavia is printed, then sews the pieces into a dress and wears it. Thus she wears the tragic story of her country literally stitched to her back. Her body becomes a measuring tape, a diagram and a map. Her objective is to establish, with the map of her lost country, a relationship that is physical as well as emotional. It is a reflection on uprooting, trauma and loss, and man's inalienable attachment to the country of his birth.

In many of her later works Bajevic uses classically feminine pursuits, for example the creation and care of clothing and household linen. She often uses sewing and embroidery, again for their symbolism. Sewing can mean restoring wholeness, putting together things that men have reduced to shreds, mending the rags of history. It also implies a physical relationship with the work, based on close attention.

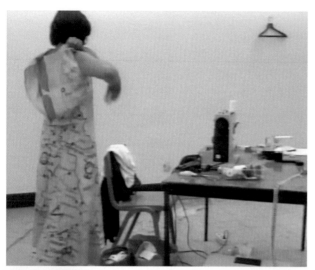

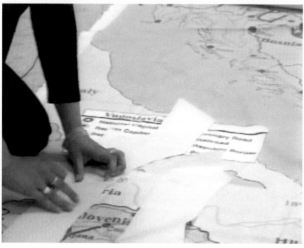

***Dressed Up*, 1999**
Single channel video,
projection, colour, sound,
running time 60' 52"
Courtesy of the artist and
Galerie Peter Kilchmann,
Zurich

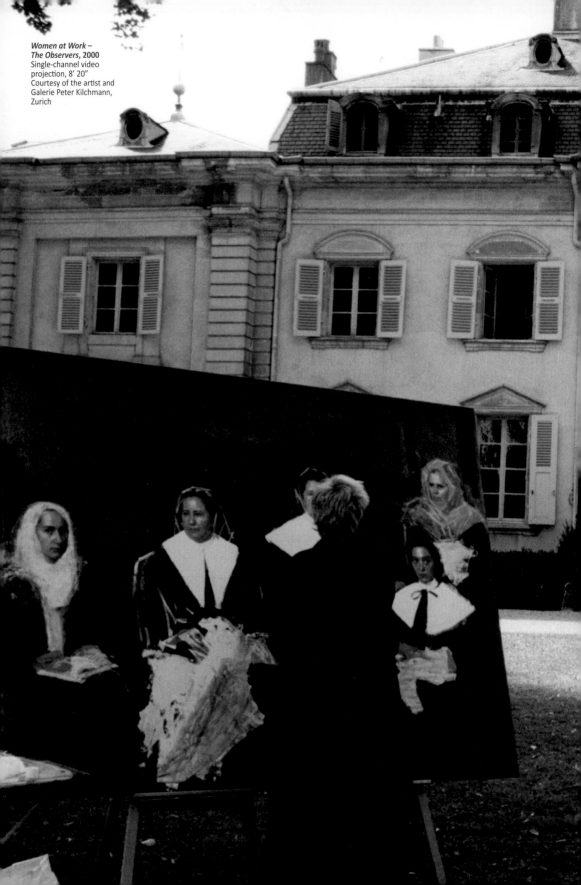

*Women at Work –
The Observers*, 2000
Single-channel video
projection, 8' 20"
Courtesy of the artist and
Galerie Peter Kilchmann,
Zurich

Women at Work – Under Construction, 1999
Single-channel projection, running time 11' 48"
Courtesy of the artist and Galerie Peter Kilchmann, Zurich

Women at Work – Washing Up, 2001
Single-channel video projection, running time 15' 14"
Courtesy of the artist and Galerie Peter Kilchmann, Zurich

Handan
Börüteçene

Waters That Tie / Waters That Untie is a work consisting of a gown, together with a series of photographs that are a documentation of a symbolic and 'diplomatic' journey made by the garment to various cities along the shores of the Mediterranean. The long, green silk dress, inspired by the fashions of the Byzantine court, is encrusted with original fragments of Byzantine pottery.

Memory is at the centre of Handan Börüteçene's work, and his own memories are of places with long, eventful histories, in which culture has been created by the mingling of ideas, tastes, identities, dreams and knowledge. The Mediterranean basin still swarms with ideas, people and merchandise, but it has also been a theatre for the troubled historical relationship between town and country. This magnificent dress,

woven with history, emphasises the importance of progressing towards the new, but wearing what was best about the past, conserving it and saving it from ruin. It speaks of the need to re-knot the threads of memory, thus overcoming the terrors of the past and the contradictions of the present; of the need to create communities in which past and present find a new equilibrium and a modern view of the future.

To convey the idea of the individual on the move, the dress is surrounded by photographs of its appearance in Istanbul, Venice and other cities. These images have the power to crystallise a presence in a specific time and place. The work symbolises diplomacy and tourism in the Mediterranean, while at the same time pointing at frenetic contemporary mobility and the ubiquity of the photo-souvenir.

Waters That Tie /
Waters That Untie
Installation view at
La Fenice Theatre, Venice,
2007. Silk dress covered
with ancient ceramic
pieces, and twelve prints
mounted on aluminium,
each *c.* 40 x 60 cm.
UniCredit Art Collection
© Handan Börüteçene

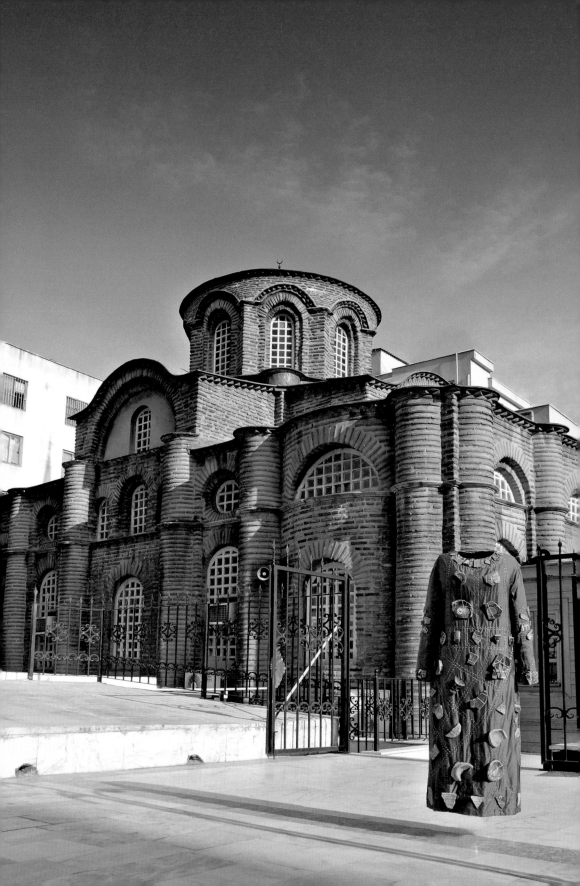

Waters That Tie /
Waters That Untie, 2007
Silk dress covered with
ancient ceramic pieces,
twelve prints mounted
on aluminium, each
c. 40 x 60 cm. Shown in
front of the Myrelaion
Church, Laleli, Istanbul.
© Handan Börüteçene

Waters That Tie /
Waters That Untie, 2007
Silk dress covered with
ancient ceramic pieces,
twelve prints mounted
on aluminium, each
c. 40 x 60 cm. Shown by
two pillar capitals from
Polyeuktos Monastery in
the garden of Istanbul
Archaeological Museum.
© Handan Börüteçene

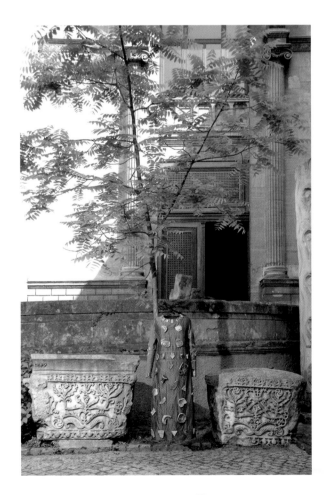

Hussein Chalayan

Hussein Chalayan regards fashion as a representation of the way we live in transition. As a London-based Turkish Cypriot, he is keenly aware of the ubiquitous nature of contemporary identity, and the extent to which notions of place, time and event are linked to our dislocated lives, and Chalayan finds creative potential in these ideas.

His work has a narrative thread and is designed for performance. Rootlessness and loss combine with society's need for radical change. His pieces are genuine metaphors for contemporary life; this includes his *Airmail Dresses*, the clothes made of LEDs and those in which the accoutrements of travel are merged into the whole: the seat or the wing of an aircraft.

His '*Son*' *of Sonzai Suru* project is characteristic of his interest in clashes of culture. It is inspired by combining haiku and bunraku, an ancient form of Japanese theatre in which the characters are represented by very large puppets. There are no special effects, and the 'puppet' is manipulated by three puppeteers who, contrary to normal practice, stand on the stage in full view of the public.

Chalayan says: 'Bunraku performers are visible within the narrative. At the same time they resemble ninja or even Islamic subjects that animate the clothes. Both dress codes define a territory where the individual can become invisible and anonymous. Bunraku scenarios possess many contradictory nuances.'

Chalayan's installation in the exhibition, therefore, makes one ponder the relationship between clothing and masks, freedom and manipulation, reality and simulacrum, the body as a poetic entity and functional prosthesis, as well as individual and collective identity.

'Son' of Sonzai Suru, 2010
Sketch, A4 paper
Courtesy the artist.
Commission by the Royal
Academy of Arts and
London College of Fashion

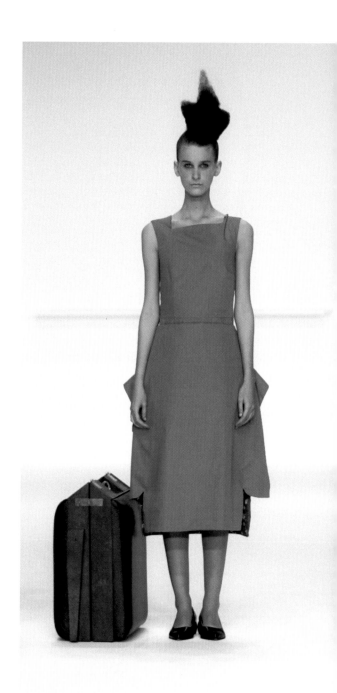

After Words, Autumn
Winter 2000
Courtesy of the artist

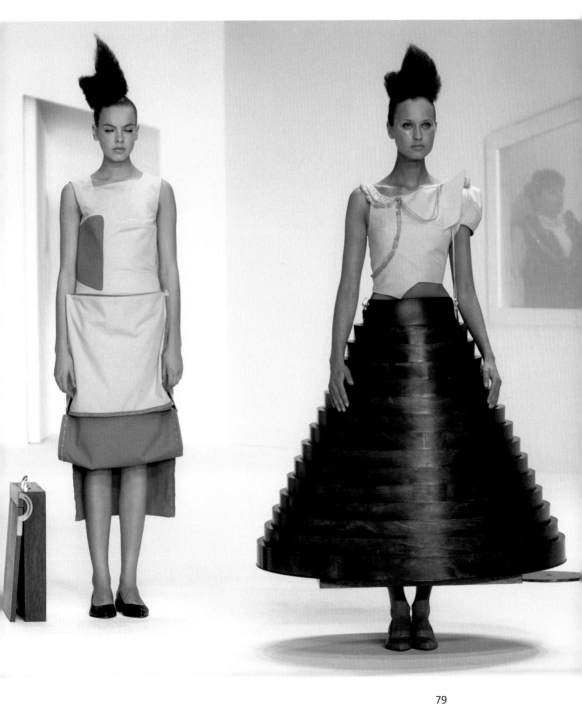

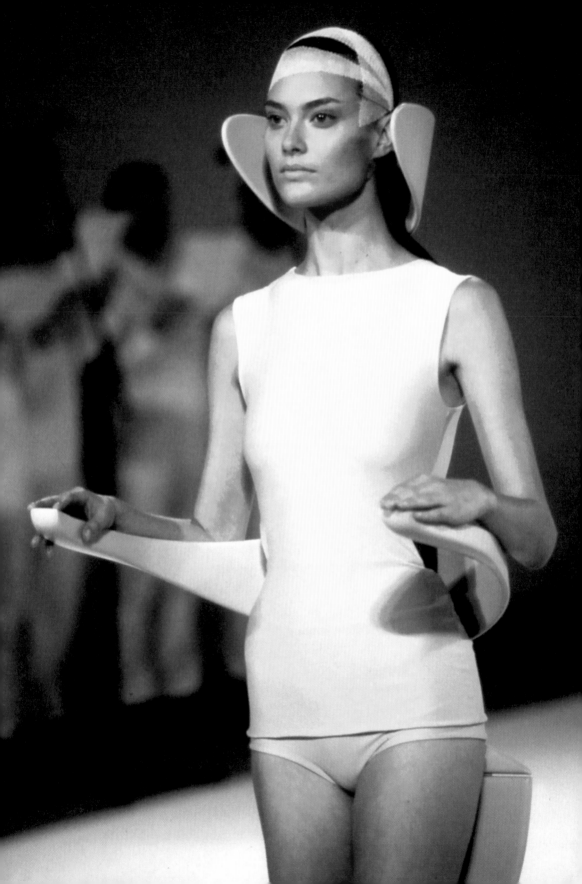

Geotropics, **Spring**
Summer 1999
Photograph

Aeroplanedress, **1998**
Photograph
Courtesy of Marcus
Tomlinson

Alicia
Framis

Based in Amsterdam and Barcelona, Alicia Framis combines different cultures in projects exploring the social components of the contemporary city. Her work is about living between different cultural heritages and the shift from one to the other, but also about the deep feelings of fear linked to tensions between intercultural dynamics, and the difficult relationships between communities.

For *100 Ways to Wear a Flag,* Framis asked several fashion designers to make dresses using the Chinese flag. This work can be seen as a perceptive, critical look at globalisation: how many women today wear clothes labelled 'Made in China'? *100 Ways to Wear a Flag* also refers to her earlier *Anti-Dog* series, a collection of designs made from Tyvec, a fabric that is fire-proof, bullet-proof

and dog-proof. The *Anti-Dog* collection protects women from aggressive behaviour and gives them the courage and strength to walk around, fearless and powerful. It questions the sudden proximity of an often contradictory modernity, and of tradition in its most limiting sense. It also shows the way our society is based on graft, influence and connections; and that even at an individual level we cannot escape having complex, composite, multi-faceted personalities.

ALICIA FRAMIS

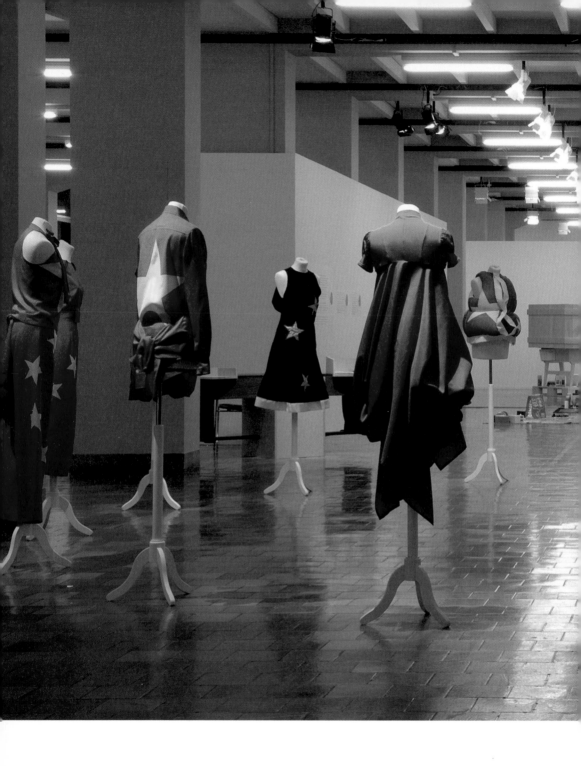

100 Ways to Wear a Flag,
2007
Textile, variable dimensions.
Courtesy Annet Gelink
Gallery, Amsterdam

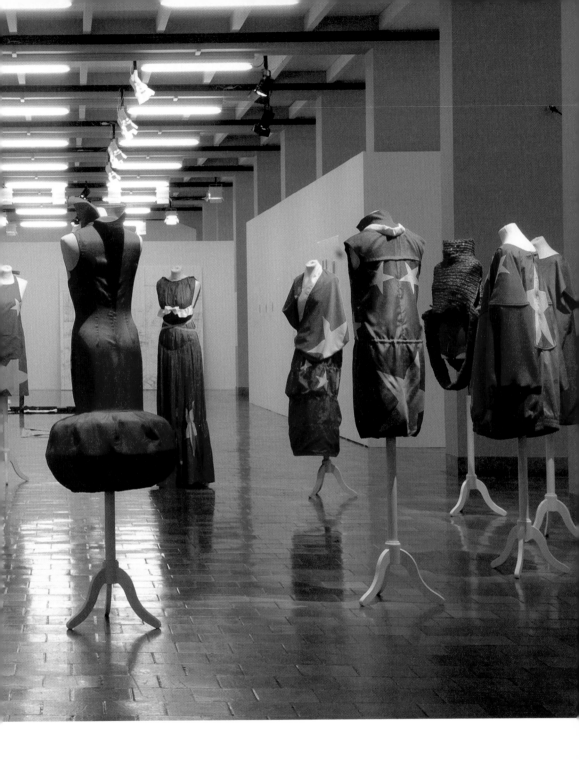

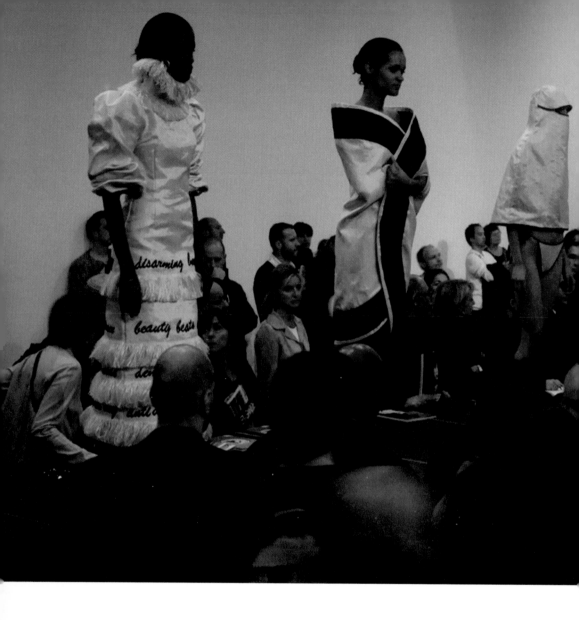

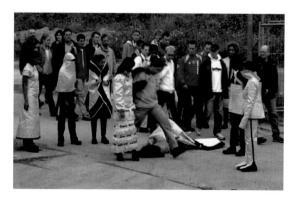

Arena Amsterdam, 2002
Videostill.
Courtesy Annet Gelink
Gallery, Amsterdam

Top:
*Anti-Dog Collection in
Palais de Tokyo, Paris,
2002*
Colour photograph.
Courtesy Annet Gelink
Gallery, Amsterdam

*Anti-Dog Copyrighting
Unwanted Sentences,
Birmingham, 3 May 2003*
Performance and video.
Courtesy Annet Gelink
Gallery, Amsterdam

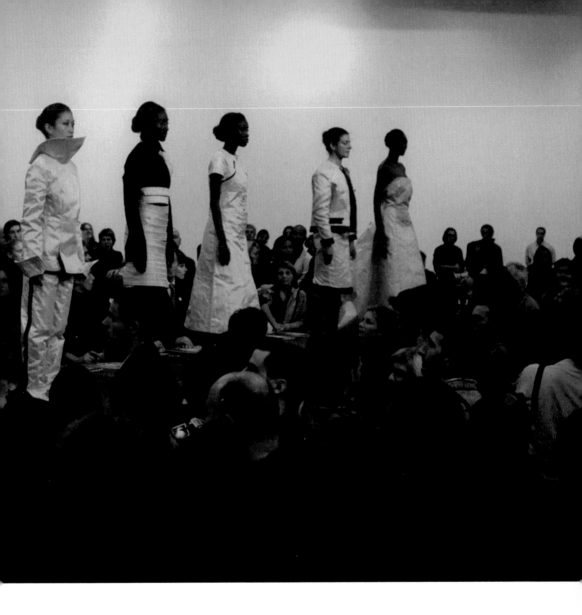

Meschac
Gaba

This installation consists of twenty of the 'architectural wigs' commissioned by Meschac Gaba in Benin, that use the African technique of hair braiding. The 'architectural wigs' are elegant, wearable sculptures made of natural and synthetic fibres; they are shaped to emulate the architecture of various cities in the world, for example the Eiffel Tower and the Empire State Building. The installation thus takes on the appearance of a kind of urban landscape. The 'wig architecture' is the outcome of the translation of diverse forms and practices, combining African culture with the representation of buildings that are symbolic of their national identity and of Western economic, political and cultural power. The wigs have a solemn beauty, yet they are as witty and playful as any hairstyle. These are hybrid, ephemeral objects which cock a snook at the monumentality that is at the heart of Western cultural tradition. They divest architecture of its pretensions to stability, and return man with his fragility, his needs and all his general lack of coherence to centre stage.

This work highlights the problems of equilibrium in a multicultural society, and offers a strong critique of the post-colonialism that still exists today, in Africa in particular, demonstrating how Western political and economic strategy still weighs heavily on the former colonies.

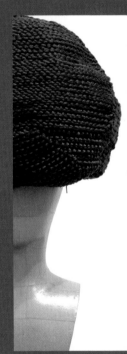

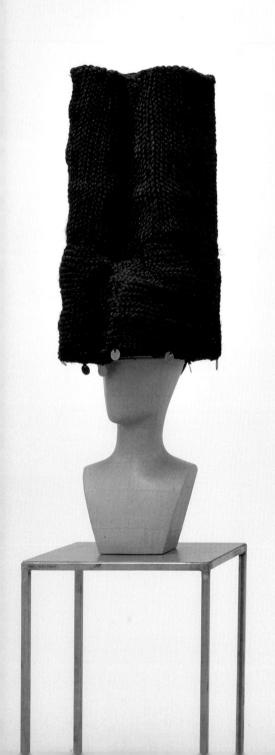

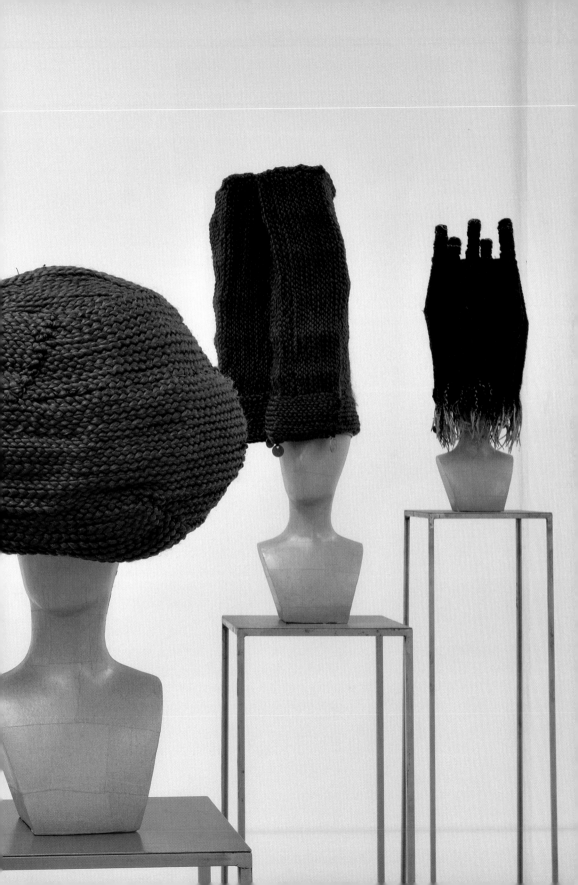

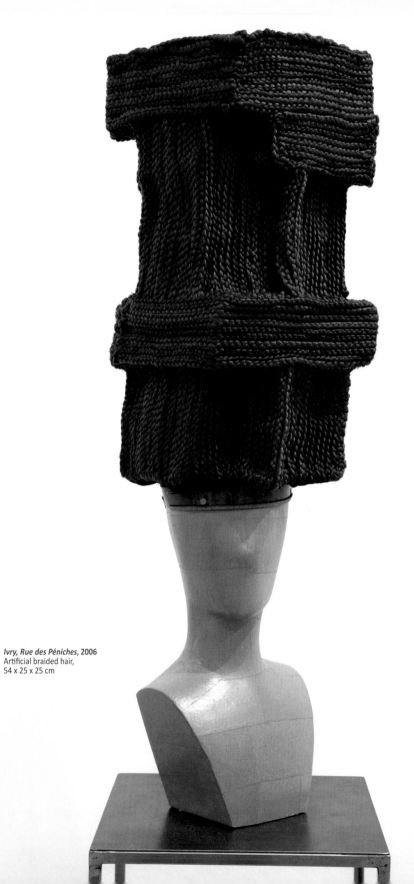

Ivry, Rue des Péniches, 2006
Artificial braided hair,
54 x 25 x 25 cm

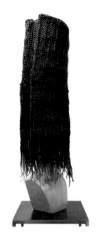

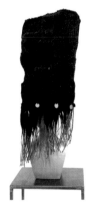

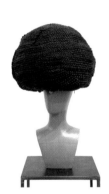

Ivry, Rue Bertheau, 2006
Artificial braided hair,
56 x 30 x 28 cm

Paris, Coeur Défense, 2006
Artificial braided hair,
42 x 41 x 26 cm

Paris, Tour Montparnasse,
2006
Artificial braided hair,
60 x 28 x 15 cm

Ivry, Tour Lénine, 2006
Artificial braided hair,
70 x 28 x 28 cm

*Paris, Géode – Cité des
Sciences es de l'Industrie*,
2006
Artificial braided hair,
30 x 30 x 30 cm

Marie-Ange Guilleminot

All Marie-Ange Guilleminot's work revolves around clothing as a sign of the various possible types of relationship between the individual and society. Many of her works have as their subject the flexible nature and the metamorphic properties of clothing. The multifunctional potential of dress is a valuable resource in an increasingly mobile world; today our clothes need to be adapted to life in constricted spaces, and have to be portable enough to carry around with us wherever we go. Thus a pair of tights can become a knapsack and a hat unrolls into a dress. *Kimono Memories of Hiroshima,* on the other hand, emerges from the memory that a dress can retain, and from the resonances and emotional impact that it can capture. Subjective and historical memory has produced a lengthy piece with the flavour of a ritual.

Guilleminot was invited to Hiroshima by the art curator, Yukiko Ito, and while staying there was moved by photographs of victims' clothing she found in a book by photographer Hiromi Tsuchida. Further research led her to study the pieces themselves, make patterns and recreate each of the garments in white fabric. The fabric of the period has been replicated, and each garment has been painstakingly reproduced with all its flaws and the hand-stitching of the seamstress who made them for a child or a worker. This labour takes us on a cathartic journey as we imagine the people behind the clothes and their lives before the tragedy. Later, Guilleminot transposed the pattern shapes of the garments on to traditional kimonos, working in collaboration with the most famous tailors in Kyoto. The Hiroshima garments cast a delicate shadow against the backdrop of history.

Tradition, living (as opposed to nostalgic) memory, healing and the intensely personal are all imbued in the work of Guilleminot.

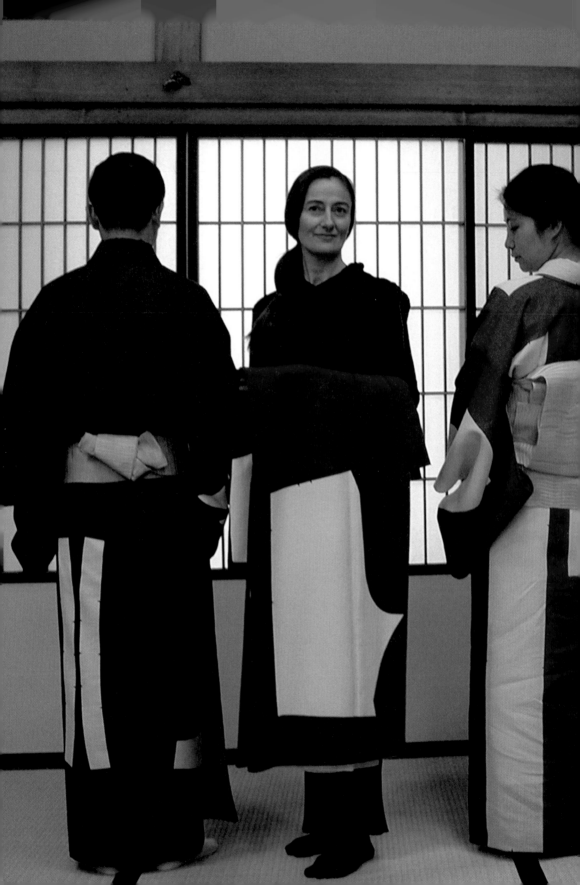

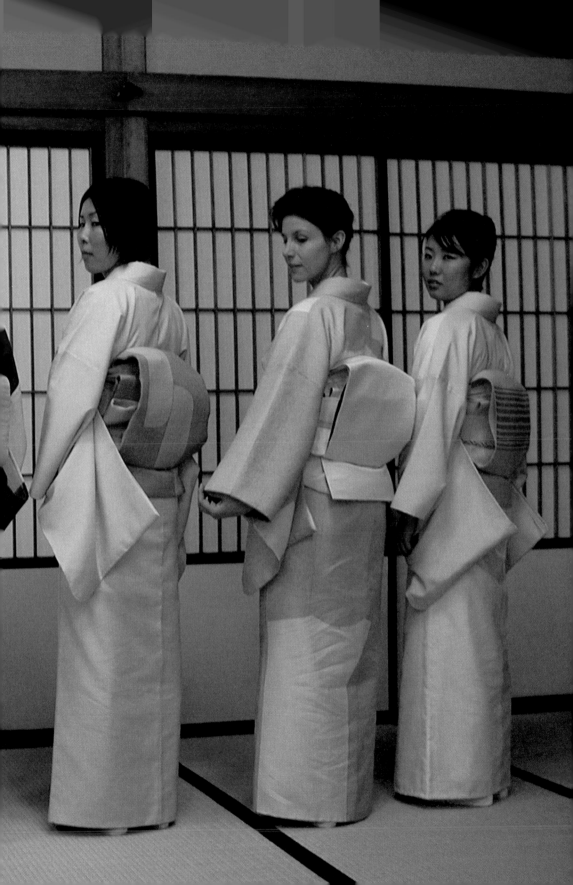

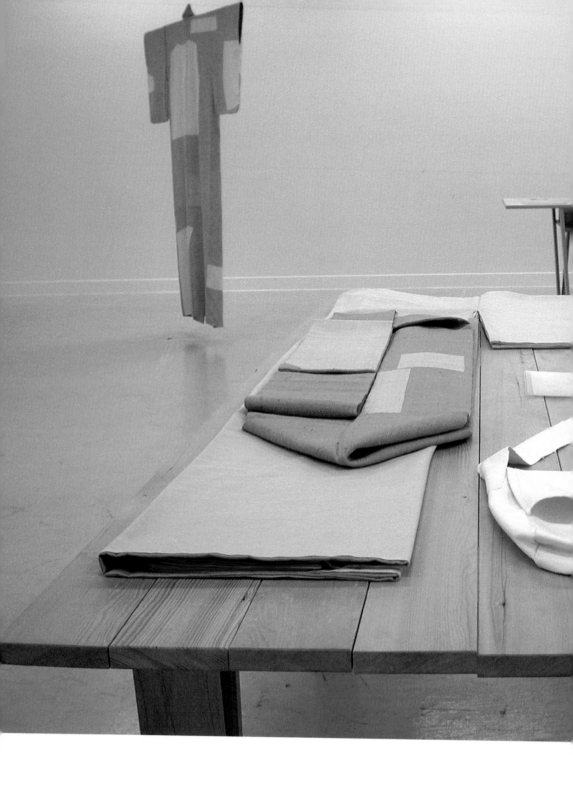

Kimono Memories of Hiroshima, 2005
Mixed media, variable dimensions.
Courtesy of the artist

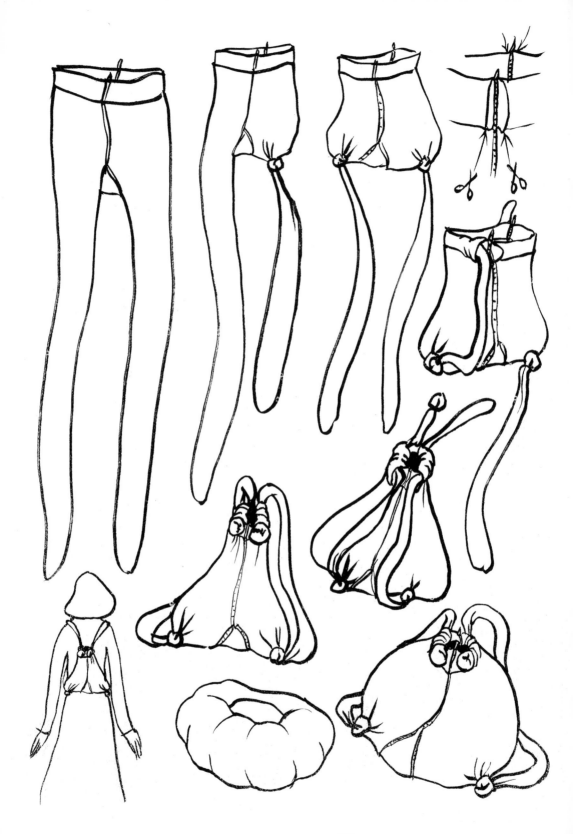

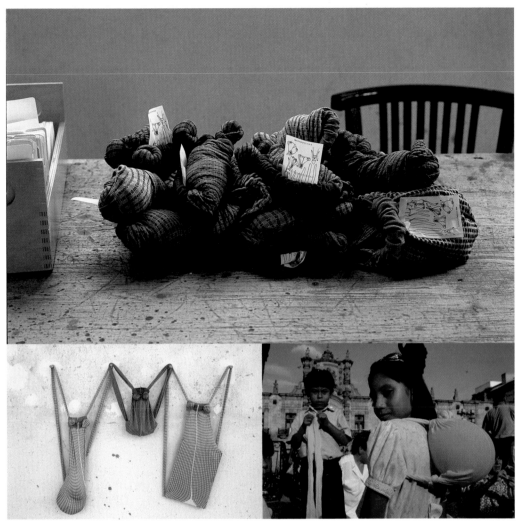

Top and above:
Cauris, sac-à-dos, collant,
Le Creux de l'Enfer, Thiers,
France, **1997**
Nylon stockings, small,
medium and large

Cauris, sac-à-dos, collant,
Guadalajara, Mexico, **1997**
Nylon stockings, small,
medium and large

Cauris, **1997**
Ink on Japanese paper
24 x 33 cm

Andreas Gursky

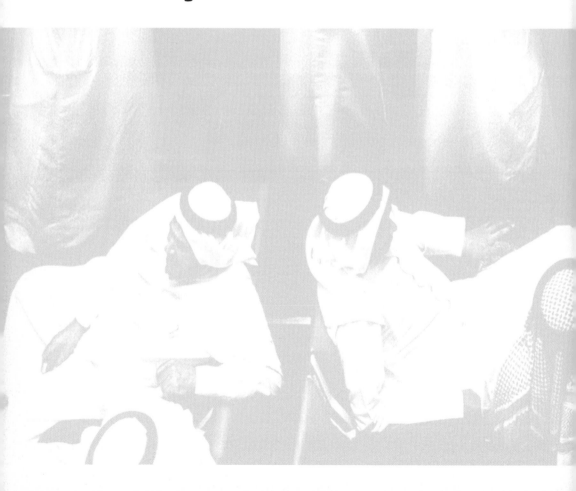

Andreas Gursky was born in Leipzig, in former East Germany. He moved to Düsseldorf, where he still lives and works, and studied with Bernd and Hilla Becher, the artists who have contributed so much to the new objectivity in photography. He began using colour photography in large format, and in 1992 began to enhance his shots digitally. His images are always carefully composed. He photographs urban and human landscapes and group scenes in which the very small and the very large can both be seen with identical clarity. He adopts various viewpoints, alternating vertiginous shots from on high with those from head height. His subjects are portrayed with apparently deliberate lack of emotion, yet he never represents simply the 'mass'. He emphasises the importance that certain powerful groups have assumed in contemporary society.

In spite of his acute eye for detail, he has no anecdotal intention. The levelling of planes in his photographs induces a sense of exclusion in the spectator, and the sharp focus of the details creates a feeling of alienation. This is how Gursky establishes his distance. All these components together allow him to present himself as some sort of cold, impassionate observer of globalisation – of its flow of data and people, architecture and mass spectacle.

Kuwait Stock Exchange I (2007) is a monumental, digitally manipulated image of Kuwaitis dressed in the traditional white working at a Stock Exchange. This photograph is the expression of a macro-phenomenon linked to global financial and economic power. The uniformity of the clothing is an expression of rigidly codified social roles, and illustrates the way the new type of economic system has managed to harmonise with traditional social structures.

ANDREAS GURSKY

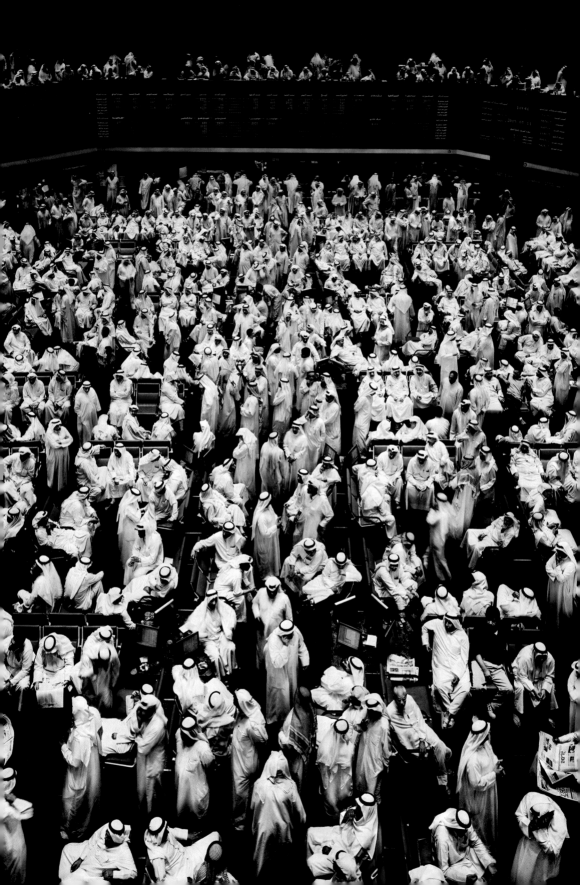

Kuwait Stock Exchange I, 2007
C-print, 295.1 x 222 x 6.2 cm
© Andreas Gursky/VG Bild-
Kunst/DACS 2010
Courtesy Sprüth Magers Berlin
London

Prada I, 1996
C-print, 127 x 220 x 6.2 cm
(framed)
© Andreas Gursky/VG Bild-
Kunst/DACS 2010
Courtesy Sprüth Magers Berlin
London

Untitled XIII, 2002
C-print, 276 x 206 x 6.2 cm
(framed)
© Andreas Gursky/VG Bild-
Kunst/DACS 2010
Courtesy Sprüth Magers
Berlin London

Mella
Jaarsma

Mella Jaarsma was born in the Netherlands, and continued her art eduction in Indonesia. Since 1984, she has lived and worked in Yogyakarta. The need to adapt to a way of life of which she had no previous knowledge led her to an understanding of the indissoluble link between culture and social mores, and to develop a particular regard for the 'cultural capital' of a place. This is the heritage transmitted by the lifestyle and expressive-symbolic aspects of a society: fashions, rituals, traditions, language, customs and food. Impelled by the need for cover and shelter, and also the need for display, she asks 'how do we live and what do we wear?'

Her work systematically deals with garments that cover the face and most of the body, leaving the eyes uncovered. Similar to the burqa, as restrictive as a shroud, as protective as a cocoon, these coat-tents cling to the shape of the body like a second skin, but also envelop and conceal it. Jaarsma creates them in a variety of materials, all of which could be found locally. She uses organic elements such as leather, horn or other parts of the animal, seaweed, pieces of fabric or, as in the case of *Refugee Only*, scraps of military uniforms. In many cases the

gowns are fitted on models who are requested to stand up and assume a neutral attitude. The eyes are always visible. Sometimes, as in the series of *Warriors*, the hems of the gowns are immersed in the saucepans and frying pans in which the women are cooking, contributing to the preparation of food to be offered to the visitors to the exhibition.

Jaarsma thus explains (and interrogates) the context, eliciting questions about gender and religious identity while implicitly confronting problems about relations between ourselves and others, about who influences whom and who is influenced by whom.

Other series, such as *Shelter Me*, consist of shirts completely covering the body for incidences of enforced nomadism, or cabins, small emergency dwellings made for a single person, also made with materials strongly linked to a particular context. This kind of refuge immediately brings us to the question of migration, and to the lives of single individuals in adverse conditions. Jaarsma confronts the whole context of clothing and habitat – the two primary symbols of individual and social identification.

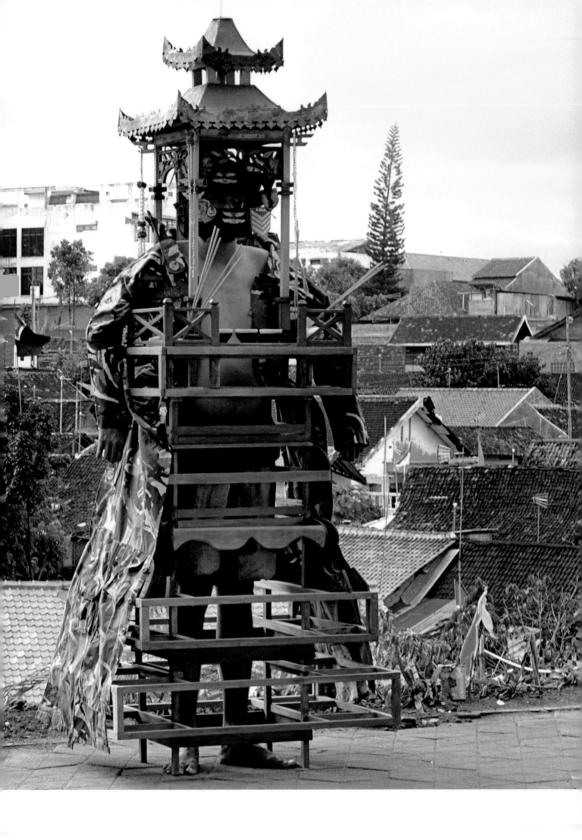

Previous page:
Shelter Me 1, 2005
Chinese – Indonesian shrine,
bowls, beats, military costumes,
essence, DVD, 220 x 80 x 50 cm
Courtesy of the artist

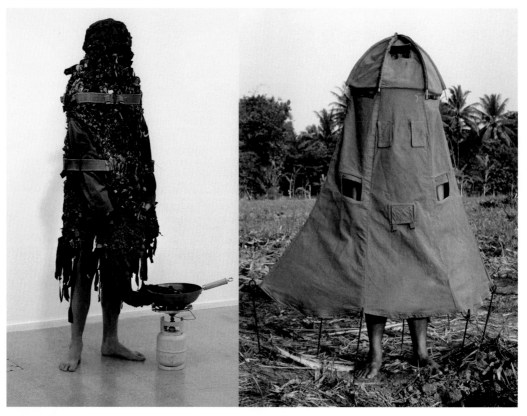

The Warrior, 2003
Military costumes, seaweed,
miso soup, stove, DVD
Courtesy of the artist

Refugee Only, 2003
Cloth, iron, personal items
(toothpaste, brush, soap, torch,
knife, sanitary napkins)
Photographs
Courtesy of the artist

The Follower, 2002
Embroidered emblems
Courtesy of the artist and
Karim Raslan, Valentine Willy

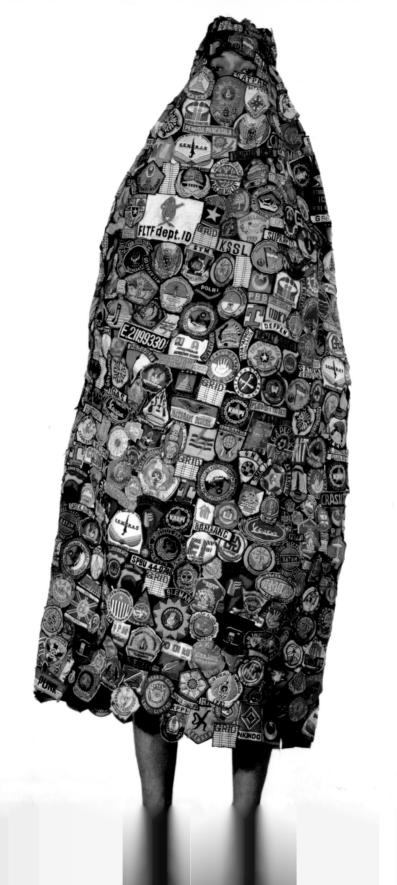

Kimsooja

Kimsooja views the dress as a symbolic material, identifiable with 'the body, the container of the spirit'. She pays particular attention to fabrics and the cultural connotations of clothes. Through her practice of sewing, she combines Eastern and Western traditions, transposing elements of Korean culture into metaphors for the universal human condition.

Ideas of transience and travel, considered in a literal and existential way, are always present in her work, which ranges from videos to objects made by cutting and sewing together scraps of old fabric and pieces of clothing that belonged to her ancestors. She is at the same time keenly aware of the present and of the complex dynamics of today's geopolitics. In her video installation *Mumbai: A Laundry Field* we find ourselves within an all-enveloping scene, exposed to a global phenomenon strongly connected with fashion: the goods we consume, and in particular clothes, are the fruit of production lines all over the globe. We witness 10,000 *dhobi-wallahs* in Bombay's Mahalaxmi Dhobi Ghat, or wash house, scrubbing several tons of clothes destined for export to our high streets. The open-air laundry is a ballet of low-cast activity, as the *dhobis* slap and twist the fabrics against the granite in thousands of multicoloured pools. The incessant movement and the packed trains passing by provide an extraordinary image of daily routine, but the work also has the grandeur of a tapestry of contemporary life.

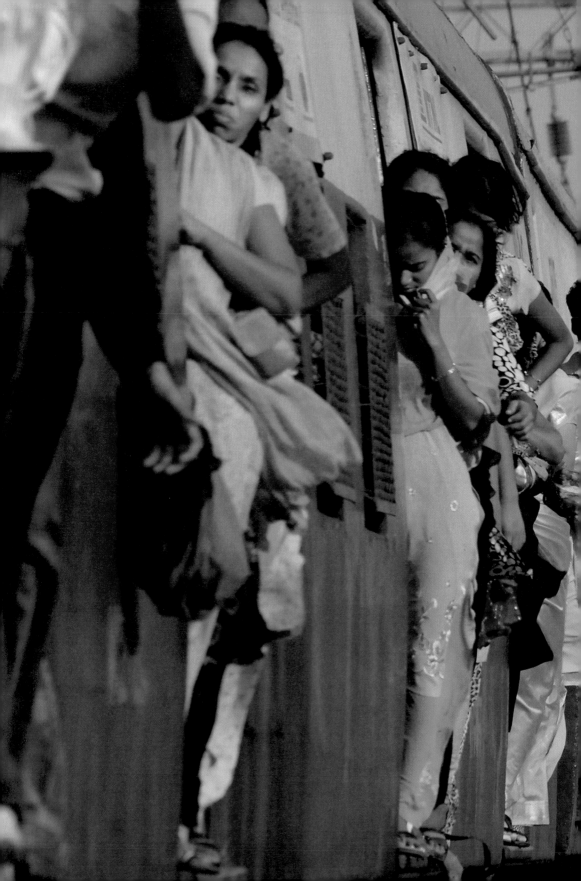

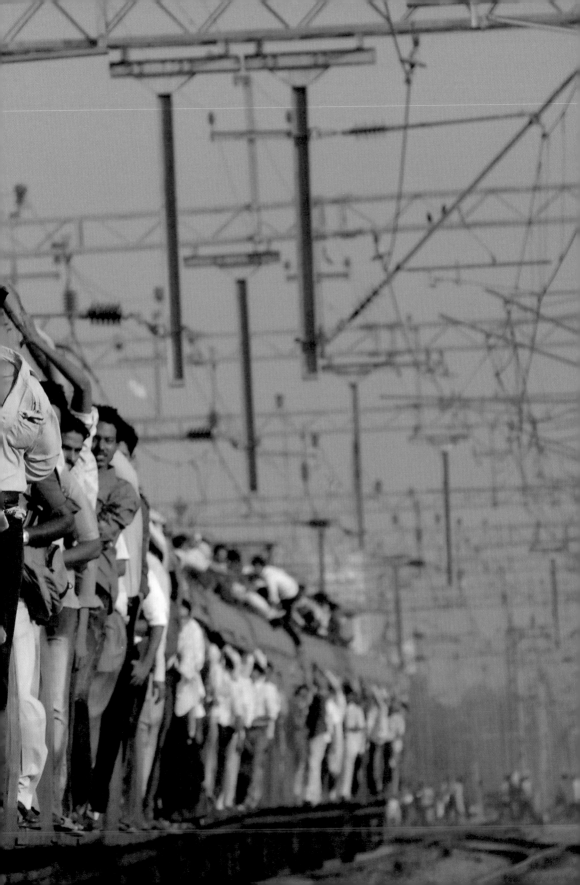

Mumbai: A Laundry Field,
2007–8
Four-channel video
projection, running time
10′ 25″ on a loop, sound.
Courtesy Galleria Continua,
San Gimignano/Beijing/
Le Moulin

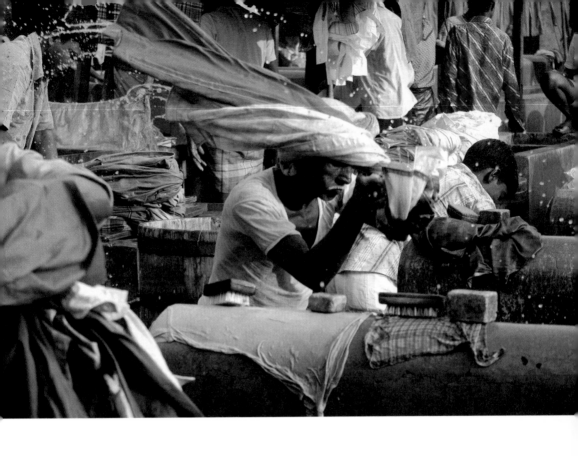

Overleaf:
*Encounter – Looking Into
Sewing*, **1998–2002**
Vivachrome print.
Courtesy Kimsooja Studio

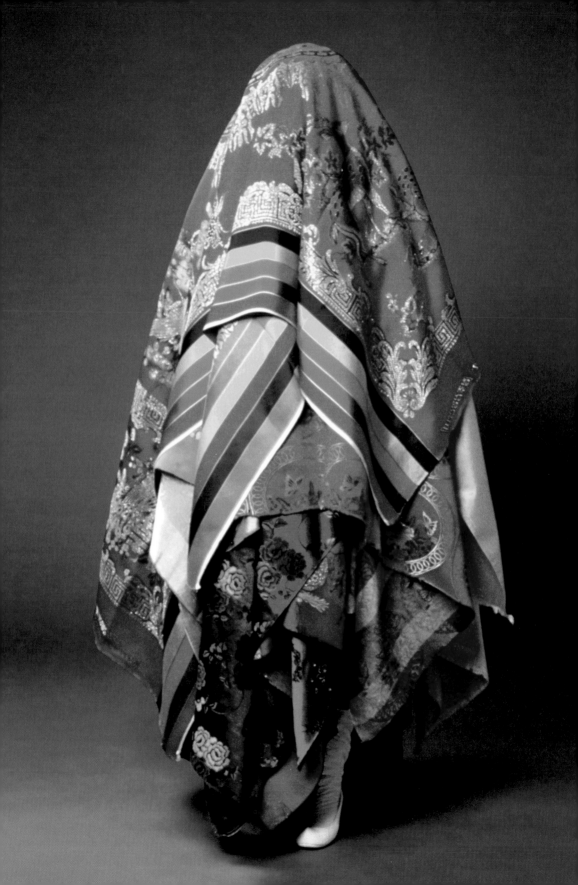

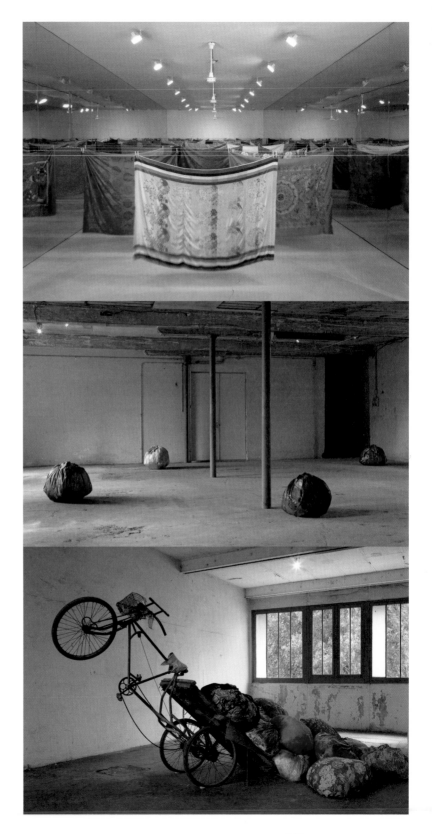

A Mirror Woman, 2002
Korean bedcovers,
parallel mirror structure
walls, four fans, cable,
Tibetan Monk chant.
Collection of MUDAM,
Luxembourg

Bottari
Installation image.
Courtesy Galleria Continua,
San Gimignano/Beijing/
Le Moulin

Bottari Tricycle
Used Chinese tricycle,
bedcovers and clothes.
Courtesy Galleria Continua,
San Gimignano/Beijing/
Le Moulin

Claudia
Losi

The needle and thread recur in the work of Claudia Losi as a metaphor for relationships; since 1998 Losi has been involved in a series of group projects connected with embroidery.

One of her recent ventures is a huge undertaking that has occupied the artist for several years. *Balena Project* consists of the creation of a faithful, life-sized copy of a mythical animal, *Balena Physalus*, the largest whale ever to have existed. 'The idea originated in an image that was always with me,' Losi tells us, 'the huge whales millions of years ago who swam between the hills of the Piacentino, where now flocks of birds fly.' The whale was created from soft cashmere fabric, and Losi began to take it around the world. The piece cropped up in the most varied places and situations: from the Apennines to the Andes, from a square facing the Golfo di Lerici in Italy to the banks of the river Po. It was only occasionally beached in a museum or an exhibition space. It was met at every stage with interest and curiosity, and inspired actions and ideas. In addition

to its striking appearance, *Balena* was the pretext for an amazing journey. After having swum for thousands of miles through different seas, *Balena* went through a final metamorphosis: it was dismembered and the fabric was used to make suits and jackets. With layers of meaning, those clothes will carry forever a memory of the adventures and relationships they collected during the journey in their previous incarnation as a whale. Not a scrap of fabric, not a thought was wasted.

The designer of the clothes – a series of protective jackets – was Antonio Marras, one of today's most sensitive fashion designers. Marras moves in the most cutting-edge fashionable circles and works in an international framework. Both his working practices and his visual repertory have a strong association with his Sardinian background. The projects have links to travel and to difference, as well as an attachment to roots. His emotionally charged, strongly self-promotional world makes his work chime perfectly with that of Claudia Losi.

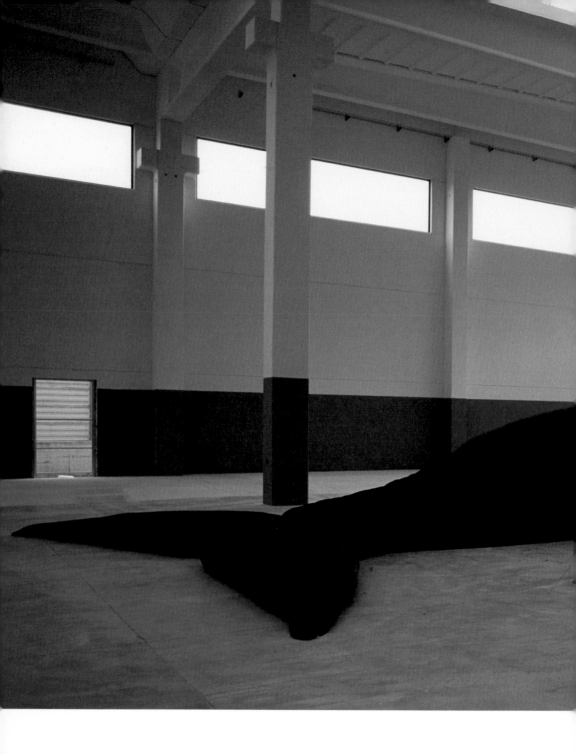

*Balena Project, Fiorenzuola
d'Arda, Piacenza, 2008*
Photograph printed on
cotton paper, embroidery,
60 x 95 cm, wooden frame.
Courtesy the artist and
Galleria Monica De
Cardenas, Milan

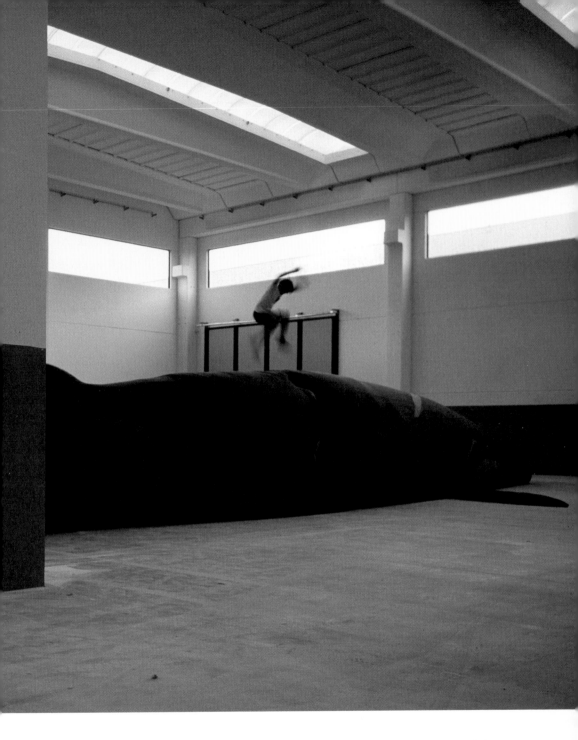

Overleaf:
*Les Funerailles de la
Baleine*, October 2010
Courtesy the artist and
Galleria Monica De
Cardenas, Milan, in
collaboration with Antonio
Marras. Supported
by Ferdinando Botto
Poala and Luisella Zignone

125

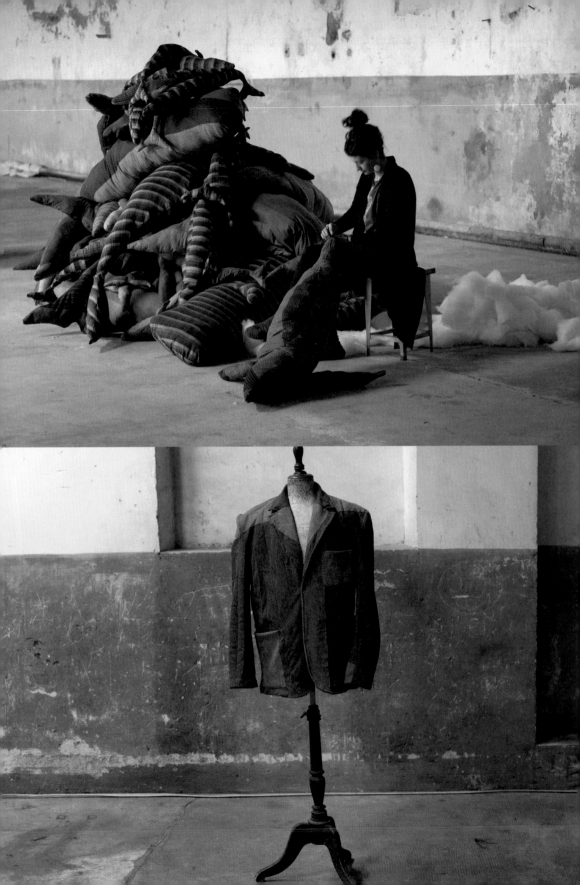

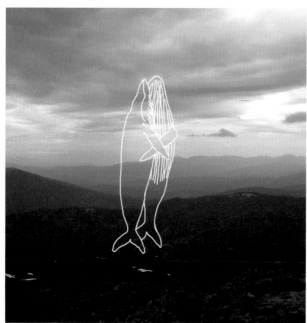

**Balena Project, Apennines,
2004**
Photograph
Courtesy of the artist

**Balena Project, Ecuador,
2005**
Photograph
Courtesy of the artist

Susie
MacMurray

Susie MacMurray's sinuous, elegant and hyper-feminine dress is black and shimmers in the light. Behind its appearance, however, there is a deception. *Widow* is as threatening as it is seductive: on inspection it proves to be made of dressmaker's pins — heavy, sharp and unapproachable. The pins may be small and insignificant, but it has a highly symbolic value. A collection of pins multiplies its danger and increases the significance of the traditional female image of the dependent woman, shut in her house, devoted to domestic tasks, such as sewing and embroidery. The dress is made with painstaking perfectionism, accentuating the idea of the enclosed woman: it makes us think of care, patience, control and routine.

With *Widow* MacMurray gives shape to feelings of separation, to a body that has suddenly become tender, to an interior solitude that repels others and condemns the wearer of the dress to painful isolation. This state is both psychological and physical; it is a transformative moment, an extreme reaction to the world, to an irreversible event. It gives form to ideas and emotions that could otherwise remain submerged, eliciting them and embodying their physical manifestation.

Some sensations are difficult to describe in words, so closely are they linked to emotion. MacMurray's work is dedicated to the exploration of emotional states, to the boundaries of human feeling. Her installations give voice to the depths of human solitude, skirting the edges of subjectivity where body and mind are joined by slogans that are transitory, but can generate far-reaching transformations.

SUSIE MACMURRAY

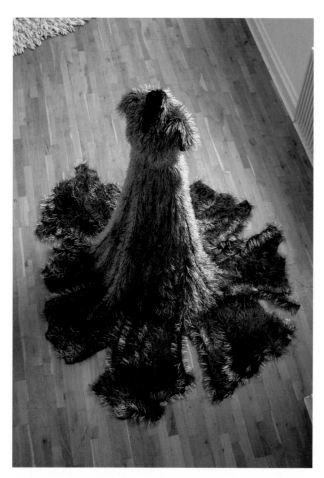

Widow, 2009
Leather and adamantine
dressmaker's pins,
165 x 240 x 200 cm.
Gallery of Costume,
Manchester City Galleries

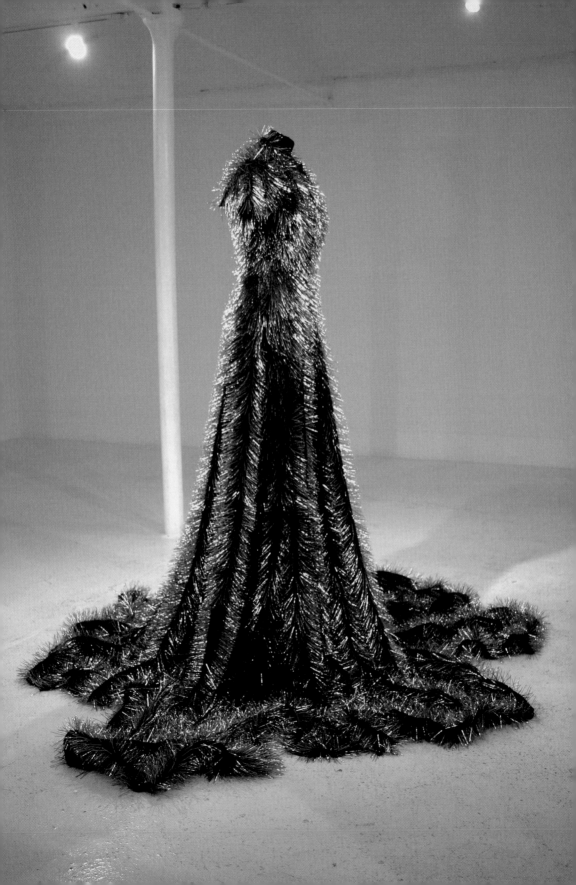

Echo, 2006
Hairnets, used violin
bow hair, variable
dimensions.
Temporary site-specific
installation at York
St Mary's, England.
York Museums Trust

Shell, 2006
Mussel shells, crimson silk
velvet, variable dimensions.
Site-specific installation
at Pallant House Gallery,
Chichester, England

A Mixture of Frailties
(detail), 2004
Yellow household gloves
turned inside out,
calico, tailor's dummy,
185 x 325 cm.
Collection of the artist

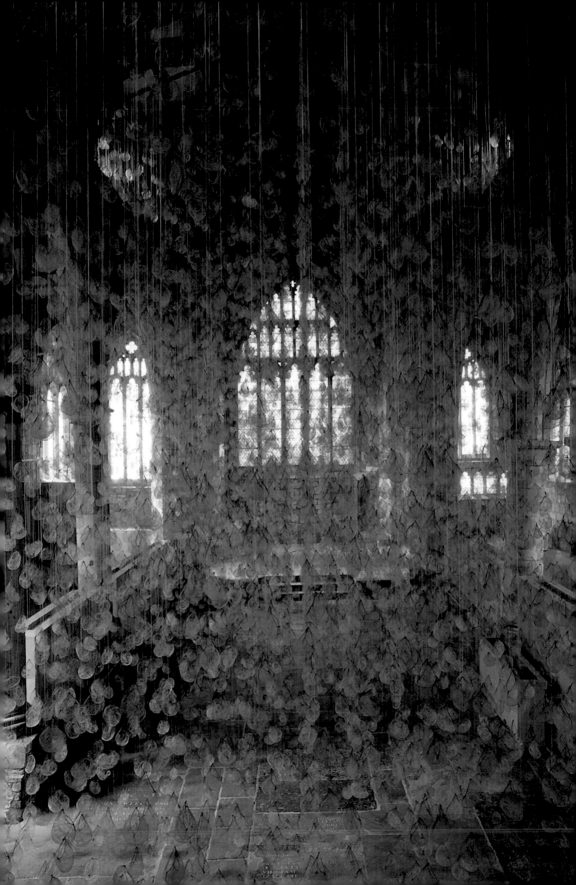

Marcello
Maloberti

Using performance, installation, video and photography, Marcello Maloberti investigates everyday life, peering into normality and sometimes pausing over small details with a delicate glance; but he perseveres, capturing the secrets of things, people and situations. He focuses on precariousness, uncertainty and waiting, the sense of magic and vague obsessions.

Maloberti is also able to confront important subjects. Without affectation, he records what is unique, 'special' about situations on the brink; he describes the periphery of the urban fabric and society, of the gaze and of the mind. His hunting ground is often the city.

The series of photographs *Marcello who Arrives by Train* was taken inside the shop of an Algerian barber in the northern Italian city of Milan, and shows single portraits of shaven men. Their facial features are reminiscent of the countries of the Mediterranean, where the barber's shop is a classic meeting place where people go to chat, exchange notes and news. The men portrayed in the photographs live in a city where, we can assume, they feel like guests rather than at home. They go to the barber to look for that small corner of culture that lurks in their hearts, and a place where relationships between people are still carried on at a human scale. This is a place where they can indulge in a little vanity and frivolity. Their specific beauty codes make sense here, where a superb red apron can become a royal cloak. Thus adorned they can magically evoke ancient aristocratic portraiture as handed on by the history of art; the cloth might be the cloak of a knight or a cardinal. In both cases it would have indicated social prestige. But perhaps it is their absolute normality that makes the men portrayed look like enigmatic figures: their faces take us 'elsewhere'.

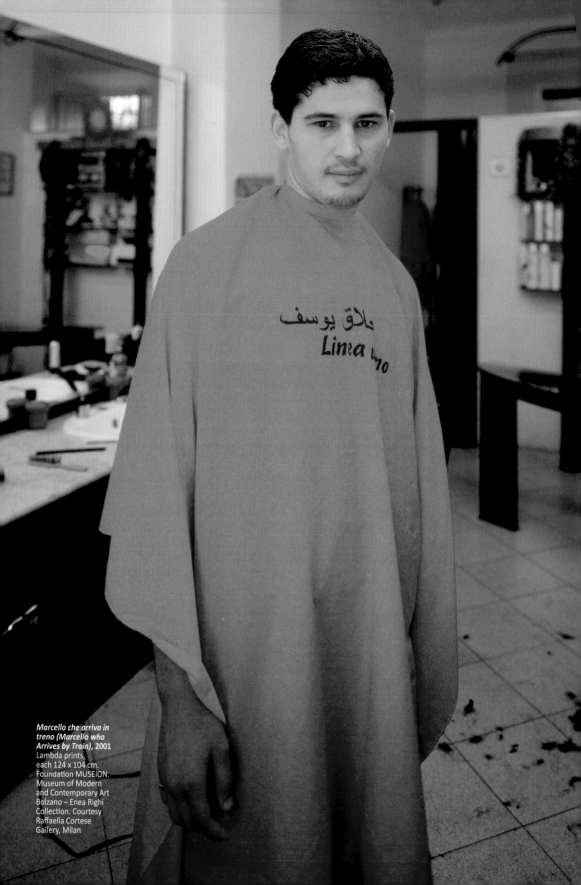

*Marcello che arriva in
treno (Marcello who
Arrives by Train)*, **2001**
Lambda prints,
each 124 x 104 cm.
Foundation MUSEION.
Museum of Modern
and Contemporary Art
Bolzano – Enea Righi
Collection. Courtesy
Raffaella Cortese
Gallery, Milan

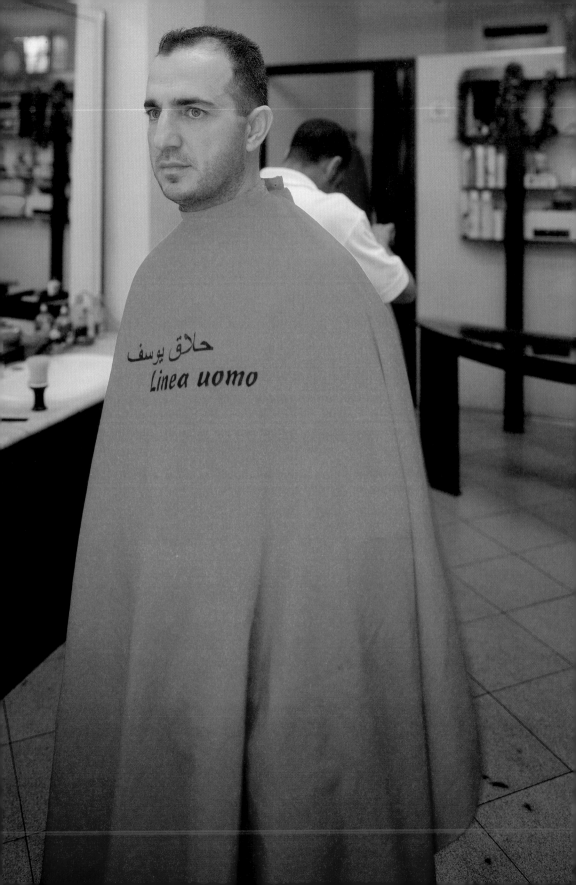

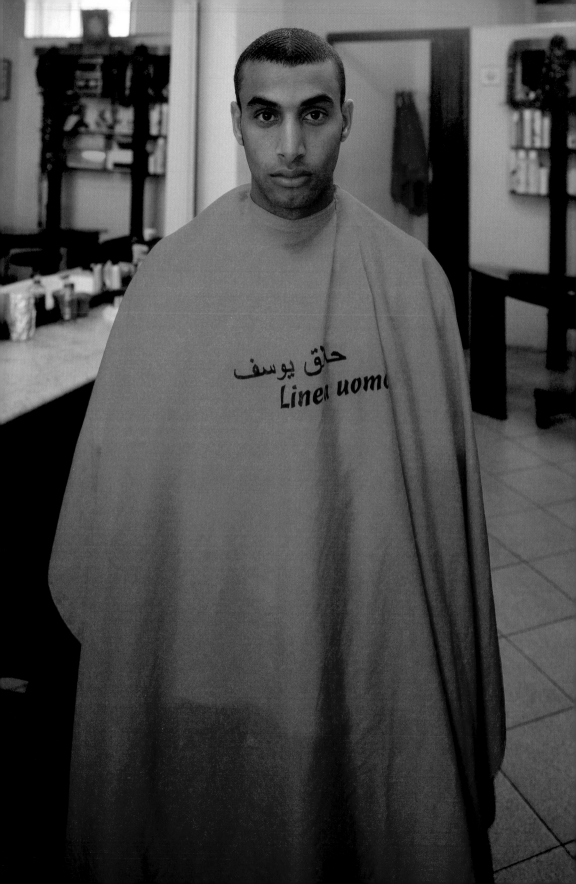

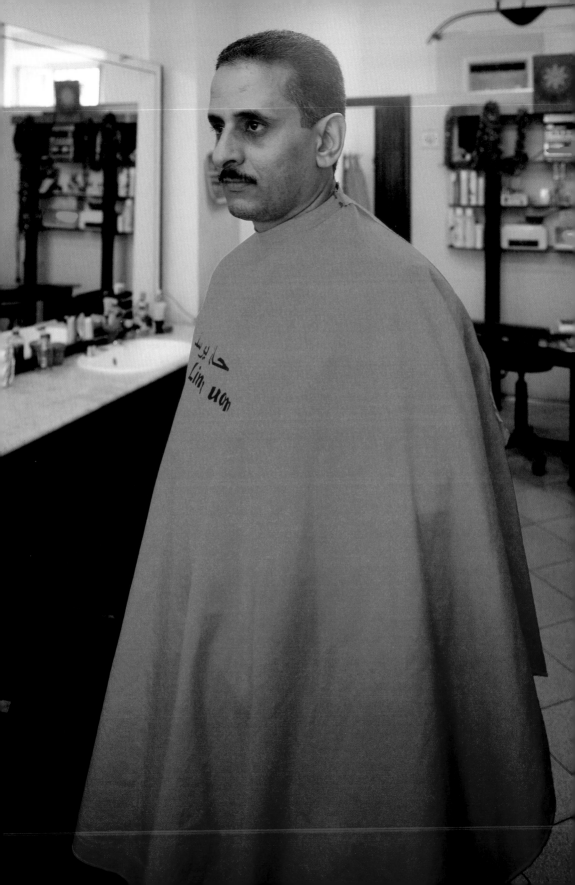

La Maison
Martin Margiela

Martin Margiela does not view utility as the sole function of clothing. When deconstructed, clothing can give a sense of the present moment and also convey the cyclical, inexorable change to which everything is subject. Everything decays, but everything can return. This idea is expressed clearly and concisely in his clothes. Margiela has created a collection based on the recycling of existing clothing. Recycling can be used to counter the current trend for consumerism by always producing the 'other'; we have to remember that we consume to live, we do not live to consume. This also means that we should not throw things away, we should prolong the life of anything we own, even though it may seem to have reached the end of its natural life. This is the most poetic act of all.

Margiela's project *(9/4/1615)*, whose development is shown in this exhibition via a photographic installation, consists of a series of clothes that were treated with bacteria and left to the elements to erode. More specifically, in collaboration with a microbiologist Margiela treated a series of historical collections with a concoction of bacterial fungus designed specifically for the composting process of each of the different fabrics. The collections were displayed on Stockman mannequins in a straight row in three locations. This was an experiment to document the natural destruction of the material, which over time reacted in strange – even beautiful – ways, as the mushrooms and fungus fed off the fabrics, creating new textures and colours. Through the destruction of his clothes, created over years of work as a commercial designer, his display evokes the endless cycle of creation, decay and rebirth. Parallels can be drawn with the consumer cycle of buying and discarding; references to the juxtaposition of fashion and sustainability can be inferred.

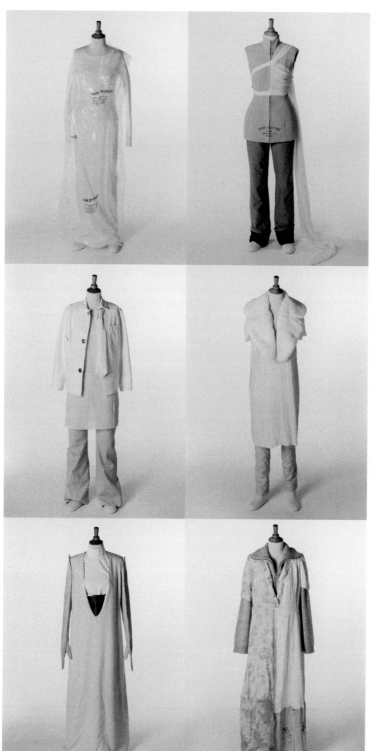

Silhouette 8
(A/W 1992/1993)

Silhouette 10
(A/W 1993/1994)

Silhouette 13
(S/S 1995)

Silhouette 14
(A/W 1995/1996)

Silhouette 16
(A/W 1996/1997)

Silhouette 17
(S/S 1997)

All images on this page:
Exhibition La Maison Martin Margiela (9/4/1615), 1997
Outfits produced in white fabric before moulding

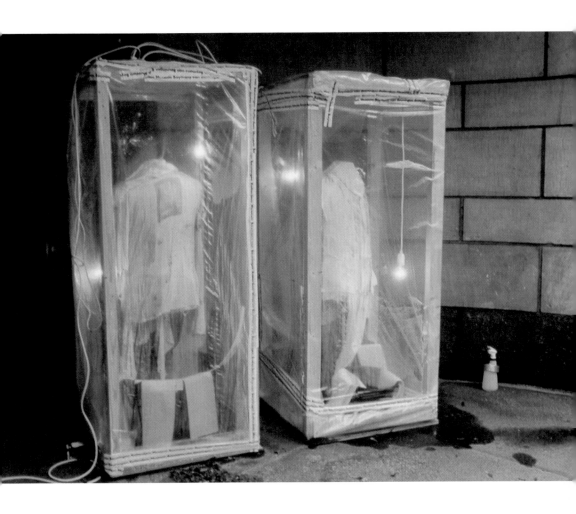

Experiment for moulding clothes. Exhibition La Maison Martin Margiela (9/4/1615), **1997**
Courtesy Museum
Boijmans Van Beuningen,
Rotterdam

Silhouette 17
(S/S 1997)

Silhouette 13
(S/S 1995)

Silhouette 16
(A/W 1996/1997)

Silhouette 14
(A/W 1995/1996)

Silhouette 8
(A/W 1992/1993)

Silhouette 10
(A/W 1993/1994)

All images on this page:
Collage for exhibition catalogue
La Maison Martin Margiela
(9/4/1615), 1997
A4 paper.
Courtesy Museum Boijmans Van
Beuningen, Rotterdam

Alexander McQueen

Alexander McQueen's catwalk shows are theatrical performances that rely on skilfully staged shock tactics. These performances question the accepted notions of fashion and beauty.

McQueen's clothes are noted for being sensationally erotic, fantastic, often androgynous creations that are painstakingly and precisely tailored. 'Sex is a big part of what I do,' said the bad boy of British fashion, but he insisted that his attitude to women was informed by the purpose of 'making women look stronger, not naive'.

For his March 1995 show, 'Highland Rape', McQueen sent his models down the catwalk in ripped lace dresses and skirts with what appeared to be watch chains attached. The explicit allusion to the sexual violation of women was a reference to the 'rape' of Scotland by the British army, a subject with personal resonance for the artist as his family is of Scottish descent. For the show, McQueen transformed an industrial loft space into a chaotic battleground, symbolising 1746's Battle of Culloden.

History and performance are also clearly evident in the 1998 collection, which was inspired by the story of Joan of Arc, who, in the 15th century, led her assembled troops to victory during the Hundred Years' War, and was eventually burnt at the stake by the English. This collection was presented on a catwalk made of lava, accompanied by the sound of crackling flames. The clothes made reference to the French army's armour, and also evoked the bravery and vulnerability of Joan. The final scene of the catwalk performance featured a model wearing a red beaded dress, encircled by flames.

McQueen's performances merge history and personal sensitivities, and are also highly experimental in terms of the fashion.

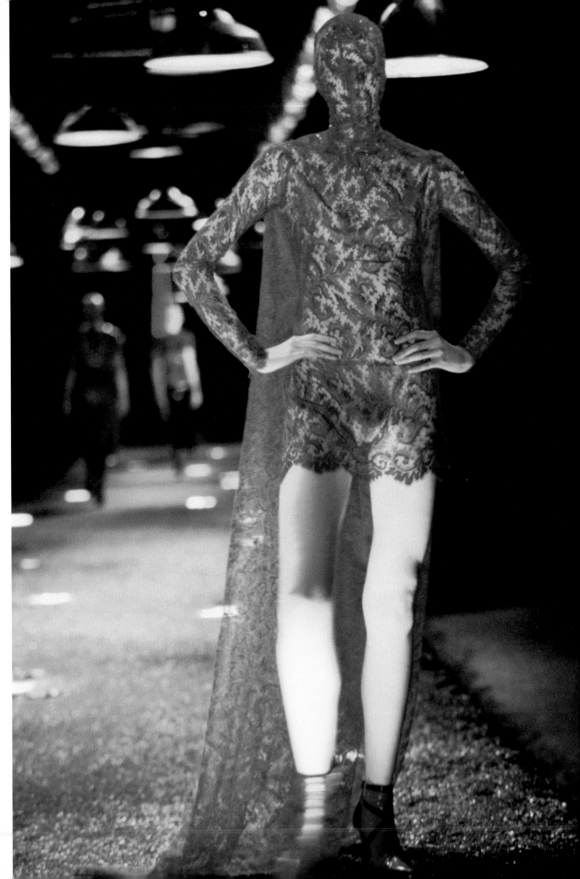

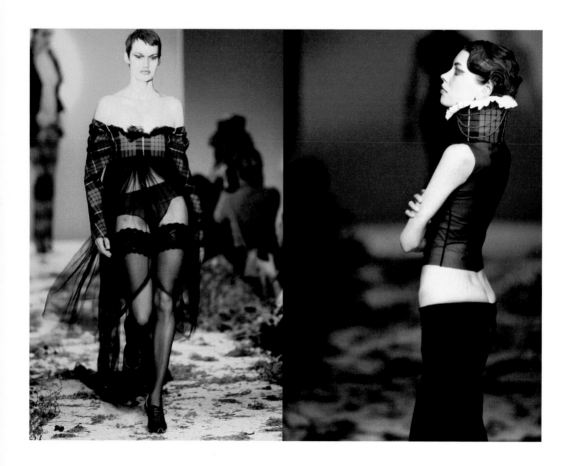

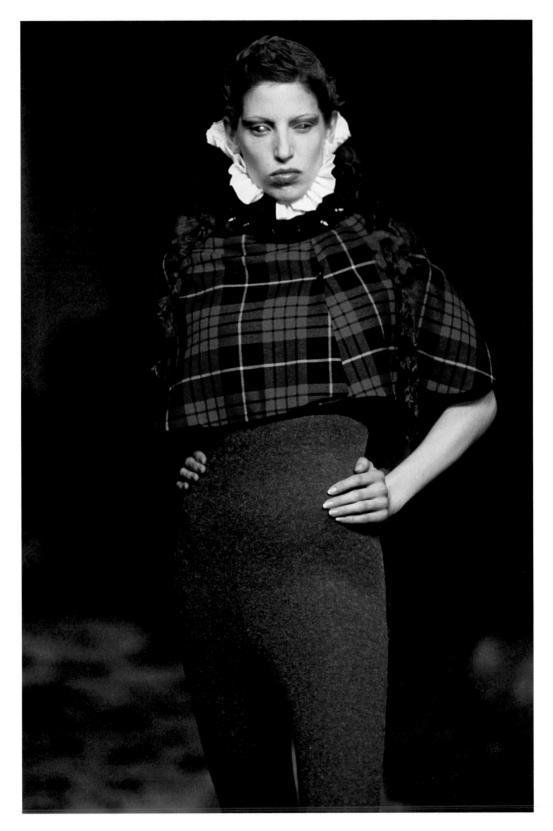

Yoko
Ono

Yoko Ono is one of the leading figures in post-war art. She is a pioneer of performance and conceptual art, and remains one of the most influential artists today. Long before she became an icon of popular culture, she developed artistic practices that have made a lasting mark in her native Japan, as well as in the West.

Cut Piece is an action that she performed in the Yamaichi Hall, Kyoto in 1964, and again at the Carnegie Hall, New York in 1965. She then performed it with the Destruction in Art Symposium at the ICA in London in 1966. Seated on a dais, Ono invited the public to come up and cut strips from her clothing. While the scraps of fabric fell to the floor one by one, the unveiling of the female body suggested the total destruction of the barriers imposed by convention; as it

progressed this became an aggressive act – still motionless, the artist was by now almost naked, exposed in all her vulnerability. The image of Ono during the performance has become an iconic symbol of the art of the period. These were the years when emancipation came to female artists often via deeply radical, destructive actions; it contributed to the definitive re-appropriation of their own bodies.

In this work Ono also challenges the neutral relationship that exists between the spectator and the art object, demonstrating the reciprocal transformation of both.

Yoko Ono performing
Cut Piece
Theatre Le Ranelagh,
Paris, France,
15 September 2003
© Yoko Ono

Yoko Ono performing
Cut Piece
Sogetsu Art Center, Tokyo,
Japan, 1964
© Yoko Ono

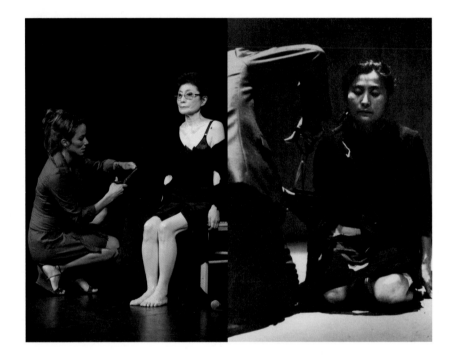

Yoko Ono performing
Cut Piece
Carnegie Recital Hall,
New York, 21 March 1965
© Yoko Ono

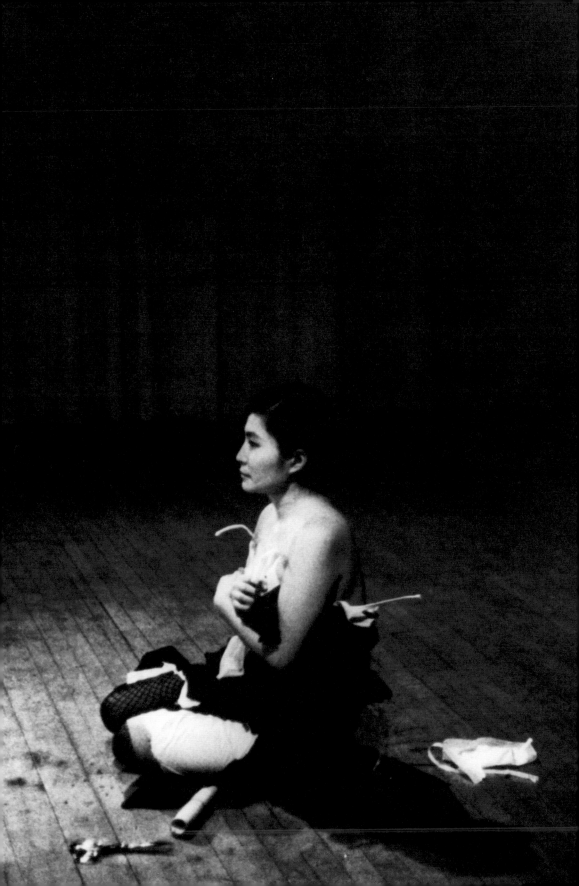

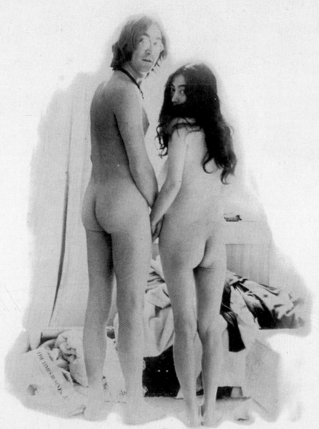

"When two great Saints meet it is a humbling experience. The long battles to prove he was a Saint." - Paul McCartney

Unfinished Music No. 1. Two Virgins. Yoko Ono/John Lennon. Apple Records May. 1968.

Unfinished Music No. 1: Two Virgins, 1969
Album cover, front (right) and back (left)
Self-portrait by John Lennon and Yoko Ono,
London
©Yoko Ono

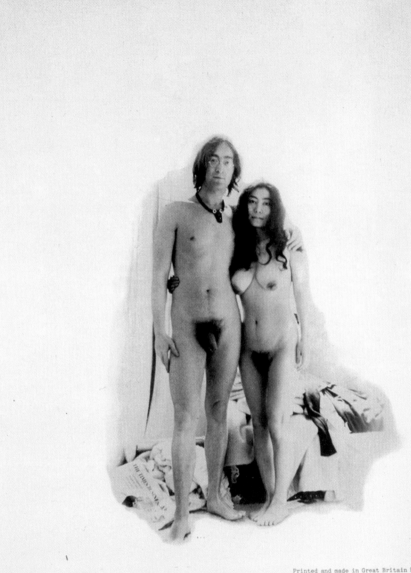

Printed and made in Great Britain by Technink Limited.

Maria
Papadimitriou

Clothing is symbolic and is linked to tradition and beliefs. Maria Papadimitriou is interested in cultural specificities and in the overcoming of stereotypes; she sets up projects with a public, social and collective dimension. In the participatory project *Sewing Together*, she worked with Roma gypsy women in order to learn their skills, comprehend their intuitive process of dressmaking and their very particular style of dressing, which is linked to their beliefs. From this mutual exchange emerged a series of beautiful dresses with traditional, brightly printed floral patterns. The artist describes the project as follows:

'The most impressive element in a [...] gypsy house is the pile of colourful blankets which is always in the centre of the room. This pile stands like a supple sculpture. The suppleness is reinforced by the fact that the gypsy blanket is the girl's dowry. This is what a mother gives her daughter and it is a symbol of the family's continuity. During the day this sculpture stands motionless and at night it becomes the mattress on which they lie and the blanket that covers their bodies. It is an autonomous unit, a cell and a shell.

'These blankets are the first object they take with them when they leave. Whether rich or poor they insist on sleeping on them. This precious unit, when transformed into a coat, becomes the dwelling of the body. It changes identity from "extremely private" to "overtly public".'

In this piece, therefore, Papadimitriou is talking about clothing as well as habitat. She is convinced of the need to be at ease in the clothing one wears, and to feel at home in one's own house – profoundly subjective experiences which chime with a secure confidence in one's own identity.

MARIA PAPADIMITRIOU

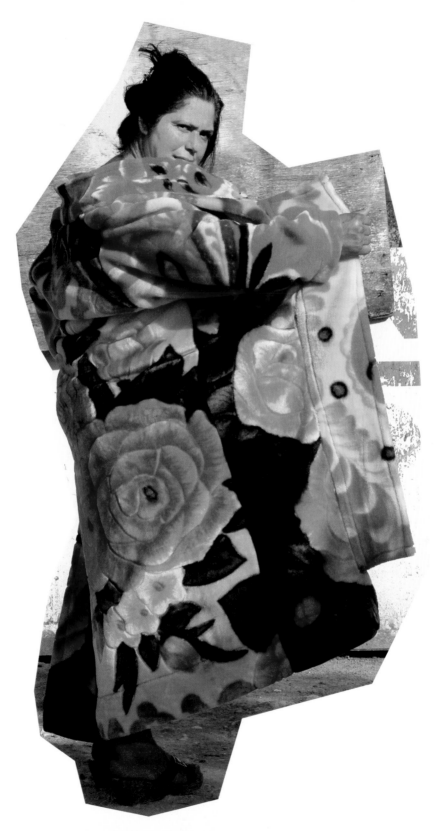

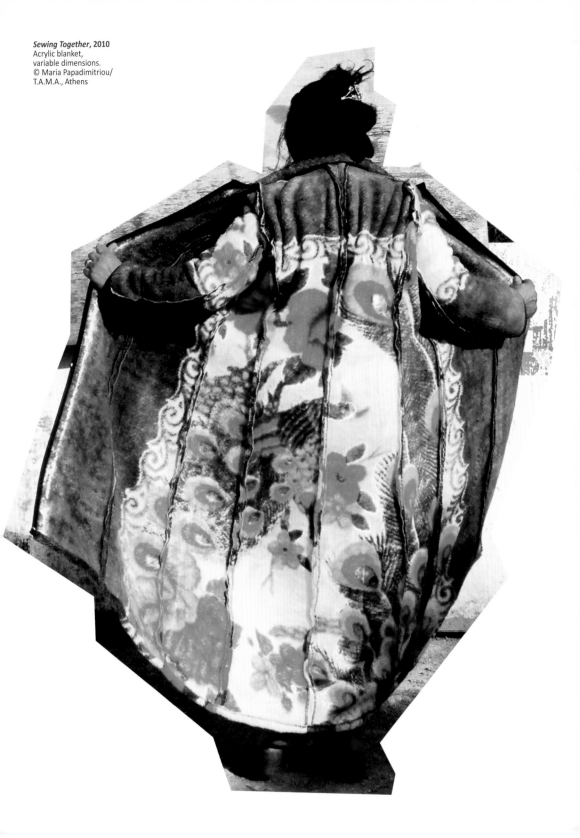

Sewing Together, 2010
Acrylic blanket,
variable dimensions.
© Maria Papadimitriou/
T.A.M.A., Athens

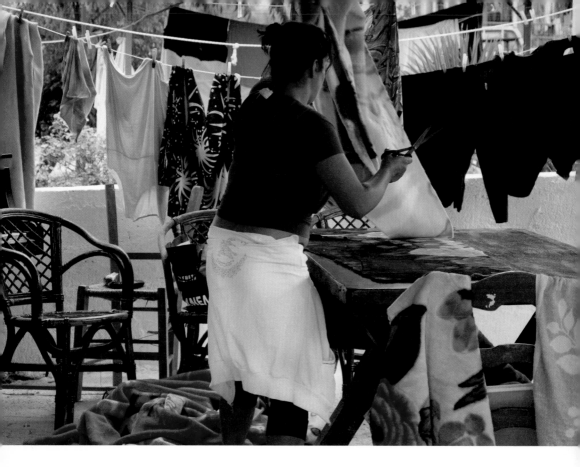

Temporary Atelier, 2010
Lambda print, variable
dimensions
© Maria Papadimitriou/
T.A.M.A., Athens

Pattern, 2010
Lambda print, variable
dimensions
© Maria Papadimitriou/
T.A.M.A., Athens

Grayson
Perry

Grayson Perry works in a wide variety of media, including ceramic, printmaking, drawing, embroidery and other textiles, as well as in graphic novels, film and performance. An important aspect of his work is the frequent appearance of his alter-ego, Claire.

His disenchanted gaze is directed towards the context in which we live, and the art world, the stage for his cross-dressing, is the subject of many of his sardonic comments as well as his works. Perry is an insider, but is capable of distancing himself.

His *Artist's Robe* is a commentary on the figure of the artist, and also bears witness to his interest in other cultures and artistic languages of communication. The robe is an elaborate, appliquéd coat of many colours, embroidered with patterns. Perry was inspired particularly by the ancient kimonos of Japanese Buddhist monks, the 'crafted formalisation of poverty'. It is made of a patchwork of luxurious fabrics, cut and stitched together, some of them acquired from the National Trust, thus symbolic of the formalised heritage of Great Britain. The garment sports a large embroidered eye, very obviously linked to the artist's work: it provides a commentary on the figure and status of the artist in the world today – stereotypes, rituals, favoured places and gurus, but also a close eye on the ways of the world.

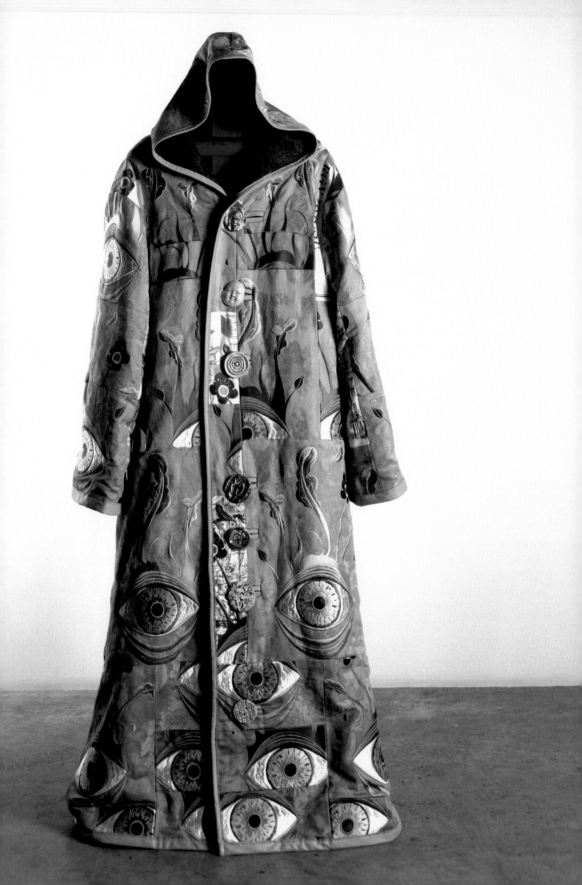

*Claire as The Mother
of All Battles,* 1996
Photographic print,
76 x 50.7 cm.
© Grayson Perry
Courtesy of Rob Weiss
and Victoria Miro Gallery,
London

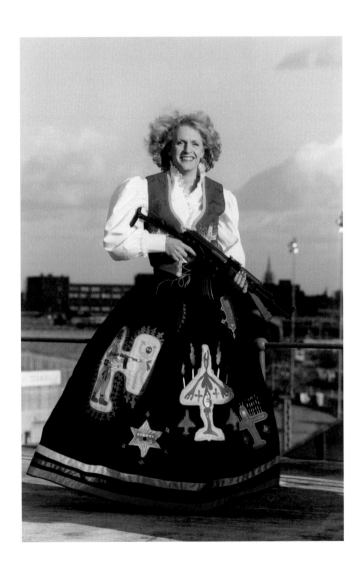

Artist's Robe, 2004
Embroidered silk brocade,
leather, printed linen
and ceramic buttons,
179 x 70 cm.
© Grayson Perry
Courtesy the artist and
Victoria Miro Gallery,
London

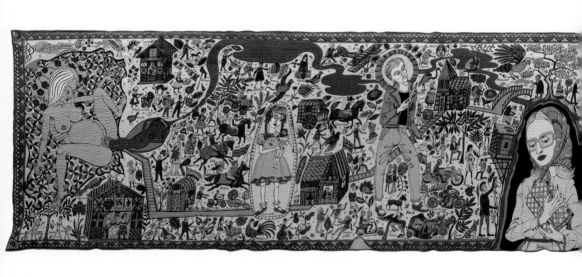

The Walthamstow Tapestry, **2009**
Tapestry, 300 x 150 cm.
© Grayson Perry
Courtesy the artist and
Victoria Miro Gallery,
London

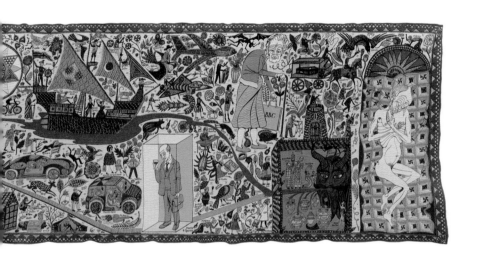

Dai
Rees

Carapace: Triptych, The Butcher's Window is an installation consisting of a series of large leather sculptures that hang from the ceiling, attached to huge butchers' hooks. Their organic forms are the outcome of a process of assembly and dis-assembly. They are actually made from 1950s' patterns, dissected and sewn back together again in a completely different way to make them look like animal carcasses. Dai Rees sews the leather together with scar-like seams, either perfectly laced or stitched with surgical linen. In some of the pieces it is still easy to recognise sections of tailoring, while in others the original form is lost. All of them evoke the remains of cows and horses. The funereal message is reinforced by the fact that on the surfaces of these huge torsos, Rees has tattooed images, including the trunk of a leafless tree and flowers in various stages of decay.

The images have been created using the ancient technique of marquetry, a process totally at odds with the speed and slickness associated with recent fashion. Rees's use of marquetry is a clever salute to the patronage of the arts that goes back to sixteenth-century Florence. He has revisited this technique and transferred the process to leather, where is also alludes to the branding iron.

The beauty and refinement of the craft displayed in this piece combines with a sensation of death and trauma, producing a distinctly uncomfortable reaction.

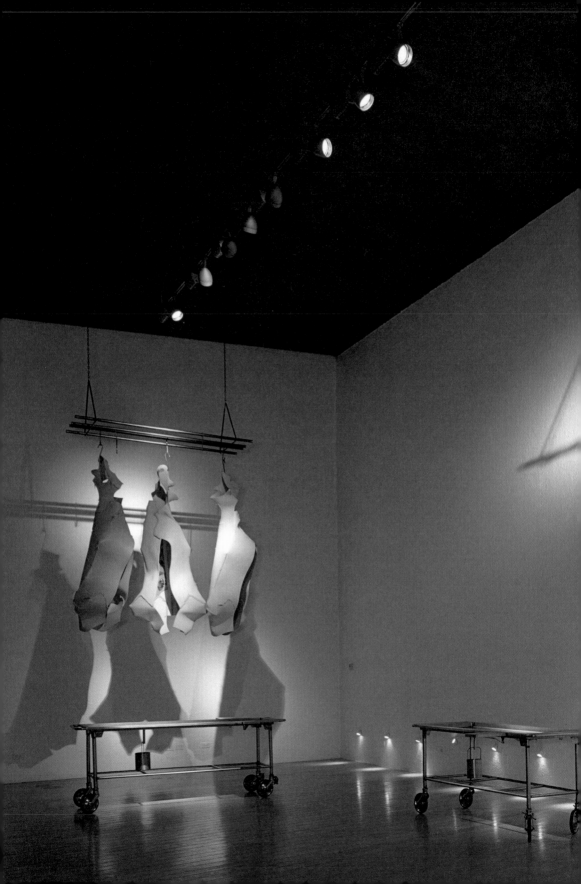

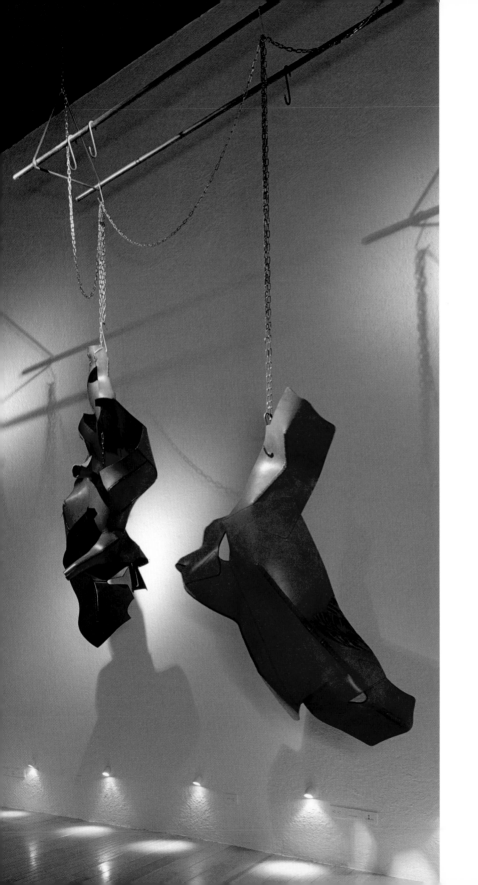

Carapace: Triptych, The Butcher's Window, 2003
Leather hide, leather marquetry, stainless steel, enamel and iodine, each piece 180 x 70 x 50 cm.
Courtesy of the artist

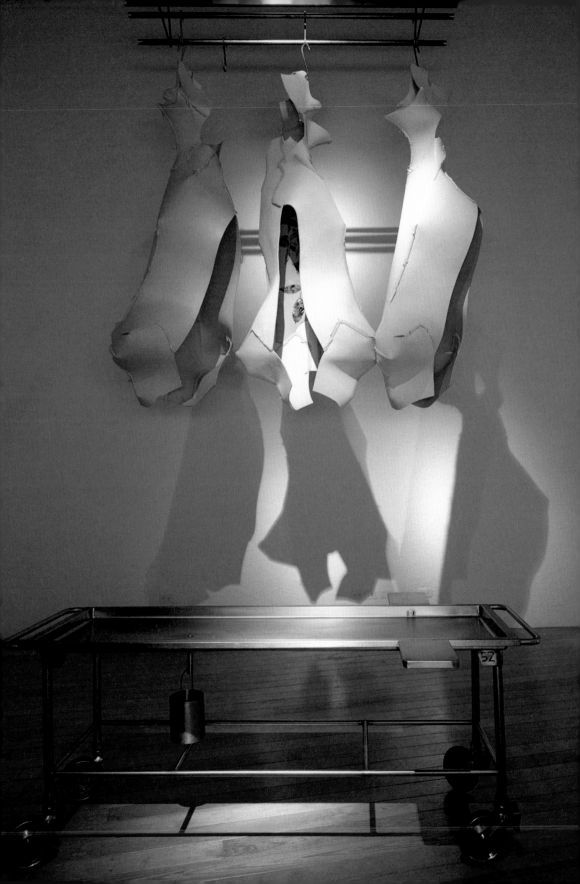

Katerina
Šedá

Katerina Šedá's piece *For Every Dog a Different Master* originates from the notion that we are 'contextual', that we build our personality in a specific social and relational environment. The collaboration arose from the desire to create a dialogue in a suburban area the artist has known since she was very young, Brno-Lisen in the Czech Republic. As a child, travelling on the bus from Brno-Lisen into the more recently built Nova Lisen, Šedá noticed how people had stopped greeting one another, and indeed her, as if she had become invisible. Growing up, she rationalised this as social atomisation, but never quite accepted it, and as an artist she decided to use this invisibility to attempt to affect a 'paradigm shift' in the network of social relationships of her town.

She printed a shirt which featured an image of a multi-coloured 1970s' housing project. She grouped all addresses for Brno-Lisen and Nova Lisen into pairs and mailed the shirt from one address to the other, marking the sender as the Brno-Lisen household, rather than herself. She then observed the resulting interactions and photographed people who, in a wide variety of everyday situations, were wearing the shirt she had designed. These people ended up forming a sort of involuntary, informal 'team'. Her work therefore deals with our physical living arrangements, and is about the urban landscape, which, in its complexity, reflects the life it contains, forming a network of existences and relationships, of actions and processes. Šedá tries to re-establish human beings in a specific urban geography and social environment.

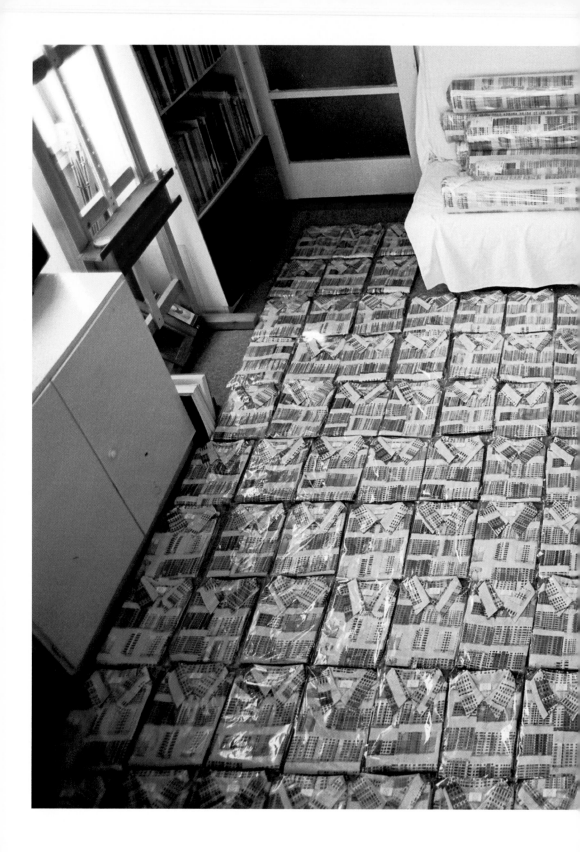

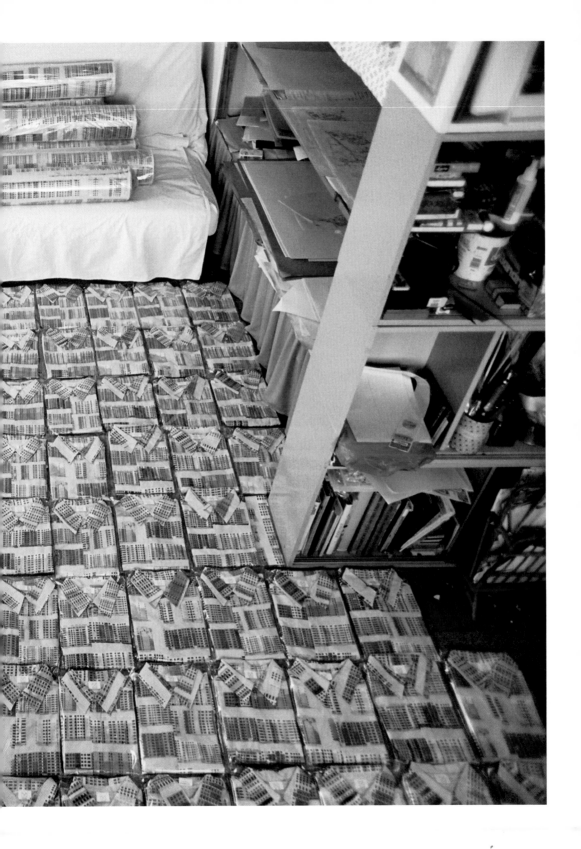

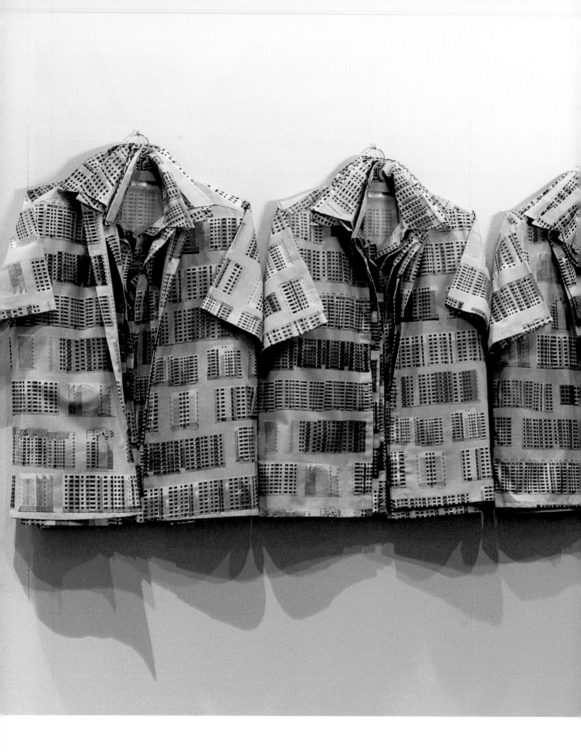

Previous page:
For Every Dog a Different Master, 2007
Colour photograph,
100 x 130 cm.
© Katerina Šedá
UniCredit Art Collection

For Every Dog a Different Master, 2007
Cotton shirts, 70 x 90 cm.
© Katerina Šedá
UniCredit Art Collection

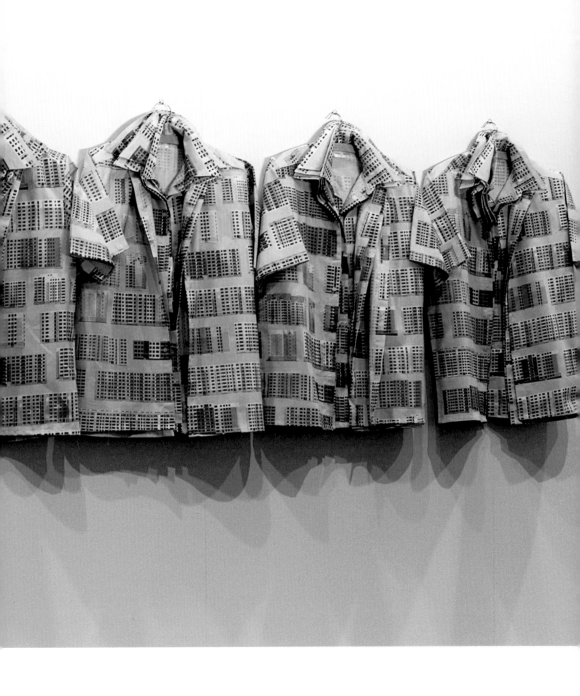

Cindy
Sherman Hon RA

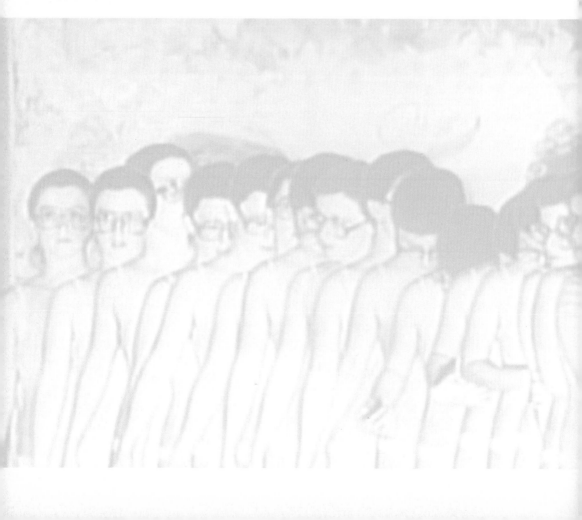

In *Doll Clothes*, we see Cindy Sherman disguised as a paper doll on her way to the dressing table. While she watches herself in the mirror, a menacing hand appears from off-camera, ripping the dress off the doll's body.

Nude again, she is stuffed back into a plastic sleeve, the straitjacket of conformism and anonymity. *Doll Clothes* illustrates the story of a failure to attain self-defined subjectivity. Sherman explains that the hand represents the parent telling the child they are misbehaving.

The act of dressing-up represents the power of masquerade and self-transformation, which have been the guiding principles of Sherman's work for over 30 years. In 1976 she produced *Bus Riders*, a kind of sociological fiction in which she represented all the possible types of passenger in an omnibus. This was followed by *Murder Mystery*, which was inspired by crime novels.

In 1977 she moved to New York and made *Untitled Film Stills*, a sequence of photographs in black and white in which she impersonates 69 characters from B-movies. The scenes and characters she represents give shape to the *déjà vus* of everyday life as we know it and as we re-live it through the best-known films, from Italian neo-realism to American *film noir*. The sets and characters are created in exact detail, and it is tempting for the spectator to develop the narrative contained in the stills much further. However, their meaning is never really explicit. The power of the work lies in the tension between the immediate identification of a famous stereotype and the individual projection space, in which imagination and private yearnings may be stirred.

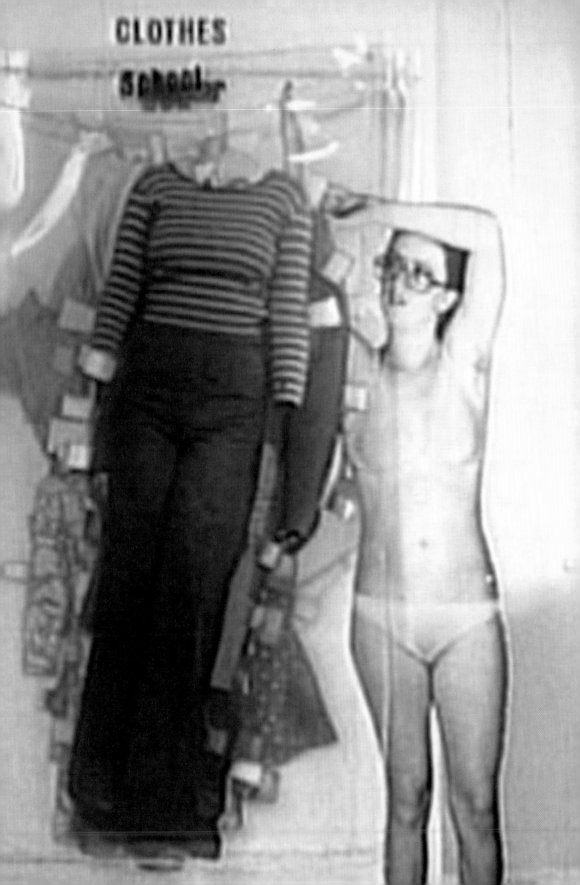

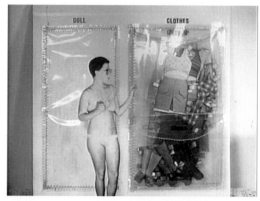

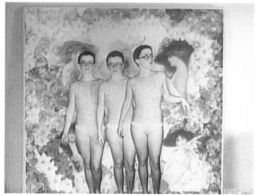

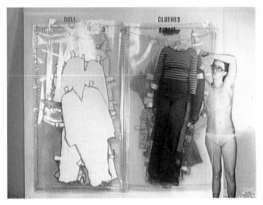

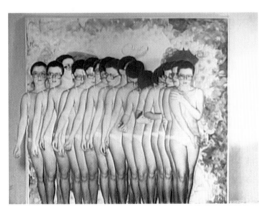

Doll Clothes, 1975
16 mm film on DVD,
running time 2' 22"
© Cindy Sherman/
Sammlung Verbund, Vienna

191

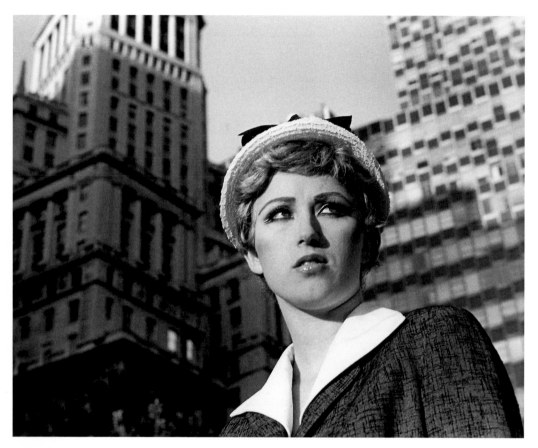

Untitled Film Still #21, 1978
© Cindy Sherman
Courtesy of the artist,
Metro Pictures and Sprüth
Magers Berlin London

Untitled #132, 1984
© Cindy Sherman
Courtesy of the artist,
Metro Pictures and Sprüth
Magers Berlin London

Yinka
Shonibare MBE

Shonibare is interested in the global process of cultural transformation. Taking his lead from the still-extant post-colonial situation of the African continent, and having described himself as a 'post-colonial hybrid', he aims to dismantle preconceptions about national definition, and historical and cultural identity, working against ethnocentrism by deconstructing icons and stereotypes.

Shonibare sees fashion as an expression of class and power; it is a means of establishing human beings in a particular historical and geographical context. His social stance makes fashion a highly sensitive sensor.

His installations often have their roots in eighteenth- and nineteenth-century paintings, a period when Western culture reached its peak, but also when slavery was at its height. Shonibare's work often consists of figures, dressed in typically European fashions made of the brightly coloured wax-printed 'African' fabrics called batik. Batik is a key material in his work;

although it originated in Indonesia, until recently these fabrics were mainly produced in Holland and Germany, but were not widely sold in Europe. Production was based on 'typical' models and was aimed at particular African markets. Batik, and clothing in general, made a general contribution to the creation and dismemberment of colonialism. 'Batik proved to have a crossbred cultural background quite of its own,' says Shonibare, 'and it's the fallacy of that signification that I like. It's the way I view culture – it's an artificial construct.'

Today, the main exporters of 'African' fabric from Europe are based in the UK and the Netherlands. Shonibare shows that it is only through awareness of our origins, and by recognising the inexorable processes of transformation of our identity, that we can conduct a calm dialogue with other cultures and move serenely towards the new age.

Fabrics used for
Little Rich Girls, 2010
Commission by the
London College of Fashion,
courtesy of the artist
and Stephen Friedman
Gallery, London.
Supported by Vlisco
© Yinka Shonibare MBE

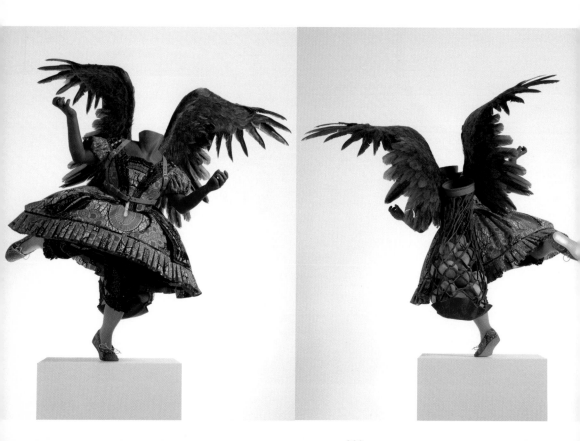

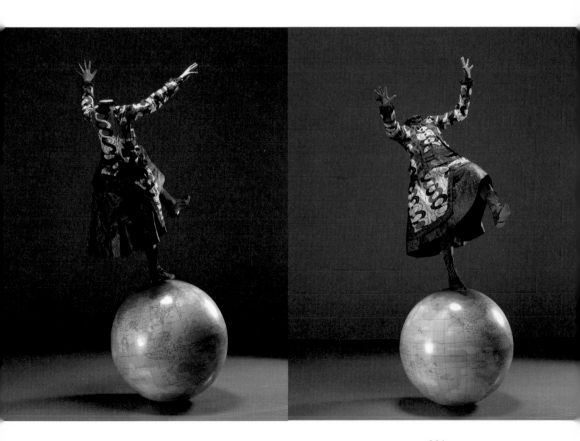

Helen
Storey

The environment, ecology and sustainable development are among the subjects engaging the artists of today, particularly those who are sensitive to the challenges facing the world in our time. Man has at last become aware of the damage he can inflict on his own habitat. The evidence of a crisis in the traditional relationship between man and his environment has elicited large numbers of reflections on the need to conserve the earth's fragility and to use the resources nature offers us wisely and carefully.

With this in mind, Helen Storey has ceased to create fashion collections in order to dedicate herself to interdisciplinary research into the way science, art, technology and fashion design can influence society and the environment. She is developing biodegradable materials that can self-destruct, leaving no polluting imprint behind.

Today, Storey creates exquisite dresses constructed from a hand-made, enzyme-based textile that dissolves in water over time. A scaffold gradually lowers the lacy fabric into giant bowls of water. Each dress behaves differently as it enters the liquid, and the dissolving material creates vibrant underwater fireworks that are magnified by the bowls.

Say Goodbye is from Storey's series of 'dissolvable dresses' and is a reflection on the non-sustainability of fashion, and the waste generated when we discard our clothes because of the dictates of fashion. This work is the result of a long-standing collaboration with the University of Sheffield.

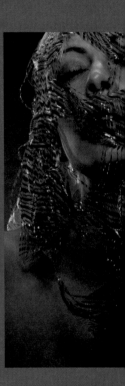

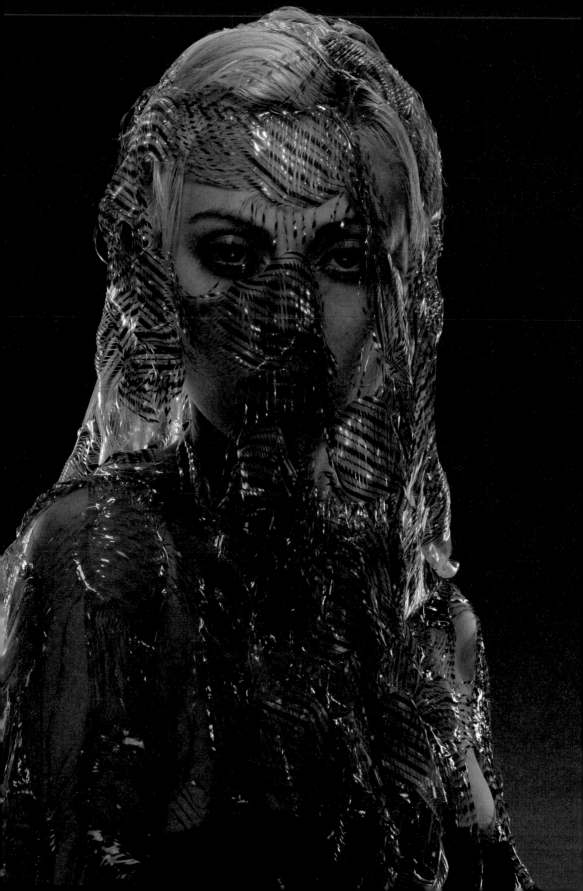

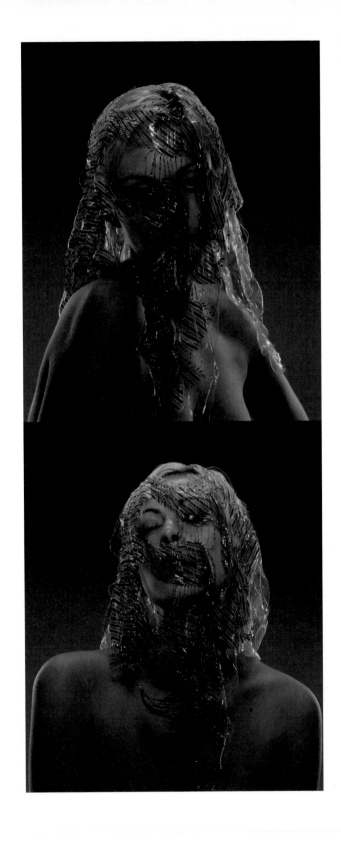

Say Goodbye, 2010
PVA (polyvinyl alcohol)
experimental dissolvable
dress, variable dimensions.
Courtesy of the artist.
Supported by the Royal
Society of Chemistry

Disappearing Dress Series:
Say Goodbye, 2010
Experimental dissolvable
dress, variable dimensions.
Courtesy of the artist

206

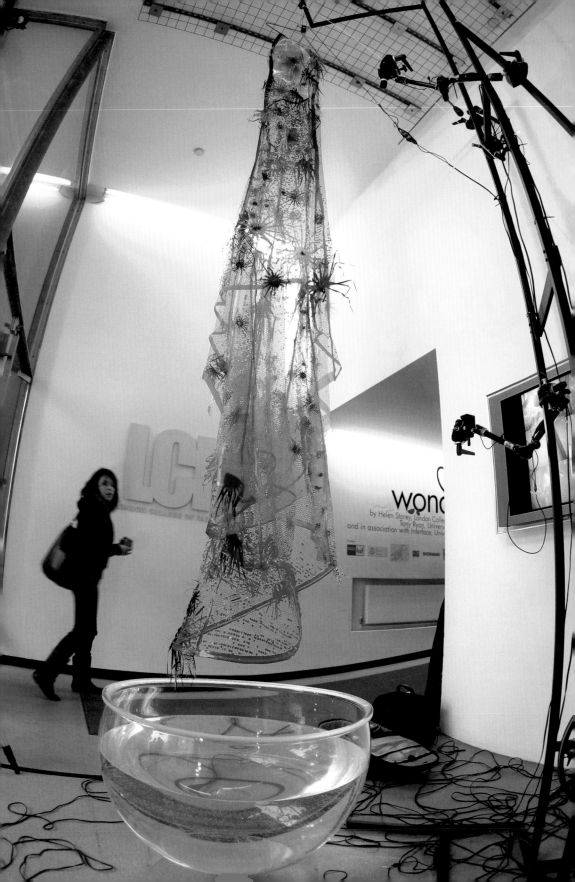

Rosemarie
Trockel

Rosemarie Trockel's work is rich and varied; it includes installations of all sizes and small drawings, sculptures in plaster and collage, but it was her objects made of knitting which brought her prominence in the 1980s.

Her knitted work is not handmade, however, although it embodies a type of work that is largely female and domestic. Trockel's knitting has an industrial appearance; this is one of the many contradictions embedded in her work, which is deliberately complex and stratified, often with a subtle sense of humour. Its interpretation is multi-layered. Her work is sensitive to feminine subjects, and to human nature in general.

Balaclava and *Schizo-Pullover* both testify to the complexity of human nature. *Schizo-Pullover* is a double-necked sweater that conveys the feeling of being at once singular and plural, implying that subjectivity is a place for encounter and change. At the same time, it expresses our inherent incompleteness, our human need for coupling and the importance of the network of relationships of which we are part.

Balaclava also shows that within ourselves we are plural, with hidden, secret aspects, in society as well as in life, in our heads and our personalities. The piece makes manifest the shadowy zone that is within each one of us. At one time the balaclava was a piece of headgear designed to protect from the elements; since the late 1960s, however, it has become a symbol of secrecy, crime and fear, and has also been associated with violence and terrorism.

As in all of Trockel's knitted works, the patterns for *Balaclava* and *Schizo-Pullover* were created with the aid of a computer and manufactured on a knitting machine. They thus also question (and potentially subvert) the notion of 'women's work'.

Schizo-Pullover, 1988
Wool, 60 x 66 cm,
edition of three.
Private collection.
Courtesy Sprüth Magers
Berlin London
© DACS 2010

Senza Titolo, 2002
Knitted woollen fabric,
180 x 400 cm.
MAXXI – Museo nazionale
delle arti del XXI secolo
Courtesy Fondazione
MAXXI
© DACS 2010

Untitled, **1988**
Wool, 60 x 66 cm,
edition of three, RTR 0038.
Courtesy Sprüth Magers
Berlin London
© DACS, 2010

Sharif
Waked

The Palestinian artist Sharif Waked directly confronts the conflict between Israel and Palestine. He is painfully aware of the complexity of the situation in the Middle East, but also deeply involved in the dismal fate of his own people. In creating a fashion collection, Waked saw a chance to re-encounter his compatriots and deliver them from the humiliations they suffer on a daily basis. His video *Chic Point* features a catwalk show with models emerging from a dark background. Zip fasteners, woven nets, hoods and buttons provide a unifying theme of exposed flesh. Suddenly, after a few minutes, the images of the parade are substituted by a series of shots in which Palestinian men can be seen lifting up their shirts, robes and jackets at Israeli checkpoints. This is a daily event: anyone needing to cross the checkpoints must demonstrate that he is not carrying arms beneath his clothing.

In *Chic Point*, the contradictory interpretations of nudity as a fashion prerogative or as the cause of humiliation juxtapose two worlds, one of high fashion and the other of semi-imprisonment. Waked makes a powerful statement about aesthetics, the body, surveillance and freedom.

Some of Waked's later work reveals the painstaking attention he pays to habits and customs, in relation to clothing in particular – clothing as a strong symbol of identity.

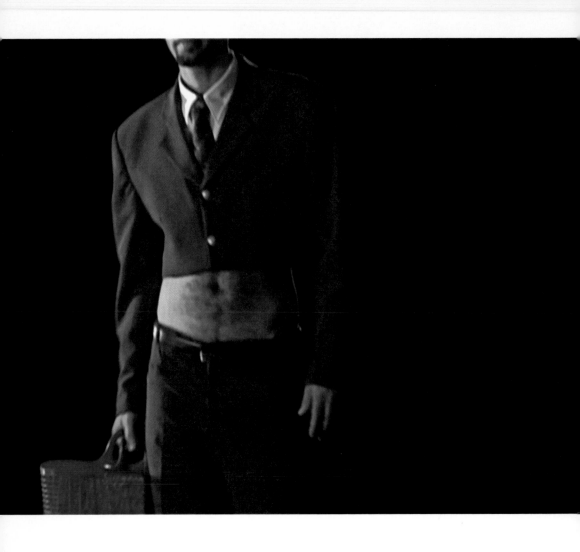

Chic Point, 2003
DVD, running time 5' 27"
Courtesy of the artist

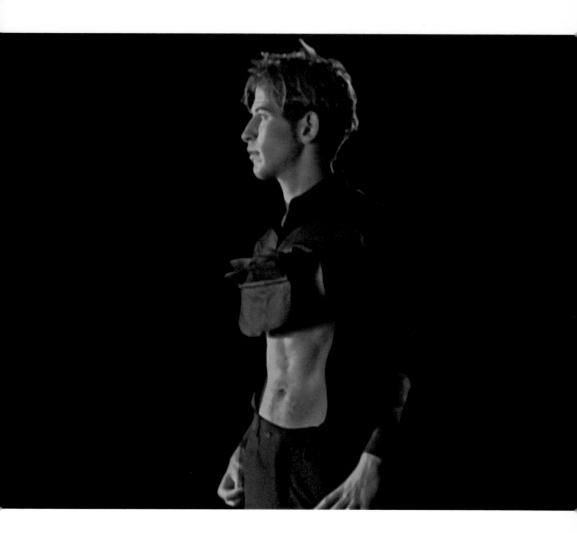

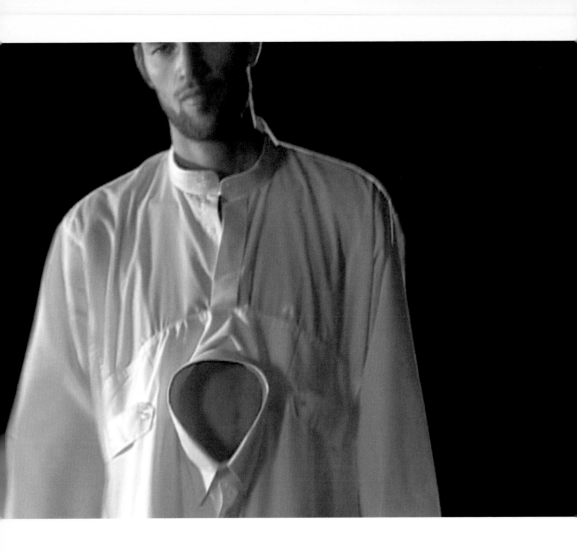

Chic Point, 2003
DVD, running time 5′ 27″
Courtesy of the artist

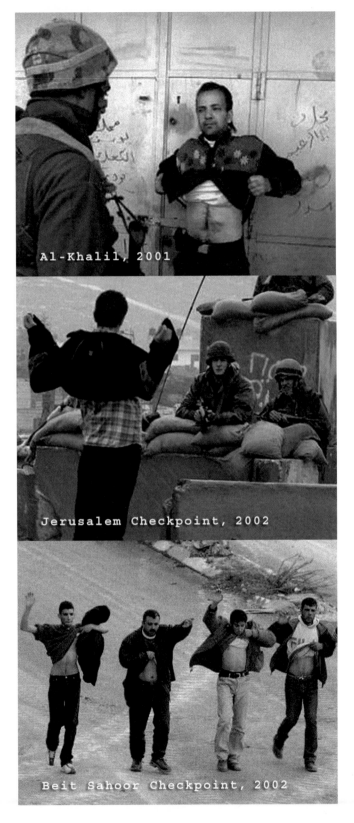

Al-Khalil, 2001

Jerusalem Checkpoint, 2002

Beit Sahoor Checkpoint, 2002

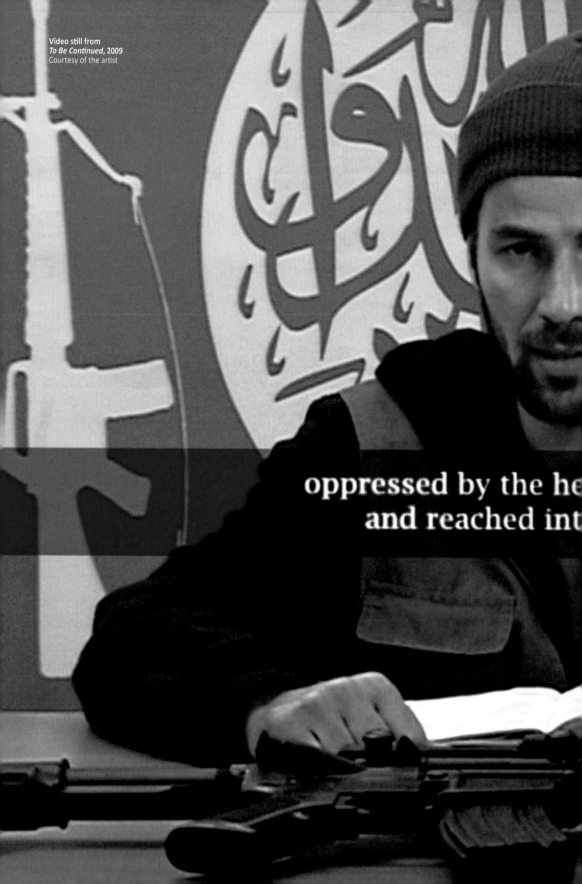

oppressed by the he
and reached int

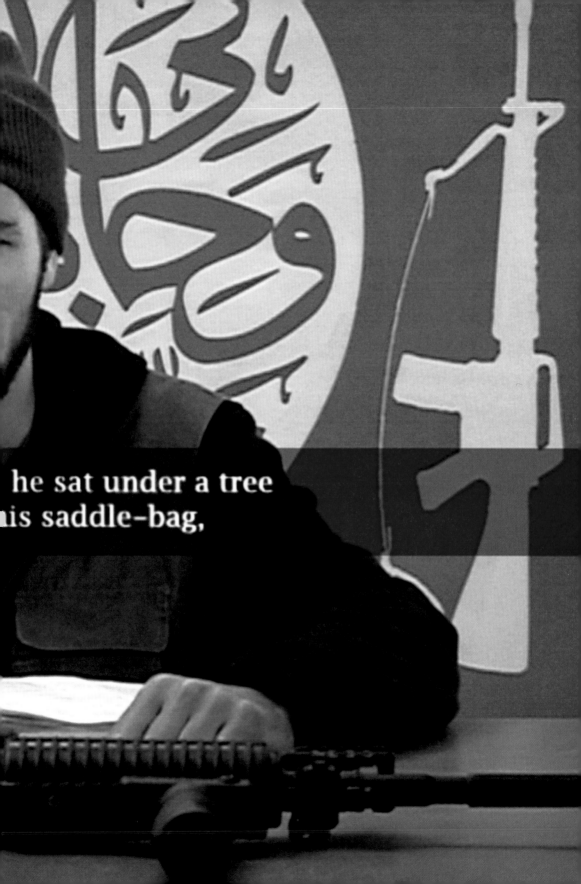

he sat under a tree
is saddle-bag,

Gillian
Wearing RA

Gillian Wearing's *Sixty Minute Silence* is a *tableau vivant*. In order to create it the artist lined up 26 people, dressed in British police uniforms, in three rows and asked them to remain motionless for an hour. After the first few minutes, the subjects began to display an energy that was to increase as the time went by. The uniformed ranks wobble slightly. The officers glance at each other. Their initial stillness eventually gives way to fidgeting. Some stifle giggles. Minute by minute, the control signified by the uniforms breaks down and the slight movement interferes with the stillness; this individuates and humanises the uniformed mass.

The uniform is the codified cloth *par excellence*. As a sign of membership of a particular group, it identifies and marks its wearer. It expresses the subject in one dimension. Wearing a uniform means belonging to a group, accepting its rules and regulations (and even feeling lost without it). The video shows the way the homogenisation of the rules and regulations represented by the uniform can be overturned when real life creeps in.

In this piece, Wearing also implicitly confronts the problem of the relationship between ourselves and others, and particularly those in power. Normally it is we who would feel ill at ease when confronted by a large group of policemen eyeing our every move; in this case, it is they who are paralysed by the situation as they are scrutinised by us. The problem has further significance here, in relation to art: the work is being looked at by us, but at the same time it is alive, and, in a certain sense, is 'watching us'. Who is the subject and who is the object? Who is observing and who is being observed?

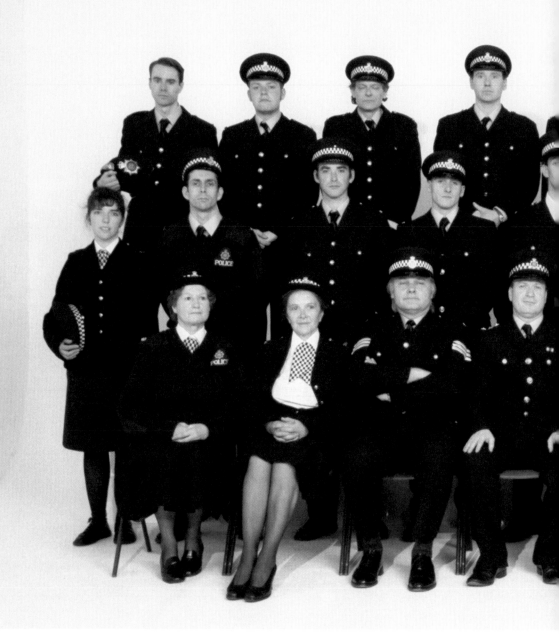

Sixty Minute Silence, 1996
Colour video projection
with sound, running
time 60'.
Courtesy of Maureen Paley,
London

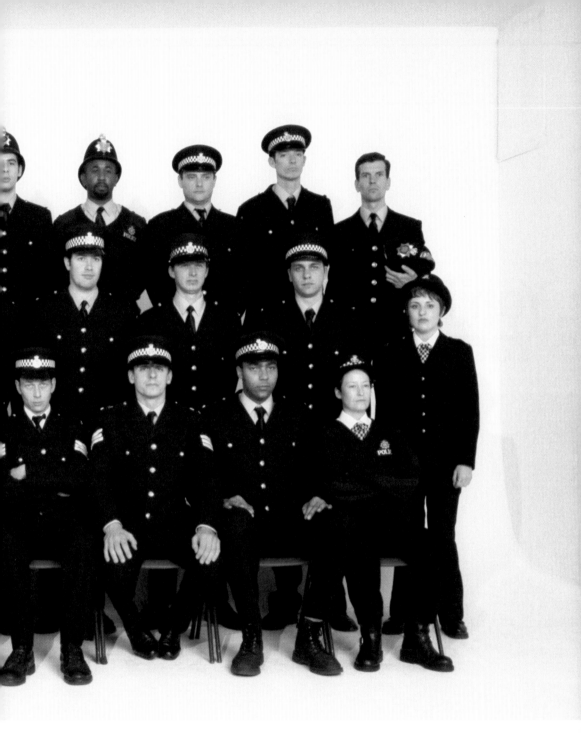

Yohji
Yamamoto

Fashion is not about glamour or opulence for Yohji Yamamoto, nor is it about vacuous optimism or the 'everything is OK' mentality. Fashion for him means rigorous perfectionism, combined with the notion that every last detail counts towards the whole. Each of his pieces is created with extreme discipline and almost monastic rigour. 'Ever since I began my career,' Yamamoto says, 'I have always questioned fashion. I could also put it this way: I hate fashion [...] Fashion yearns for trends. I want timeless elegance. Fashion has no time. I do. I say: Hello, Lady, how can I help you? Fashion has not time even to ask such a question, because it is constantly concerned with finding out: what will come next? It is more about helping women to suffer less, to attain more freedom and independence.

'My job is to regain respect for clothing. Merchandising and advertising have become too powerful, too dominant during the past few years. I say: Wait a moment, slow down [...] The acceleration of things prevents us thinking about them. Doubts are excluded. All follow. Until everything looks like everything else. A sort of equalisation.'

For *Autumn-Winter 1991–92, Yohji Yamamoto Femme Collection*, he assembles very ordinary planks of wood, the sort that are normally the basic components of our home environment. From these planks he creates a series of dresses and bodices, sheathing his models in them. The direct contact between skin and wood creates a very unorthodox juxtaposition. The wood is sculptural and rigid, both severe and humorous; the gown becomes a piece of architecture, and the body becomes a matrix and a reference to the dimensions of the architecture; via this gown we inhabit the world. Increasingly mobile, we tend to carry our houses with us.

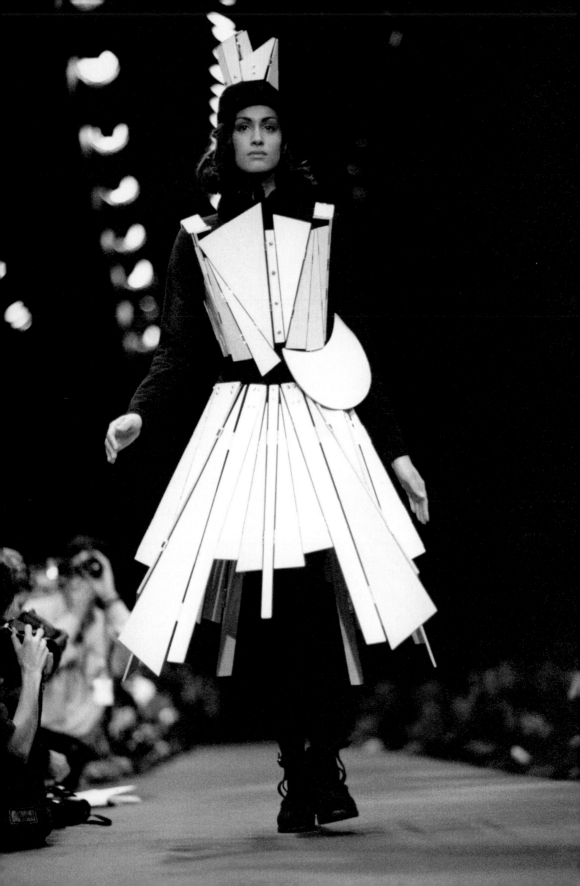

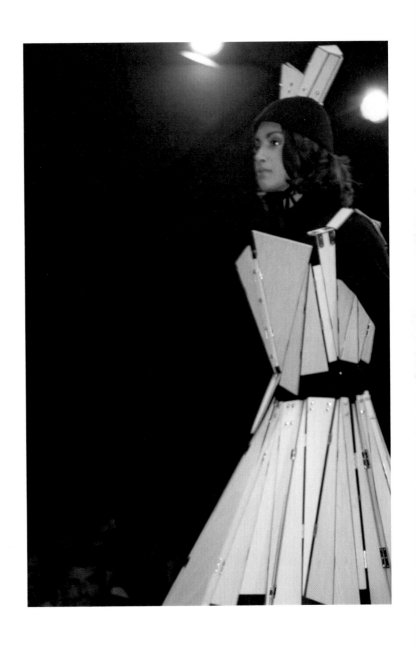

Autumn-Winter 1991–92,
Yohji Yamamoto Femme
Collection, **1991–2**
Plywood, *c.* 100 x 200 cm.
© Thierry Chomel for
Yohji Yamamoto

Andrea
Zittel

Andrea Zittel's clothes are also functional objects. She makes garments out of natural materials, a few pieces every year, designed to be worn for a few months – they mark the stages and rites of various times of life, in addition to their everyday function. They are made by hand using traditional techniques and then dyed with natural colouring. She also makes organic felt, using long-established felting methods. Hundreds of different fabrics and styles are utilised to suit different occasions, from exquisite accessories to traditional aprons for housewives.

Many of Zittel's clothes can be folded: once they are unfolded they represent maps. This is an allusion to our being part of a more complex whole. Her clothing promotes the rejection of consumerism. She always produces something 'different' in order to advocate a return to simplicity and sustainability.

Her work breathes a feeling of freedom, autonomy and self-determination; we can read in it a responsible attitude to life. She also organises her daily life and activities in such a way as to foster conservation as far as possible.

Zittel views concept, method and praxis as one and the same; care for one's self and for the environment is a way of giving meaning to life in a world in which micro and macro, the individual and the environment are all organically linked.

A–Z Fibre Form Uniform:
Fall/Winter 2003 #2, **2003**
Dark and light-green felted
Merino wool, black turtle-
neck, scarf and black skirt,
71.1 x 53.3 cm (overall
97.8 x 101.6 cm).
© Andrea Zittel/Courtesy
Andrea Rosen Gallery,
New York

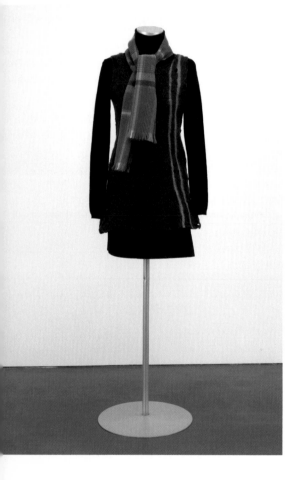

A–Z Fibre Form Uniform:
Winter 2005 (brown with
black cross), **2005**
Brown felted Merino wool
dress, white shirt, grey
skirt, 83.8 x 62.2 cm.
© Andrea Zittel/Courtesy
Andrea Rosen Gallery,
New York

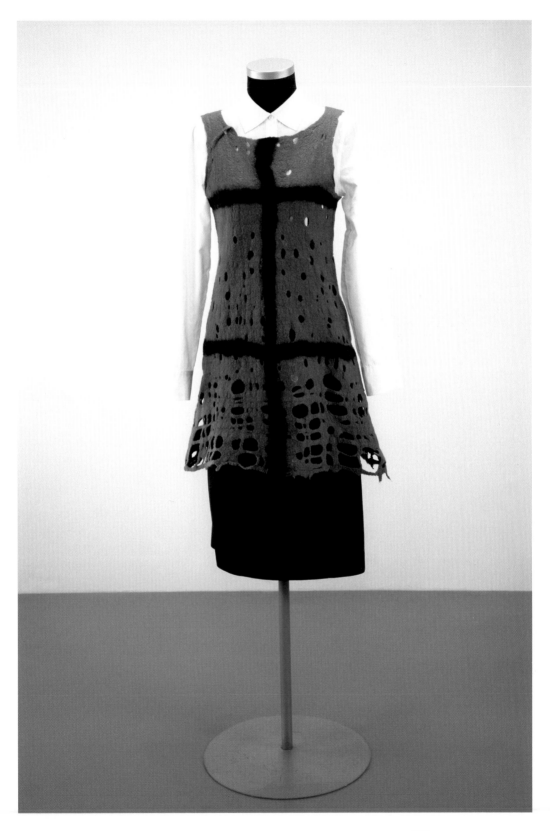

A–Z Fibre Form Uniform: Fall/Winter 2005 #1, 2005
Dark-red felted Merino wool dress, brown skirt, white shirt.
© Andrea Zittel/Courtesy Andrea Rosen Gallery, New York

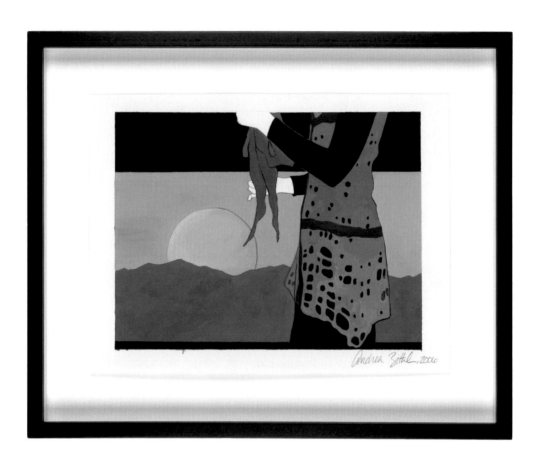

Study for Billboard: AZ
Holding Scarf in A–Z Fibre
Form, 2006
Gouache on paper,
22.9 x 30.5 cm.
© Andrea Zittel
Courtesy Andrea Rosen
Gallery, New York

A-Z Fiber Form - looks like a collapsing grid - February 2005 Andrea Zittel

A–Z Fibre Form – Looks
Like a Collapsing Grid –
February 2005
Gouache on paper,
22.9 x 30.5 cm.
© Andrea Zittel
Courtesy Andrea Rosen
Gallery, New York

Artist biographies

MARINA ABRAMOVIĆ
Abramović, born in Serbia in 1946, studied at the Academy of Fine Arts in Belgrade and graduated from the Academy of Fine Arts in Croatia in 1972. Rising to prominence in the 1970s as a performance artist, she explored various themes, such as the limits of body and mind as well as the relationship between performer and audience. Most notable works include *Rhythm 0* (1974) and *The Artist is Present* (2010). In 1997 Abramović was the recipient of the Golden Lion Award at the Venice Biennale.

VITO ACCONCI / ACCONCI STUDIO
Born in New York in 1940, Vito Acconci studied at the College of the Holy Cross, where he received a BA in literature in 1962. He rose to prominence in the 1970s as a conceptual artist, with notable works including *Seedbed* (1971), *Theme Song* (1973) and *The Red Tapes* (1976). Acconci works across a variety of disciplines, including film and video, sound, sculpture, performance, photography and architecture. He founded the Acconci Studio, a group of architects based in Brooklyn, New York, who design projects for public spaces.

AZRA AKŠAMIJA
Born in Sarajevo in 1976, Akšamija is an artist and architect who explores the relationship between, and the representation of, Islamic identity and architecture. Having studied architecture at Technical University Graz and Princeton University (M.Arch), she is currently researching her Ph.D. dissertation on contemporary mosque architecture at the Massachusetts Institute of Technology.

MAJA BAJEVIC
Born in Sarajevo in 1967, Bajevic studied at École des Beaux-Arts in Paris. Focusing on a variety socio-political issues, Bajevic uses performance, video and installation pieces to investigate both personal and universal identity. Her video work *Double Bubble* (2001) focused on the misuse of religion in modern society, while another video, *Back in Black* (2003), stems from the artist's personal experience of war and violence.

HANDAN BÖRÜTEÇENE
Börüteçene was born in Istanbul in 1957, and studied at Istanbul State Academy of Art and École Nationale Supérieure des Beaux-Arts Paris. Her work focuses on memory and the paths of body and culture over time, furthermore influenced by her heritage and the history Mediterranean. Exhibiting worldwide, notable works include *Break and See* (1985) and *Reserved: For Freedom – motus animi continuus* (2002).

HUSSEIN CHALAYAN
Born in Cyprus in 1970, Chalayan studied fashion design at Central Saint Martins. Known for his cutting-edge use of materials and progressive approach to new technology, he draws inspiration from architectural ideas and the sciences. Having produced over twenty collections, Chalayan received the title of British Designer of the Year both in 1999 and 2000. He was the subject of an exhibition at the Design Museum, London, in 2009.

ALICIA FRAMIS
Born in Barcelona in 1967, Framis studied Fine Arts at the Barcelona University and at École des Beaux-Arts in Paris. In 2002 she created her *Anti-Dog* clothing collection, comprising 23 bullet-resistant and stab-proof dresses which addressed the victimisation of women. Other notable works include *Remix Buildings* (2000), which combined buildings and concepts usually kept separated, and *Lost Astronaut* (2009), a performance piece commenting on the role of women in the contemporary world.

MESCHAC GABA
Gaba was born in 1961 in Benin and studied at the Rijksakademie voor Beeldende Kunsten in Amsterdam. During his studies, Gaba created The Museum of Contemporary African Art (1997–2002) as a way of examining the presence – or lack – of African art in Western society. Working in a variety of media, he explores the cultural balance and imbalance between Africa and the West.

MARIE-ANGE GUILLEMINOT
Born in France in 1960, Guilleminot graduated from Villa Arson, Nice in 1981, and now works in a variety of media including film, sculpture and performance. Focusing on various objects and materials, she creates new functions and characteristics in an approach that is both aesthetic and scientific. Exhibiting internationally, notable works include *Mes Poupées* (1993) and *Mes Robes* (1992–5).

ANDREAS GURSKY
Born in 1955 in Leipzig, Germany, Gursky is known for his large-scale photographs. Having studied at Düsseldorf Kunstakademie in the early 1980s, he began producing small, black-and-white prints, but eventually broke from this style to create vast, colour photographs, usually taken from a high vantage point. His subjects often include buildings, landscapes and large groups of people, distinctly depicted in such works as *Chicago Board of Trade II* (1999) and *99 Cent II Diptychon* (2001).

MELLA JAARSMA
Born in the Netherlands in 1960, Jaarsma studied visual art at Academie Minerva, Groningen, followed by studies at the Art Institute of Yogyakarta and later the Indonesian Institute of the Arts. Working as both an artist and curator, Jaarsma has recently become known for her complex costumes. Works such as *Hi Inlander (Hello Native)* (1998–9) focus on cultural and racial diversity through clothing.

KIMSOOJA

Born in South Korea in 1957, Kimsooja earned her BFA and MA from Hong-Ik University in Seoul. Using video, performance and installation, she combines the traditions of the East and the West, exploring the commonality between the private, personal self and those of the increasingly larger global community. Notable works include such films as *A Needle Woman* (1999–2001) and *A Beggar Woman* (2001).

CLAUDIA LOSI

Losi, born in Italy in 1971, studied at the Academy of Fine Arts in Bologna and received a degree in Foreign Languages and Literature from the University of Bologna in 1998. Her work often illustrates her interest in the natural sciences as well as the historical and anthropological aspects of the environment. Losi also explores the concept of story-telling through art, often using projects to link and create new communities of human interaction.

SUSIE MACMURRAY

MacMurray was born in London in 1959 and studied at Manchester Metropolitan University, where she received her BA Sculpture and MA Fine Art. She works in a variety of media, including drawing, sculpture and performance, and is known for her site-specific architectural installations. Using a combination of materials in an innovative way is central to MacMurray's practice, and she often focuses on creating intricate detail. Notable works include *A Mixture of Frailties* (2004) and *Promenade* (2010).

MARCELLO MALOBERTI

Maloberti was born in Italy in 1966. He predominately uses videos, performances, installations and photographs to create surreal environments that merge reality and fantasy. Notable works include *Set* (2006), *Bowling Cervello* (2008) and *The Ants Struggle on the Snow* (2009).

LA MAISON MARTIN MARGIELA

Martin Margiela was born in 1957 in Belgium. He studied at the Royal Academy of Fine Arts in Antwerp, graduating in 1980. In 1989, he showed his first collection under his own label, La Maison Martin Margiela. Known for his style of construction and deconstruction approach and use of non-traditional fabrics, he exposes the composition and conception of his creations.

ALEXANDER MCQUEEN CBE

Alexander McQueen (1969 – 2010) was an English fashion designer best known for his unorthodox designs. He studied at Central Saint Martins, where he received his Masters degree in fashion design. He was head designer at Givenchy from 1996 to 2001, having already founded the labels Alexander McQueen and McQ. His notable accomplishments include receiving the title of British Designer of the Year four times, from 1996 to 2003, as well as being named International Designer of the Year in 2003 by the Council of Fashion Designers.

YOKO ONO

Ono was born in 1933 in Tokyo. She works in a variety of media including music, performance and film. Although her work often explores identity and the relationship between performer and audience, she also addresses the issues of gender, sexism and human suffering. Notable works include her performance work *Cut Piece* (1964), the film *No. 4* (1966) and her participatory project *Wish Tree* (1996). In 2009 she was the recipient of the Golden Lion Award for lifetime achievement at the Venice Biennale.

MARIA PAPADIMITRIOU

Papadimitriou was born in Athens in 1957 and studied at École Nationale Supérieure des Beaux-Arts in Paris. An artist and self-educated architect, she is known for taking a realistic and workable approach to the development of contemporary cities and, in 1998, she founded the Temporary Autonomous Museum for All. Papadimitriou teaches in the Department of Architecture at the University of Thessaly, and won the Deste Prize for Contemporary Greek Art in 2003.

GRAYSON PERRY

Born in 1960, Perry received his BA in Fine Art from Portsmouth Polytechnic in 1982. Although he works in a variety of media such as photography and embroidery, he is best known for his work in ceramics. Using classically shaped vases, he illustrates serious themes and dark subject-matter, often depicting images of his personal family life and his transvestite alter-ego, Claire. Perry won the Turner Prize in 2003 for his use of traditional ceramics to express personal and social issues in *Boring Cool People* (1999), *Village of Penians* (2001) and *Golden Ghosts* (2001).

DAI REES

Rees was born in South Wales in 1961, and studied ceramics and glass at the Royal College of Art. In 1997 he began his career in fashion, working predominantly in millinery, accessories and womenswear. He is currently a Professor at the London College of Fashion where his research project, entitled 'Patronage, Artisan, Media and Audience: A Model for Twenty-First Century Craftsmanship', will produce objects that explore the relationship between modern and historical techniques.

KATERINA ŠEDÁ

Šedá was born in 1977 in the Czech Republic, and studied at the Academy of Fine Arts in Prague. Her work explores and intervenes on patterns of interaction and behaviour, often focusing on the relationships within her family as well as those in her community. Notable works include *It Doesn't Matter* (2005) and *There's Nothing There* (2003), in which Šedá had a small village carry out their day-to-day activities simultaneously.

CINDY SHERMAN HON RA

Born in New Jersey in 1954, Sherman studied Art at Buffalo State College from 1972–6, focusing on photography. Her photographs, in which she uses herself as a model, illustrate the various satirical stereotypes of women, often using pop-culture references from soap operas, old movies and pulp magazines. An example of this style can be seen in her most notable work, *Untitled Film Stills* (1977–80). Although working predominately in photography, Sherman directed her first film, *Office Killer*, in 1997. She was elected an Honorary Royal Academician in 2010.

YINKA SHONIBARE MBE

Shonibare, a British-Nigerian artist born in 1962, completed his BA at Goldsmiths College in 1991. Using painting, sculpture, photography, film and performance, he addresses the issues of race, class and identity, often exploring the colonial and post-colonial relationship between Africa and Europe. Notable works include *Nelson's Ship in a Bottle* (2010), which occupied the Fourth Plinth in London's Trafalgar Square, and his exhibition 'Double Dutch', which led to his nomination for the Turner Prize in 2004.

HELEN STOREY

Born in 1959, Storey received a BA in fashion in 1982 from Kingston University before moving to Rome to train at Valentino and Lancetti. In 1984 she launched her own fashion label, receiving the award for Most Innovative Designer and Best Designer Exporter in 1990. With the success of her fashion collection 'Primitive Streak', she established the Helen Storey Foundation, a not-for-profit arts organisation, in 1997. Storey is also known for her work in the sciences and new technology fields.

ROSEMARIE TROCKEL

Trockel was born in 1952 in Germany and studied painting at the Kölner Werkschulen in Cologne. Although she works in a variety of media, she rose to prominence through her knitted pictures that addressed a number of controversial issues. Exploring the role of women and their place in society, Trockel challenged the notions of sexuality and culture. Other notable works include *Painting Machine and 56 Brush Strokes* (1990).

SHARIF WAKED

Born in Nazareth in 1964, Waked studied Fine Arts at Haifa University. Known for his video work, he often combines humour and satire with serious subjects, such as the political relationship and conflict between the Middle-East and the West. Notable works include *Jericho First* (2002), *To Be Continued...* (2009) and *Beace Brocess* (2010).

GILLIAN WEARING RA

Wearing was born in 1963. She is a photographer and filmmaker and studied at Chelsea College of Art (1985–7) and Goldsmiths College (1987–90). Citing fly-on-the-wall-style documentaries as her initial inspiration, her work reflects the difference between private and public lives, as well as the connection between her own life and the lives of others. In 1997, Wearing won the Turner Prize with her video works *Sixty Minute Silence* and *Sacha and Mum*. She was elected a Royal Academician in 2007.

YOHJI YAMAMOTO

Born in Tokyo in 1943, Yamamoto graduated from Keio University with a degree in Law, before studying Fashion Design at Bunka Fashion College. In 1981 he debuted in Paris, also establishing his self-titled clothing line the same year. Known for his radical ideas, Yamamoto has a tendency to use unconventional shapes and proportions.

ANDREA ZITTEL

Born in California in 1965, Zittel studied at the Rhode Island School of Design where she received a MFA in sculpture in 1990. Working in a variety of fields including sculpture, architecture and fashion design, Zittel set up A–Z Administrative Services as a way to simplify domestic life by creating objects and spaces with multiple functions. Most notable works include her 'Living Units' and 'Escape Vehicles' and, in 1999, she was commissioned by the Danish government to create a 44-ton floating concrete island called 'A–Z Pocket Property'.

Acknowledgements
The curators extend their thanks to those organisations and individuals who have assisted with this exhibition.

Photographic credits

Vito Acconci: page 53
John Akehurst: page 39 (bottom)
Azra Akšamija and Rahkeen Grey: page 58
Thierry Bal: page 39 (top)
Pradeep Bhatia: pages 118, 119
Ela Bialkowska: pages 92, 93
Bill Beckley: page 52
Handan Börütçene: pages 72, 73
Christopher Burke: pages 235–7
Mie Cornoedus: pages 110, 113
Susan Crowe: page 137
Giovanna dal Magro: page 45
Thierry Depagne: page 121 (bottom)
Fotostudio Schaub (Bernhard Schaub, Ralf Höffner): page 210
Roberto Galasso: page 213
Bob Goedewaagen: page 146
Peter Guenzal: page 37
Marie-Ange Guilleminot and Kyoto Art Centre: pages 96, 98
Hirata: page 158 (right)
Invernomuto: page 124
Niteen Kosle: page 116
Dario Lasagni: pages 126 (bottom), 127
Pierre Leguillon: page 101
Susie MacMurray: pages 132–5
Alex Maguire: page 207
The Mahler.com: page 47 (bottom right)
Antonio Maniscalco: pages 13–23
Ken McKay: page 158 (left)
Jörg Mohr: pages 56, 57
Aurélien Mole: page 90
Chris Moore: pages 78–80, 153–5
Daniela Morreale: page 126 (top)
Museum für Gestaltung Zürich. Regula Bearth © ZHdK: page 84
Minoru Niizuma: page 159
Nuova Icona, Venice: page 70
Bill Orcutt: page 121 (top)
Maria Papadimitriou: pages 164–7
Ann Marie Peña: pages 196–8
Dai Rees: pages 176, 179
John Ross: pages 204, 205
Oren Slor: pages 234 (left), 241
Lee Jong Soo: page 120
Sharif Waked: pages 218–223

Works by Helen Storey
From a series of 'Disappearing Dresses' from *The Wonderland Project*
 © 2008. Dresses by Helen Storey (London College Fashion,
 University of the Arts London), assisted by Helen Bailey.
Science partner: Professor Tony Ryan OBE (University of Sheffield).
Textiles: Trish Belford (University of Ulster).
Scaffold design and build: Richard Wilkinson (University of Sheffield).
Supported by the Royal Society of Chemistry.
Dissolvable polymer 'spaghetti' kindly developed and supplied by
 MonoSol AF Ltd.
Say Goodbye: model Pixie @ Profile Model Management Ltd;
 make-up and hair by Sam Basham.

Supported by

 GlaxoSmithKline

Media Partner

BAZAAR

BASTYAN

Hotel Partner

THE MAY FAIR
LONDON

RSC | Advancing the Chemical Sciences

VLISCO

BURLINGTON
ARCADE
Since 1819

Mondriaan Stichting
(Mondriaan Foundation)

 Kingdom of the Netherlands

Mr and Mrs James Kirkman
Mrs Aboudi Kosta
Lady Lever of Manchester
Sir Sydney Lipworth QC and
 Lady Lipworth CBE
Mr William Loschert
Mark and Liza Loveday
Mr Nicholas Maclean
Mr and Mrs Richard Martin
The Mulberry Trust
Mr and Mrs D J Peacock
Mr Basil Postan
The Lady Henrietta St George
Mr and Mrs Kevin Senior
Christina, The Countess of Shaftesbury
Mrs Lesley Silver
Richard and Veronica Simmons
Jane Spack
Mrs Elyane Stilling
Sir Hugh Sykes DL

Bronze
Lady Agnew
Miss H J C Anstruther
Edgar Astaire
Mrs Marina Atwater
Jane Barker
Stephen Barry Charitable Settlement
James M Bartos
Mrs Ginny Battcock
The Duke of Beaufort
Mrs J K M Bentley
Mrs Marcia Brocklebank
Mr and Mrs Charles H Brown
Mr Graham Brown
Jeremy Brown
Lord Browne of Madingley
Mr Raymond M Burton CBE
Mr F A A Carnwath CBE
Jean and Eric Cass
Mr and Mrs George Coelho
Denise Cohen Charitable Trust
Mark and Cathy Corbett
Mr and Mrs Sidney Corob
Julian Darley and Helga Sands
The Countess of Dartmouth
Lord and Lady Davies of Abersoch
Peter and Andrea de Haan
Mrs Norah de Vigier
Dr Anne Dornhorst
Lord Douro
Ms Noreen Doyle
Mr and Mrs Maurice Dwek
Lord and Lady Egremont
Miss Caroline Ellison
Mr and Mrs David Fenton
Bryan Ferry
Mr Sam Fogg
Mrs Kay Foster
Mrs Jocelyn Fox
Mr Monty Freedman
Arnold Fulton
The Lord Gavron CBE

Patricia and John Glasswell
Mark Glatman
Lady Gosling
Piers Gough
Mr Louis Greig
Sir Ewan and Lady Harper
Mr Mark Hendriksen
Mr and Mrs Christoph Henkel
Ms Alexandra Hess
Ms Joanna Hewitt
Mr Patrick Holmes
Mrs Pauline Hyde
Mrs Raymonde Jay
Fiona Johnstone
Dr Elisabeth Kehoe
Mr Gerald Kidd
Norman A Kurland and Deborah A David
Joan H Lavender
Inez and George Lengvari
Mr Peter Lloyd
Mrs Diane Lockett
Miss R Lomax-Simpson
The Marquess of Lothian
Mr and Mrs Henry Lumley
Gillian McIntosh
Andrew and Judith McKinna
Sally and Donald Main
Mrs Sally Major
Mr and Mrs Eskandar Maleki
Mr Michael Manser RA and
 Mrs Jose Manser
Mr Marcus Margulies
Zvi and Ofra Meitar Family Fund
Mrs Alan Morgan
Mrs Joy Moss
Marion and Guy Naggar
Dr Ann Naylor
Ann Norman-Butler
North Street Trust
Mr Michael Palin
John H Pattisson
Mr Philip Perry
Mr David Pike
Mr and Mrs Anthony Pitt-Rivers
HRH Princess Marie-Chantal of Greece
Mrs Jasmin Prokop
Mr Mike Pullen
John and Anne Raisman
Miss Myrna Rassam
Mrs Bianca Roden
Mrs Jenifer Rosenberg OBE
Lord Rothschild
Mr and Mrs K M Rubie
Ms Edwina Sassoon
H M Sassoon Charitable Trust
Carol Sellars
Dr Lewis Sevitt
Mr Robert N Shapiro
Victoria Sharp
Jonathan and Gillie Shaw
Mr James B Sherwood
Alan and Marianna Simpson
Brian D Smith

Mr Malcolm Smith
Mr J Sumption OBE
Mrs Kathryn Sumroy
Mrs D Susman
Lord Taylor of Holbeach and Lady Taylor
Mr Ian Taylor
Mr Anthony J Todd
Miss M L Ulfane
John and Carol Wates
Edna and Willard Weiss
Anthony and Rachel Williams
Mr William Winters
*and others who wish to remain
anonymous*

Benefactor Patrons

Mary Fedden RA
Lord and Lady Foley
Mrs Mary Graves
Mrs Sue Hammerson
The Swan Trust
Sir Anthony and Lady Tennant

Benjamin West Group Patrons

Chairman
Lady Barbara Judge CBE

Platinum
Charles and Kaaren Hale

Gold
Lady Barbara Judge CBE

Silver
Lady J Lloyd Adamson
Mrs Spindrift Al Swaidi
Mrs Adrian Bowden
Mr and Mrs John R Olsen
Mr and Mrs Dave Williams

Bronze
Ms Ruth Anderson
Mr Andy Ash
Mr Max Audley
Mr Stefano Aversa
Mr Mark Beith
Ms Michal Berkner
Ms Maryn Coker
Mr and Mrs Paul Collins
Mr Mark Dichter
Mr Jeffrey E Eldredge
Arthur Fabricant
Ms Clare Flanagan
Mr John Flynn
Cyril and Christine Freedman
Mr Metin Guvener
Mr Andrew Hawkins
Mr Brandon Hollihan
Mr and Mrs Marc Holtzman
Suzanne and Michael Johnson
Alistair Johnston and Christina Nijman

Mr and Mrs Kovacs
Mr and Mrs Wilson Lee
Mr and Mrs Kenneth Lieberman
Charles G Lubar
Mrs Victoria Mills
Mr and Mrs Frank Moretti
Neil Osborn and Holly Smith
Lady Purves
Sylvia Scheuer
Mrs Sahim Sliwinski-Hong
Mr Adrian Smaus
Carl Stewart
Mrs Sayoko Teitelbaum
Lloyd Thomas
Mr and Mrs Julian Treger
Frederick and Kathryn Uhde
Mrs Yoon Ullmo
Prof Peter Whiteman QC
John and Amelia Winter
Mary Wolridge
Mrs Deborah Woodbury
*and others who wish to remain
anonymous*

Schools Patrons Group

Chairman
Ms Clare Flanagan

Platinum
Mr Campbell Rigg
Matthew and Sian Westerman

Gold
Lord and Lady Myners
Mr James Stewart

Silver
Lord and Lady Aldington
Mr Sam Berwick
John Entwistle OBE

Bronze
Mrs Inge Borg Scott
Ian and Tessa Ferguson
Prof Ken Howard OBE RA and
 Mrs Dora Howard
Mr Philip Marsden
Peter Rice Esq
Mr James Robinson
Anthony and Sally Salz
Mr Ray Treen
*and others who wish to remain
anonymous*

Contemporary Patrons Group

Chairman
Susie Allen

Patrons
Viscountess Bridgeman
Alla Broeksmit

Dr Elaine C Buck
Jenny Christensson
Mr Peter R d'Eugenio
Loraine da Costa
Helen and Colin David
Belinda de Gaudemar
Chris and Angie Drake
Mrs Wendy Ehst
Dr Barry Grimaldi
Caroline Hansberry
Mrs Susan Hayden
Margaret A Jackson
Mr and Mrs Stephen Mather
Jean-Jacques Murray
Mr Andres Recoder and
 Mrs Isabelle Schiavi
Mrs Catherine Rees
Richard and Susan Shoylekov
Bob and Amy Stefanowski
John Tackaberry
Mrs Inna Vainshtock
Cathy Wills
Manuela and Iwan Wirth
Mary Wolridge
*and others who wish to remain
anonymous*

Trusts and Foundations

The Atlas Fund
The Ove Arup Foundation
Aurelius Charitable Trust
The Peter Boizot Foundation
The Bomonty Charitable Trust
The Charlotte Bonham-Carter
 Charitable Trust
William Brake Charitable Trust
The Britten-Pears Foundation
R M Burton 1998 Charitable Trust
C H K Charities Limited
P H G Cadbury Charitable Trust
The Carew Pole Charitable Trust
The Carlton House Charitable Trust
The Clore DuYeld Foundation
John S Cohen Foundation
The Ernest Cook Trust
The Sidney and Elizabeth Corob
 Charitable Trust
The Coutts Charitable Trust
Alan Cristea Gallery
The de Laszlo Foundation
The D'Oyly Carte Charitable Trust
The Dovehouse Trust
The Gilbert and Eileen Edgar Foundation
The Eranda Foundation
Lucy Mary Ewing Charitable Trust
The Fenton Arts Trust
The Margery Fish Charity
The Flow Foundation
Gatsby Charitable Foundation
Goethe Institut London
The Golden Bottle Trust
The Great Britain Sasakawa Foundation

Sue Hammerson Charitable Trust
The Charles Hayward Foundation
The Hellenic Foundation
Heritage Lottery Fund
A D Hill 1985 Discretionary Settlement
The Harold Hyam Wingate Foundation
Institut fuer Auslandsbeziehungen e.V.
The Ironmongers' Company
The Japan Foundation
Stanley Thomas Johnson Foundation
The Emmanuel Kaye Foundation
The Kindersley Foundation
The Kobler Trust
The Lankelly Chase Foundation
Lapada Association of Art &
 Antique Dealers
Lark Trust
The David Lean Foundation
The Leche Trust
A G Leventis Foundation
The Leverhulme Trust
The Lynn Foundation
The Maccabaeans
The McCorquodale Charitable Trust
Mactaggart Third Fund
The Simon Marks Charitable Trust
The Paul Mellon Centre for Studies in
 British Art
The Paul Mellon Estate
The Mercers' Company
Margaret and Richard Merrell Foundation
The Millichope Foundation
The Henry Moore Foundation
The Mulberry Trust
The J Y Nelson Charitable Trust
Newby Trust Limited
OAK Foundation Denmark
The Old Broad Street Charity Trust
The Peacock Charitable Trust
The Pennycress Trust
PF Charitable Trust
The Stanley Picker Charitable Trust
The Pidem Fund
The Edith and Ferdinand Porjes
 Charitable Trust
The Fletcher Priest Trust
The Privy Purse Charitable Trust
Pro Helvetia
Mr and Mrs J A Pye's Charitable
 Settlement
The Radcliffe Trust
Rayne Foundation
The Reed Foundation
T Rippon & Sons (Holdings) Ltd
The Rootstein Hopkins Foundation
The Rose Foundation
The Rothschild Foundation
Schroder Charity Trust
The Sellars Charitable Trust
The Archie Sherman Charitable Trust
The South Square Trust
Spencer Charitable Trust
Stanley Foundation Limited

Oliver Stanley Charitable Trust
The Steel Charitable Trust
Peter Storrs Trust
Strand Parishes Trust
The Joseph Strong Frazer Trust
The Swan Trust
Swiss Cultural Fund in Britain
Thaw Charitable Trust
Sir Jules Thorn Charitable Trust
Tiffany & Co
Tillotson Bradbery Charitable Trust
The Albert Van den Bergh Charitable Trust
The Bruce Wake Charity
Celia Walker Art Foundation
Warburg Pincus International LLC
The Wax Chandlers' Company
Weinstock Fund
The Garfield Weston Foundation
Wilkinson Eyre Architects
The Spencer Wills Trust
The Maurice Wohl Charitable Foundation
The Wolfson Foundation
The Hazel M Wood Charitable Trust
The Worshipful Company of
 Painter-Stainers
The Xander Foundation

American Associates of the Royal Academy Trust

Burlington House Trust
Mrs James C Slaughter

Benjamin West Society
Mr Francis Finlay
Mrs Deborah Loeb Brice
Mrs Nancy B Negley

Benefactors
Mrs Edmond J Safra
The Hon John C Whitehead

Sponsors
Mrs Drue Heinz HON DBE
David Hockney CH RA
Mr Arthur L Loeb
Mrs Lucy F McGrath
Mr and Mrs Hamish Maxwell
Diane A Nixon
Mr and Mrs Frederick B Whittemore
Dr and Mrs Robert D Wickham

Patrons
Mr and Mrs Steven Ausnit
Mr Donald A Best
Mrs Mildred C Brinn
Mrs Benjamin Coates
Mr and Mrs Stanley De Forest Scott
Mrs June Dyson
Mr Jonathan Farkas
Mr and Mrs Lawrence S Friedland
Mr and Mrs Leslie Garfield

Dr Bruce C Horten
The Hon W Eugene Johnston and
 Mrs Johnston
Mr and Mrs Wilson Nolen
Lady Renwick
Mrs Mary Sharp Cronson
Mrs Frederick M Stafford
Ms Joan Stern
Ms Louisa Stude Sarofim
Martin J Sullivan OBE
Mr Arthur O Sulzberger
Ms Britt Tidelius
Mr Robert W Wilson

Donors
Mr James C Armstrong
Mr Constantin R Boden
Dr and Mrs Robert Bookchin
Mrs Edgar H Brenner
Laura Christman and William Rothacker
Lois M Collier
Mr Richard C Colyear
Mr and Mrs Howard Davis
Ms Zita Davisson
Mr Robert H Enslow
Mrs Katherine D Findlay
Mr and Mrs Gordon P Getty
Mrs Judith Heath
Ms Elaine Kend
Mr and Mrs Nicholas L S Kirkbride
Mr and Mrs Gary Kraut
The Hon Samuel K Lessey Jr
Annette Lester
Mr Henry S Lynn Jr
Ms Clare E McKeon
Ms Christine Mainwaring-Samwell
Ms Barbara T Missett
Mrs Charles W Olson III
Cynthia Hazen Polsky and Leon B Polsky
Jane Richards
Mrs Martin Slifka
Mr Albert H Small

Corporate and Foundation Support
Annenberg Foundation
Bechtel Foundation
The Blackstone Charitable Foundation
The Brown Foundation
Fortnum & Mason
Gibson, Dunn & Crutcher
The Horace W Goldsmith Foundation
Leon Levy Foundation
Loeb Foundation
Henry Luce Foundation
Lynberg & Watkins
Sony Corporation of America
Starr Foundation
Thaw Charitable Trust

Corporate Members of the Royal Academy
Launched in 1988, the Royal Academy's Corporate Membership Scheme has proved highly successful. Corporate membership offers benefits for staff, clients and community partners and access to the Academy's facilities and resources. The outstanding support we receive from companies via the scheme is vital to the continuing success of the Academy and we thank all members for their valuable support and continued enthusiasm.

Premier Level Members
A T Kearney Limited
The Arts Club
Barclay's plc
BNY Mellon
CB Richard Ellis
Deutsche Bank AG
FTI Consulting
GlaxoSmithKline plc
Goldman Sachs International
Insight Investment
JTI
King Sturge
KPMG
LECG Ltd
Lombard Odier Darier Hentsch
Schroders plc
Smith and Williamson

Corporate Members
Abellio
All Nippon Airways
Aon
Apax Partners LLP
AXA Insurance
BNP Paribas
Booz & Co
The Boston Consulting Group
Bovis Lend Lease Limited
British American Business Inc
British American Tobacco
Capital International Limited
Christie's
Clifford Chance LLP
Control Risks
Credit Agricole CIB
The Economist
Ernst & Young
ExxonMobil
F & C Asset Management plc
GAM
Generation Investment Management LLP
Heidrick & Struggles
HSBC
Jefferies International
John Lewis Partnership
JP Morgan
Lazard

Man Group plc
Mizuho International plc
Momart Limited
Morgan Stanley
Northern Trust
Panasonic Europe
Pentland Group plc
Rio Tinto
Royal Bank of Scotland
Royal Society of Chemistry
Slaughter and May
Société Générale
Timothy Sammons Fine Art Agents
Trowers & Hamlins
UBS
Vision Capital Group
Weil, Gotshal & Manges

Sponsors of Past Exhibitions
The President and Council of the Royal
Academy would like to thank the following
sponsors and benefactors for their
generous support of major exhibitions in
the last ten years:

2010
*Pioneering Painters: The Glasgow Boys
 1880–1900*
2009–2013 Season supported by JTI
Glasgow Museums
*Treasures from Budapest: European
 Masterpieces from Leonardo
 to Schiele*
OTP Bank
Villa Budapest
Daniel Katz Gallery, London
Travel Partner: Cox & Kings
Sargent and the Sea
2009–2013 Season supported
 by JTI
242nd Summer Exhibition
Insight Investment
*Paul Sandby RA: Picturing Britain,
 A Bicentenary Exhibition*
2009–2013 Season supported
 by JTI
*The Real Van Gogh: The Artist and
 His Letters*
BNY Mellon
Hiscox
Heath Lambert
Travel Partner: Cox & Kings
RA Outreach Programme
Deutsche Bank AG

2009
GSK Contemporary
GlaxoSmithKline
Wild Thing: Epstein, Gaudier-Brzeska, Gill
2009–2013 Season supported
 by JTI
BNP Paribas
The Henry Moore Foundation

Anish Kapoor
JTI
Richard Chang
Richard and Victoria Sharp
Louis Vuitton
The Henry Moore Foundation
*J. W. Waterhouse: The Modern
 Pre-Raphaelite*
2009–2013 Season supported
 by JTI
Champagne Perrier-Jouët
GasTerra
Gasunie
241st Summer Exhibition
Insight Investment
*Kuniyoshi. From the Arthur R. Miller
 Collection*
2009–2013 Season supported
 by JTI
Canon
Travel partner: Cox & Kings
Premiums and *RA Schools Show*
Mizuho International plc
RA Outreach Programme
Deutsche Bank AG

2008
GSK Contemporary
GlaxoSmithKline
Byzantium 330–1453
J F Costopoulos Foundation
A G Leventis Foundation
Stavros Niarchos Foundation
Travel Partner: Cox & Kings
*Miró, Calder, Giacometti, Braque:
 Aimé Maeght and His Artists*
BNP Paribas
Vilhelm Hammershøi: The Poetry of Silence
OAK Foundation Denmark
Novo Nordisk
240th Summer Exhibition
Insight Investment
Premiums and *RA Schools Show*
Mizuho International plc
RA Outreach Programme
Deutsche Bank AG
*From Russia: French and Russian Master
 Paintings 1870–1925 from
 Moscow and St Petersburg*
E.ON
2008 Season supported by Sotheby's

2007
*Paul Mellon's Legacy: A Passion for
 British Art*
The Bank of New York Mellon
Georg Baselitz
Eurohypo AG
239th Summer Exhibition
Insight Investment
Impressionists by the Sea
Farrow & Ball
Premiums and *RA Schools Show*

Mizuho International plc
RA Outreach Programme
Deutsche Bank AG
The Unknown Monet
Bank of America

2006
238th Summer Exhibition
Insight Investment
Chola: Sacred Bronzes of Southern India
Travel Partner: Cox & Kings
Premiums and *RA Schools Show*
Mizuho International plc
RA Outreach Programme
Deutsche Bank AG
Rodin
Ernst & Young

2005
China: The Three Emperors, 1662–1795
Goldman Sachs International
*Impressionism Abroad: Boston and
 French Painting*
Fidelity Foundation
*Matisse, His Art and His Textiles:
 The Fabric of Dreams*
Farrow & Ball
Premiums and *RA Schools Show*
The Guardian
Mizuho International plc
*Turks: A Journey of a Thousand Years,
 600–1600*
Akkök Group of Companies
Aygaz
Corus
Garanti Bank
Lassa Tyres

2004
236th Summer Exhibition
A T Kearney
*Ancient Art to Post-Impressionism:
 Masterpieces from the Ny Carlsberg
 Glyptotek, Copenhagen*
Carlsberg UK Ltd
Danske Bank
Novo Nordisk
The Art of Philip Guston (1913–1980)
American Associates of the
 Royal Academy Trust
The Art of William Nicholson
RA Exhibition Patrons Group
*Vuillard: From Post-Impressionist to
 Modern Master*
RA Exhibition Patrons Group

2003
235th Summer Exhibition
A T Kearney
*Ernst Ludwig Kirchner: The Dresden and
 Berlin Years*
RA Exhibition Patrons Group
Giorgio Armani: A Retrospective

American Express
Mercedes-Benz
Illuminating the Renaissance: The Triumph
of Flemish Manuscript Painting in
Europe
American Associates of the Royal
Academy Trust
Virginia and Simon Robertson
Masterpieces from Dresden
ABN AMRO
Classic FM
Premiums and *RA Schools Show*
Walker Morris
Pre-Raphaelite and Other Masters:
The Andrew Lloyd Webber Collection
Christie's
Classic FM
UBS Wealth Management

2002
234th Summer Exhibition
A T Kearney
Aztecs
British American Tobacco
Mexico Tourism Board
Pemex
Virginia and Simon Robertson
Masters of Colour: Derain to Kandinsky.
Masterpieces from The Merzbacher
Collection
Classic FM
Premiums and *RA Schools Show*
Debenhams Retail plc
*RA Outreach Programme**
Yakult UK Ltd
Return of the Buddha: The Qingzhou
Discoveries
RA Exhibition Patrons Group

2001
233rd Summer Exhibition
A T Kearney
Botticelli's Dante: The Drawings for
Dante's Divine Comedy
RA Exhibition Patrons Group
The Dawn of the Floating World
(1650–1765). Early Ukiyo-e Treasures
from the Museum of Fine Arts, Boston
Fidelity Foundation
Forty Years in Print: The Curwen Studio
and Royal Academicians
Game International Limited
Frank Auerbach, Paintings and Drawings
1954–2001
International Asset Management
Ingres to Matisse: Masterpieces of
French Painting
Barclays
Paris: Capital of the Arts 1900–1968
BBC Radio 3
Merrill Lynch
Premiums and *RA Schools Show*
Debenhams Retail plc

*RA Outreach Programme**
Yakult UK Ltd
Rembrandt's Women
Reed Elsevier plc

* Recipients of a Pairing Scheme Award,
managed by Arts + Business. Arts +
Business is funded by he Arts Council of
England and the Department for Culture,
Media and Sport

Other Sponsors
Sponsors of events, publications and other
items in the past five years:

Carlisle Group plc
Castello di Reschio
Cecilia Chan
Country Life
Guy Dawson
Derwent Valley Holdings plc
Dresdner Kleinwort Wasserstein
Lucy Flemming McGrath
Fosters and Partners
Goldman Sachs International
Gome International
Gucci Group
Hines
IBJ International plc
John Doyle Construction
Harvey and Allison McGrath
Martin Krajewski
Marks & Spencer
Michael Hopkins & Partners
Morgan Stanley Dean Witter
The National Trust
Prada
Radisson Edwardian Hotels
Richard and Ruth Rogers
Rob van Helden
Warburg Pincus
The Wine Studio